Landscape Photography:
From
Snapshots to
Great Shots

Rob Sheppard

Peachpit
Press

Landscape Photography: From Snapshots to Great Shots
Rob Sheppard

Peachpit Press
1249 Eighth Street
Berkeley, CA 94710
510/524-2178
510/524-2221 (fax)

Find us on the Web at www.peachpit.com
To report errors, please send a note to errata@peachpit.com
Peachpit Press is a division of Pearson Education.

William Henry Jackson photograph courtesy of DeGolyer Library, Southern Methodist University, Dallas, Texas, AG1982.0124x, "Les geysers d'Amerique, Mud Geyser in Action."

Editor: Susan Rimerman
Production Editor: Lisa Brazieal
Developmental/Copy Editor: Elizabeth Kuball
Proofreader: Bethany Stough
Composition: WolfsonDesign
Indexer: James Minkin
Cover Design: Aren Straiger
Cover Image: Rob Sheppard
Interior Design: Riezebos Holzbaur Design Group

ISBN-13: 978–0–321–82377–9
ISBN–10: 0–321–82377–X

9 8 7 6 5 4 3 2
Printed and bound in the United States of America

DEDICATION

To all of the beautiful and amazing natural landscapes of our world. They deserve the best from all of us as photographers and lovers of beauty. And of course, I also dedicate this book to another beauty, my wife of many years, Vicky.

ACKNOWLEDGMENTS

I suppose my love of nature started with my dad being transferred to Minnesota when I was a child; he took us camping and fishing into the beautiful places of Minnesota, so I thank him for that. I have no idea where my interest in photography came from—it started when I was very young (I built a darkroom when I was 13) and no one else in my family or friends were photographers.

This book would not exist without the encouragement and wonderful support of all the folks I've worked with at Peachpit: Ted Waitt, Susan Rimerman, Elizabeth Kuball, Lisa Brazieal, and others who have worked on the book but whom I haven't met. This has been such a great group of folks who have made this book a true pleasure to put together.

I also thank all my students in my classes and workshops, such as those at BetterPhoto.com and Light Photographic Workshops. They're such a wonderful resource of questions and photographic ideas. I'm always learning new things from the way they photograph and approach the world. From beginners to expert photographers, they're all amazing.

I also want to thank Steve Werner and Chris Robinson with Outdoor Photographer magazine. They've long been friends and supporters of my work, and they both have always made me think. I've learned so much from both of them.

Even though I never met them and they've long passed from the scene, I really do appreciate all that I learned from Ansel Adams, Eliot Porter, Ernst Haas, and Andreas Feininger, photographers who inspired me as I "grew up" as a photographer.

Finally, I have to acknowledge my wife who always supports me. It is such a joy to have a life partner who acknowledges and accepts me as I am. I also thank my professor son, Adam, who makes me think about how we communicate to others, and my sports-information daughter, Sammi, who keeps me thinking about photography and how it affects others.

Contents

Introduction

One of the earliest photographs that I remember taking was of Gooseberry Falls in Minnesota as a teenager. I have gone back to that location again and again over the years, even after leaving Minnesota for California. Early impressions can definitely affect a lifetime of work. You'll even find Gooseberry Falls State Park images in this book.

Growing up in Minnesota was challenging at times as I was learning to become a nature and landscape photographer. Minnesota has no towering mountains, no roaring rivers, no geysers, no skyscraping redwoods, and no dramatic deserts. Yet, I think that this gave me an education in working with the landscape that forced me to find good pictures, not simply make snapshots of spectacular locations.

Throughout this book, you'll find all sorts of landscapes. I've tried to include images of landscapes from throughout the country, not just from the dramatic West. Certainly, there is a long tradition of Western landscape photography starting with William Henry Jackson in the 1870s. That was also promoted by the wonderful photography of Ansel Adams.

My growing up in Minnesota really encouraged me to go beyond simply pointing my camera at the obviously dramatic landscapes. Good landscape photography goes beyond such subjects. It requires a sensitivity to light, perspective, composition, and more. If you learn to work with these aspects of landscape photography on any landscape, all your pictures will improve. Your photography will definitely go from landscape snapshots to landscape great shots.

Sure, a bold, dramatic landscape is nice, but sometimes that great subject can distract you from getting your best images. We've all been distracted by beautiful scenes that so overwhelm us that we forget that we can't cram that beautiful scene into our camera. We can only create a photograph that represents it. We have to interpret that scene because the three-dimensional, wild scene itself cannot be forced into the small, two-dimensional image that is a photograph. Only an interpretation can bring something of that landscape into a photograph.

I really want you to feel successful when photographing landscapes. I want you to be able to get excited about any landscape, not just a landscape you see once every few years on vacation. Our world is filled with wonderful places all around us that deserve to be photographed every bit as much as the icons that we've seen so many times.

That isn't to say that photographing iconic landscapes can't be a lot of fun and a wonderful way of using your photography. But these landscapes are simply not available to most of us most of the time. The techniques in this book are designed to help you bring the most out of landscapes wherever you are, whether that's an iconic national park visited rarely or a nature center near where you live.

The landscapes in your area are important, no matter where you live. They provide a sense of place. You honor that sense of place by getting great photographs of those locations nearby. You also feel more connected to your landscape when you go out and explore it photographically.

No matter what you do, take a lot of pictures. A great thing about digital photography is that once you own the camera and memory cards, you can take as many pictures as you want without any film or processing costs. Those costs used to be a lot and could restrict how many shots professionals took. Now you don't have to have those restrictions. Experiment with the ideas in this book. I've included assignments at the end of each chapter and I would like you to try them out! Make sure to join the book's Flickr group and share your results with other readers: www.flickr.com/groups/landscapesfromsnapshotstogreatshots.

Don't be afraid to experiment with new ways of taking pictures and expect some failures. I think that's how we learn. I can't tell you how many pictures I've tossed out over the years because I tried something new. But I learned from every one. And I still do.

Most of all, have fun. Enjoy your time outdoors in this beautiful world around us. Discover the possibilities of landscape photography wherever you are.

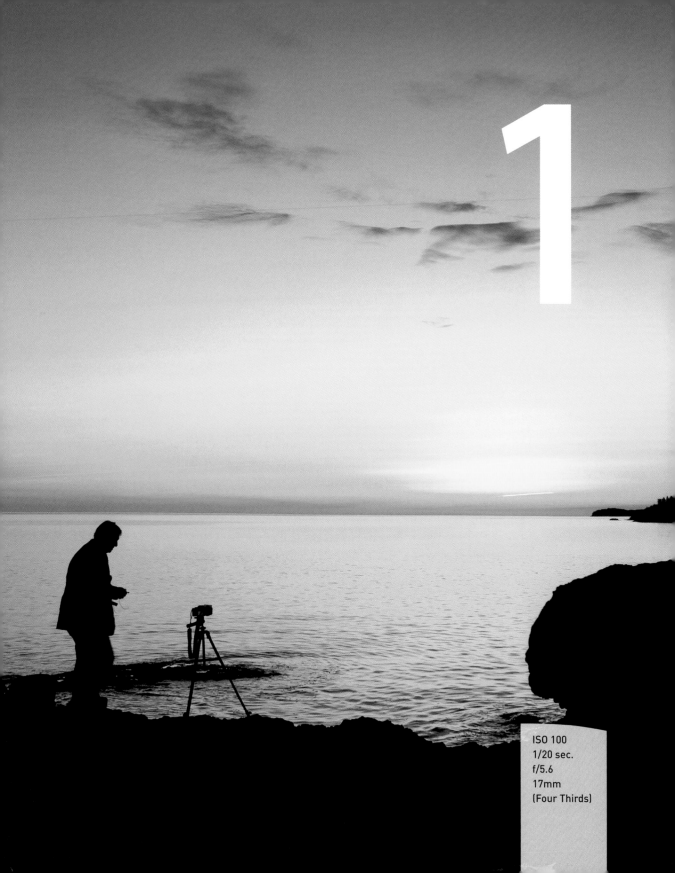

1

ISO 100
1/20 sec.
f/5.6
17mm
(Four Thirds)

Equipment

UNDERSTANDING YOUR GEAR
TO TAKE BETTER PHOTOGRAPHS

Bring up the subject of camera gear if you're around any group of photographers, and you're sure to stir up all sorts of discussions. You have some sort of camera and lens in order to take a photo, but exactly what type of gear you need depends on a lot of factors. This isn't a simple discussion at all.

Or maybe it is. Truthfully, you can take fine landscapes with any camera on the market today. Ansel Adams was one of the finest of landscape photographers, and he often said that what's in your head and how you use the gear are more important than the gear itself. Professional landscape photographers will pick and use specific types of camera gear because of certain features that work for the way that they take pictures. Whether that can work for *your* way of taking pictures is a different story. In this chapter, I examine some of the things that are important to consider about your gear and landscape photography.

PORING OVER THE PICTURE

This scene in Utah's Zion National Park was changing fast as a front moved through, bringing cold weather in May and snow in the higher elevations. You have to know your gear so that you can set up quickly and be prepared for conditions like this. I shot continuously for quite a while as the clouds shifted and moved through the scene. You can't just shoot one photo in these conditions and think you've captured the landscape. Having my camera on a tripod let me concentrate on the changes in the scene instead of having to constantly recompose the shot.

The scene between the rocky cliffs of the mountains of Kolob Canyon kept giving different views because of the shifting clouds. This made for exciting landscape photography!

The camera's white balance can be very important for conditions like this so that colors are rendered well.

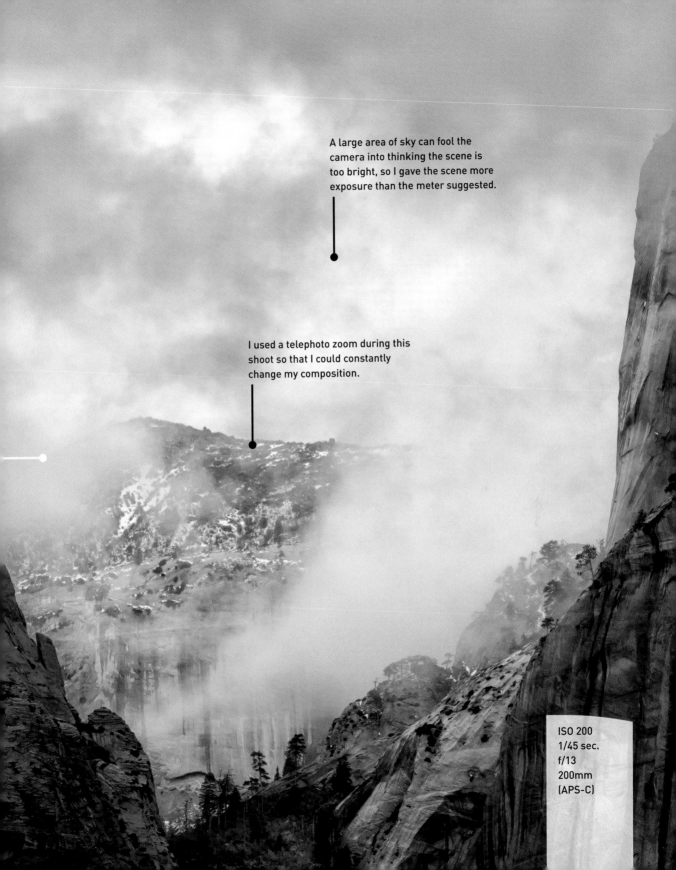

A large area of sky can fool the camera into thinking the scene is too bright, so I gave the scene more exposure than the meter suggested.

I used a telephoto zoom during this shoot so that I could constantly change my composition.

ISO 200
1/45 sec.
f/13
200mm
(APS-C)

How you look at a scene is as important as the gear you use. For this scene, I was in Everglades National Park in Florida. I was looking for some interesting landscapes, but the light wasn't quite right when I got to this location at West Lake. So, I left my main camera, lenses, and tripods in the car as I took a short trail to check on the lake. Out on a short boardwalk, I saw these amazing mangrove trees, and the light was perfect for their color and texture. I had my small Sony HX9V compact digital camera in my pocket, so I quickly got it out. I treated that little camera the same as my big cameras in how I looked at this landscape as a photograph. This is no snapshot, but an image carefully considered for its composition and how I responded to the scene.

Even on what is essentially a point-and-shoot camera (though a very nice one), white balance can be set to ensure that colors are recorded properly. Auto white balance is usually a poor choice for conditions like this.

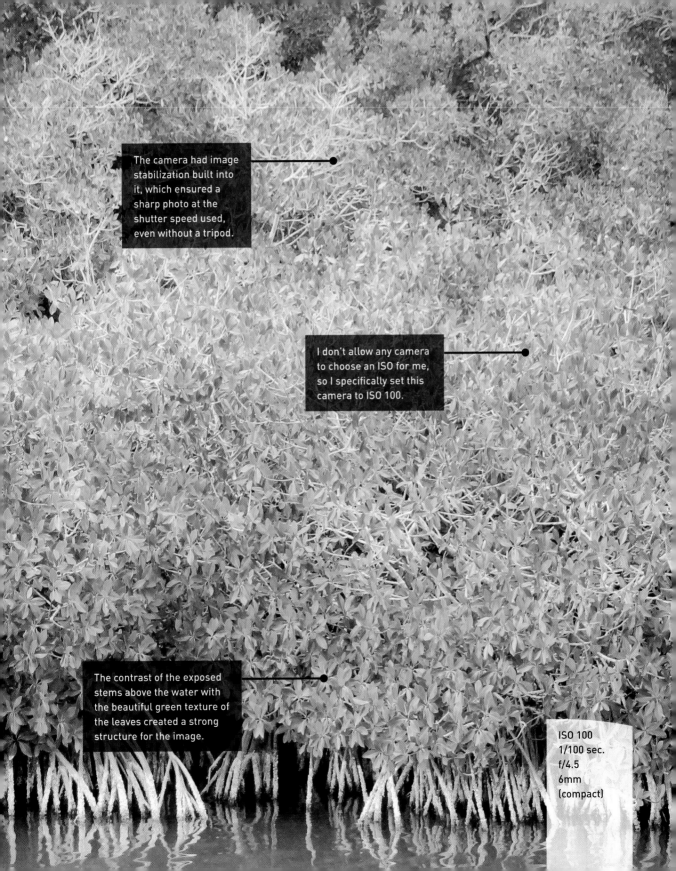

The camera had image stabilization built into it, which ensured a sharp photo at the shutter speed used, even without a tripod.

I don't allow any camera to choose an ISO for me, so I specifically set this camera to ISO 100.

The contrast of the exposed stems above the water with the beautiful green texture of the leaves created a strong structure for the image.

ISO 100
1/100 sec.
f/4.5
6mm
(compact)

CAMERAS

Cameras come in all shapes and sizes. It's certainly still possible to shoot excellent landscape images with film, but film cameras have basically disappeared as a major way of taking pictures. Digital cameras simply offer too many advantages over film, from being able to immediately see what your photograph looks like on the LCD to gaining very high-quality images with a large range of ISO settings.

BRAND

Go to any camera club and ask what the best camera is, and you're sure to start a big argument about which brand is doing the best for photography today. And you know something very interesting about that discussion? All the photographers advocating for specific brands of cameras are right, and they're all wrong, too! The right camera for one person may be the wrong camera for someone else.

I've owned and shot with Canon, Nikon, Olympus, and Sony. I've created excellent landscape photographs with all of them, and I've had my share of duds with all of them as well. In addition, when I worked as an editor of *Outdoor Photographer* magazine, I had the chance to shoot with every brand of camera, and I found that I could get excellent landscape photographs with any of them.

So, it doesn't matter what brand of camera you have, right? Not exactly. One important thing about using a camera is being comfortable with it. You need to have a camera that you like using (**Figure 1.1**). You need a camera that has the right controls for you and that's organized in a way that makes sense. Some of it comes with experience, so when you have a particular camera brand, you're usually best staying with that brand because it makes photography easier.

But there are some things to think about when choosing a camera or when changing a camera brand that will affect how you take pictures. This usually is not about ultimate picture quality (because cameras are so good that image quality is extremely good from camera to camera). One thing that a brand will affect is the options you have for lens choice and other accessories (**Figure 1.2**). When you buy a camera, you're not simply buying a camera. You're also buying into a system of lenses, flashes, and more. It can be important to look at that system to see that it has what you need and want for your type of photography.

FIGURE 1.1
When you're comfortable with your camera, you'll like using it and enjoy the photography more.

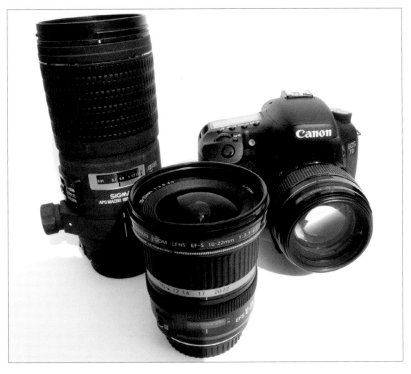

FIGURE 1.2
When you buy a camera body, you also gain access to a certain set of lenses and other accessories.

MEGAPIXELS

I saw firsthand the beginnings of the megapixel race among camera manufacturers. I worked at *Outdoor Photographer* magazine through the entire transition to digital, starting before the average photographer even considered digital as a way of shooting until it became the main way that photographers took pictures outdoors.

When digital cameras first came out, sensors had less than 1 megapixel. Pixels are the smallest picture element and the smallest points that capture light on the sensor. More pixels allow you to capture more detail up to a point. With the first low-cost sensors, there weren't enough pixels to fully capture the detail of any scene. So, the megapixel race began.

At first, megapixels really did make a difference. Then at 3 megapixels there was a significant change. Images had enough detail to match 35mm film at an 8-x-10-inch print size (**Figure 1.3**). At 4 to 5 megapixels, there was enough detail to easily print 11-x-14-inch images that matched 35mm. A lot of careful workers were even finding they could go much bigger. And once 6 megapixels was reached, many photographers were creating excellent 16-x-20-inch images.

FIGURE 1.3
I shot this Newfoundland landscape early on in the digital transition. I used a 3-megapixel Nikon 880.

ISO N/A
1/80 sec.
f/8
8mm
(compact)

By 10 megapixels, you could essentially match 35mm imagery at any print size. By 16 megapixels, most photographers were finding they could match medium-format film. Except now there started to become a problem that the megapixel wars didn't address: As pixels are more densely packed into a sensor, some problems occur:

- Noise increases.

- Sensors have a harder time dealing with tone and color capture.

Simply adding pixels can mean that you'll have a decrease in image quality even though you have more megapixels in the camera. A high-quality 10-megapixel sensor can outperform a high-megapixel sensor that simply has too many pixels crammed into its surface.

As technology gets better, camera manufacturers are able to increase the density of pixels and maintain image quality (**Figure 1.4**). However, there is no question that manufacturers often push this to the limits and introduce cameras that have more pixels than they really should have for the technology available at the time.

FIGURE 1.4
A modern-day digital camera sensor holding millions of sensing elements or pixels.

SENSOR SIZE

One of the most misleading aspects of digital photography is the physical size of the sensor (this is an area size and is not part of megapixels). I hear people all the time say that they have to have a full-frame sensor in order to get the best images, especially of landscapes. And, of course, there are all those crude jokes about whether size matters. This is, to put it bluntly, nonsense. Sensor size does affect certain things, and it can be worth considering, but there is no arbitrary good or bad about sensor size simply based on the size.

You'll sometimes hear people refer to the APS-C size format as a cropped sensor. This is one of the worst names for that format because it's totally misleading. If you really think about it, you'll see that either there is no such thing as a cropped sensor or every sensor is a cropped sensor. You see, there is always a bigger or smaller sensor than any sensor that is in a camera (obviously at some point there is an ultimate huge sensor size, but that is not something that's going to be in a camera), so all sensors can be considered "cropped," but that is pretty silly.

Sensor size is a format size, just like 35mm, APS, medium format, 4 x 5, and so forth are film format sizes. And just like film sizes, sensor size or format affects how lens focal lengths perform and certain aspects of image quality such as noise.

The common digital formats are, from largest physical size to smallest, full frame (which is technically full 35mm frame), APS-C, Four Thirds, and variations of compact digital camera sensor sizes (compact digital cameras do have some common sensor sizes but they don't have specific names), as shown in **Figure 1.5**.

Here's what sensor sizes do:

- Larger sensors require physically larger lenses and longer focal lengths for the same equivalent angle of view of the landscape. Conversely, smaller sensors use physically smaller lenses and shorter focal lengths for that angle of view.

- Larger sensors require bigger camera bodies and mean that you have heavier and larger lenses to carry with you. Smaller sensors can be put in smaller camera bodies and result in lighter and smaller gear to carry.

- Larger sensors of the same technology as smaller sensors will have less noise at higher ISO settings. This usually means that you can use larger sensors at much higher ISO settings than smaller sensors.

- Larger sensors of the same technology may offer more finely separated tones and colors, but a newer small sensor will often match an older large sensor.

- Larger sensors need longer focal lengths for a given angle of view, which results in less depth of field at any given aperture. Smaller sensors need shorter focal lengths for a given angle of view, which results in more depth of field at any given aperture.

←———————— 36mm wide ————————→

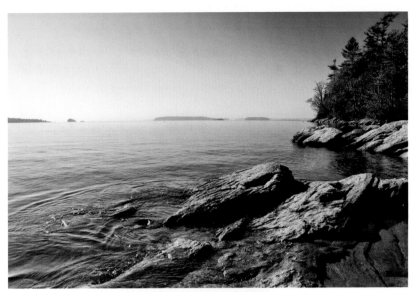

FIGURE 1.5
These images give you a feel for the relative sizes of the common digital camera formats.

Full 35mm frame

APS-C

Four Thirds

Typical compact digital camera

SENSOR SIZE AND EQUIVALENT FOCAL LENGTH

Because sensor size acts like a film format, the same focal length acts differently on cameras with different sensor sizes. We need to have some way of talking about this when we're looking at focal lengths and landscape photography because the same focal length doesn't act the same with different sensor sizes (**Figure 1.6**). Because 35mm photography was such an established and familiar format, focal lengths often are given equivalent focal lengths as compared to 35mm. This is simply a way of comparing how a given focal length sees the world in front of the camera. The focal length itself doesn't change—the only thing that changes is the way the sensor uses that focal length.

Here are the four sensor sizes I refer to in the figure captions of this book:

- **Full frame:** A full-frame sensor is a sensor that's the size of one frame of 35mm film. In this format, a focal length is considered a midrange or "normal" focal length at about 40mm to 60mm. Any focal length shorter than that is considered to be a wide-angle lens. Any focal length longer than that is considered to be a telephoto lens.

- **APS-C:** An APS-C sensor is smaller than a full-frame sensor, so it sees only a fraction of the image area that a full-frame sensor would see with a given lens. That gives it a slight magnification of any subject. If you multiply the focal length used by an APS-C sensor by 1.5 to 1.6 (depending on the camera), you'll get an equivalent focal length that tells you how the lens acts compared to 35mm. For example, a 50mm lens on a camera with an APS-C sensor actually will act like a 75mm lens, making it a short telephoto rather than a midrange focal length. Midrange for APS-C is about 28mm to 40mm. Again, any focal length shorter than that is wide angle, and anything longer than that is telephoto.

- **Four Thirds:** A Four Thirds sensor is slightly smaller than APS-C, so it sees a little less of the image area from a given lens. To get an equivalent focal length of 35mm, you multiply the focal length used by a Four Thirds sensor by 2. In this case, a 50mm lens will act like a 100mm lens. Midrange for Four Thirds is 20mm to 30mm, so any focal length shorter than that is wide angle and anything longer is telephoto. Micro Four Thirds is a camera system type that uses the same Four Thirds size sensor, but a different lens mount.

- **Compact:** Because compact digital cameras have slightly varying sizes for sensors, manufacturers typically give the 35mm equivalent of their focal lengths. If you look at the real size of the focal length, you'll notice that they have very low-millimeter numbers.

← 36mm wide →

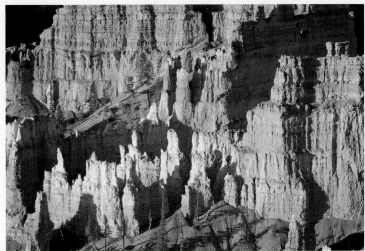

FIGURE 1.6
The same focal length is seen differently by different formats.

Full 35mm frame

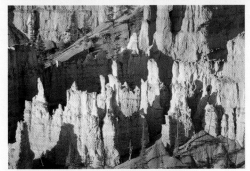

APS-C

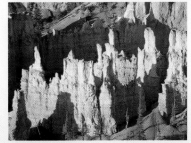

Four Thirds

Typical compact digital camera

CHOOSING GEAR

You now have a lot of information about megapixels, sensor size, focal length equivalents, and more. What do you do with this information when you're looking at camera gear for landscape photography? You don't have to be overwhelmed by all that information. I'm going to give you some ideas on things to look for when you're choosing gear for your landscape photography. I'll also give you some ideas of gear that I use and why I made the choices that I did.

First, I think it's really important that you handle gear and you try it out before you purchase it. Even cameras from the same manufacturer will handle differently, and you may like one over another. Never feel that you have to buy a certain camera because of its price—either high or low—or because someone else says that's the camera you have to have. Buy a camera based on how it feels to *you*.

I hear stories from friends in the camera retail business that they see business professionals such as doctors and lawyers who have money to afford a more expensive camera turning up their noses at lower-priced cameras just because of the price. Unfortunately, they end up with cameras that aren't as well suited to their needs. When someone buys a camera just because he feels it reflects his status, he isn't buying the camera as a tool to use for better photography.

In addition to how a camera fits your way of photography, I think there are four important things to consider as you're looking at a camera for landscape photography:

- Size and portability
- Availability of lenses and focal lengths
- Price
- High ISO settings

Finally, there are some special features that you may want to consider based on unique needs you may have as a photographer.

SIZE AND PORTABILITY

As soon as you have more than a camera and a single lens, you have to deal with the size and weight of your gear (**Figure 1.7**). Some cameras are considerably heavier and larger than others. In addition, larger sensors or formats require bigger and heavier lenses because the optics must create an image circle that includes the larger sensor.

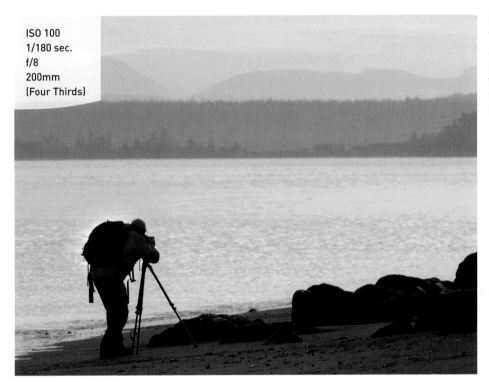

ISO 100
1/180 sec.
f/8
200mm
(Four Thirds)

FIGURE 1.7
The size of your sensor has a big impact on the gear you'll need to carry for photographing landscapes.

That can be a very big issue when you're out in the field shooting landscapes. If you're always shooting landscapes from locations that are easily reached by car, then this may be much less of an issue. But if you're traveling a lot by plane or hiking any distance from your car, the size and weight of your gear can make a big difference.

Look at both the size of the camera that you're thinking of getting, as well as how big the lenses have to be for equivalent focal lengths.

AVAILABILITY OF LENSES AND FOCAL LENGTHS

You'll learn a lot more about focal length choices in Chapter 5. Both wide-angle and telephoto focal lengths are useful for landscape photography. Some people think that the only way to do landscapes is with a wide-angle lens, but that's simply not true.

However, you'll likely find that you use certain focal lengths again and again. It's important that the camera system that you're working with has the focal lengths that you feel work best for your way of photography. If you want to minimize the number of lenses that you carry by using zooms, make sure that the zooms available for your camera include the focal lengths you need. If your camera system itself doesn't have

the focal lengths you need, then see if you can get them from a reputable independent lens manufacturer such as Sigma, Tamron, or Tokina.

PRICE

Price is a tricky criteria for looking at cameras and lenses. Price isn't a simple measurement of quality. Some cameras are more expensive because they have certain features that increase the price of the camera but don't necessarily change the image quality. An example of that would be a camera that shoots more frames per second (which is not something you need for landscape photography).

So-called "pro" cameras are more expensive partly because they're built for abuse. They can handle extreme conditions that pros have to shoot in. Most landscape photographers never shoot in the extreme conditions that a pro sports photographer does, for example, so they don't necessarily need the camera to handle that abuse. Some pro lenses also have additional expense from this type of construction.

Full-frame cameras are more expensive than smaller-sensor cameras, but full-frame cameras aren't necessarily higher quality. It's much more expensive to manufacture a full-frame sensor, and that cost is reflected in the cost of the camera. For example, a camera with a full-frame sensor typically will cost at least 50 percent more than the same camera with an APS-C size sensor.

You also have to be very careful when looking at lenses and price. Many things factor into the price of a lens. One is the maximum aperture. If you have two lenses that have the same basic specs, but one has a maximum aperture of f/2.8 and the other has a maximum aperture of f/4, the f/2.8 lens can be 50 percent to 200 percent more expensive, even though both have the same quality. With landscape photography, you rarely need "fast" lenses with big maximum apertures.

HIGH ISO SETTINGS

There is no question that being able to shoot at high ISO settings with low amounts of noise is nice. Modern cameras with sensors of any size do much better than cameras of even a few years ago. Still, cameras with the largest sensors tend to do better in reducing noise than cameras with small sensors (**Figure 1.8**).

ISO 1600
1/30 sec.
f/8
6mm
(compact)

FIGURE 1.8
I was hiking toward dusk on a very cloudy day, so light was low. I had only a compact digital camera, a Canon PowerShot G11, and no tripod, so I had to shoot with a high ISO. Noise is high at ISO 1600 when used with a small sensor.

Most of the time, noise isn't such a big issue for landscape photography because you usually don't need high ISO settings. However, some photographers are experimenting with very low-light landscape photography, including landscape photography at night. These conditions can make a large sensor with very low noise at high ISO settings an important tool.

Another area where low noise can be very important is in shooting black-and-white photography, where you're interested in high-contrast interpretations of scenes. This tends to really bring out any noise that's in an image, so it can be helpful to have a minimum amount of noise from the start.

One answer to the noise issue is to use noise-reduction software with your photos when needed. Because I don't have or use a full-frame camera, I do use the noise-reduction feature of Lightroom (from Lightroom 3 on, it's very capable of reducing average amounts of noise). For high amounts of noise, I like using Nik Software Dfine.

SPECIAL FEATURES

There are a couple of special features that you may want to consider. These aren't things that every photographer will be thinking about, but if you need these features, they're worth considering as you look at cameras.

With cameras that have a lot of megapixels and a big sensor, you can do more extensive cropping to the image; plus, you can make prints that measure 3 x 4 feet and more. With almost any DSLR camera that has at least 10 megapixels, you can make high-quality prints 16 x 24 inches in size.

Of course, with landscape photography, you shouldn't need to do a lot of cropping. The landscape isn't running all over the place as you shoot, so you should be paying attention to composition so that you aren't doing a lot of cropping to the final image.

Many cameras today have tilting or swivel LCDs (**Figure 1.9**), which can be extremely useful for certain types of landscape photography. These special LCDs include live view and allow you to place the camera both high and low and still see what the lens is seeing. This can allow you to take a picture from a higher angle then you might otherwise be able to do because you can tilt the LCD back and still see how the camera is framing. They also allow you to take a picture very close to the ground for a unique angle. In addition, they make it much more comfortable to use the camera on a tripod at heights other than eye level.

A unique benefit of live view is the ability to magnify the screen to help with focus. If you find focus difficult with standard viewfinders, then this feature can be really helpful. You can magnify what the lens is actually seeing and projecting on the sensor so that you can clearly see when something is going in and out of focus.

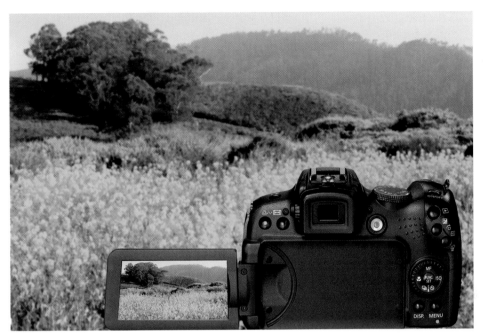

FIGURE 1.9
Live view and
swivel LCDs give
your camera more
flexibiliity for land-
scape photography.

TWO PHILOSOPHIES OF GEAR

There are two very valid philosophies about how a photographer deals with gear. Some photographers want to have every bit of gear that they think they may need and carry it with them. Other photographers want to keep the amount of gear to a minimum.

This is not a pro versus amateur philosophy. There are pros who like to take everything with them and always have as much as possible and pros who do just the opposite and carry only the minimum of gear. For example, Frans Lanting is a well-known nature photographer who often shoots for *National Geographic* and is also well known for shipping multiple cases of gear with him when he goes on a trip. Peter Essick, on the other hand, an environmental and landscape photographer who is also a *National Geographic* photographer, is known for traveling with only a single camera bag (and tripod) that he carries with him at all times.

The point is that it's easy to be misled when you know which gear your favorite photographers have. That gear may or may not be appropriate to your work. Some photographers just don't feel comfortable if they don't have everything that they think they might need when shooting at a particular location. Other photographers don't feel comfortable having that much gear and feel best when they take only what they think they might actually use. What matters is that *you* feel comfortable as a photographer so that you can do your best work.

THE TRIPOD

A good tripod is absolutely critical for landscape photography. You need it for two reasons:

- **A tripod helps stabilize your camera when you're shooting at slow shutter speeds.** The number-one cause of unsharpness in landscape photos is camera movement or shake during exposure. A tripod greatly reduces the possibility of that problem (**Figure 1.10**). If you want to get the maximum quality from any lens, use a tripod.

- **A tripod helps you lock in your composition and refine it as needed.** Since your landscape isn't moving while you're photographing, you can take your time getting the best composition of the scene. By having your camera on a tripod, you can more readily study and adjust your composition.

FIGURE 1.10
A good tripod is an important investment for a landscape photographer because it means you'll get the maximum quality from your lenses.

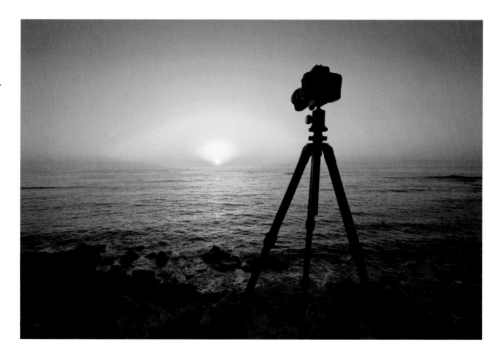

Even though tripods are really important for landscape photography, they aren't as sexy as other gear. Many photographers have a tendency to skimp on a tripod and put all their money into the camera and lens. I can guarantee that I'll get consistently higher-quality pictures with an inexpensive DSLR and lens on a solid, sturdy tripod than I will with the most expensive pro DSLR on a cheap tripod or no tripod at all.

I've been to amazing landscape locations such as Yosemite National Park and been amazed by something away from the landscape: photographers with expensive cameras on cheap tripods. A poor-quality tripod just isn't going to give you the image quality your camera is capable of.

Consider a good tripod an investment—it will last a long time and it isn't going to go out of date. Don't skimp on your tripod and head.

To pick a good tripod, follow these tips:

- Look for a tripod that is easy to set up and easy to carry. You simply won't use a tripod that is hard to use and too heavy.

- Get a tripod from a camera store. The best tripods are at camera stores, not at discount stores.

- Consider a carbon-fiber tripod. They're expensive—no question about it. But they're extremely lightweight for their strength. Plus, they're strong and rigid to keep your camera stable and still. In addition, when the temperature drops, they aren't as cold on your fingers as metal tripods are.

- When checking out tripods, extend the tripod to its full height, and then lean on it and add a slight twisting movement. A sturdy tripod won't wobble as you do that.

- Check whether the legs change their angle of spread so that the tripod can be adjusted more easily on uneven ground (**Figure 1.11**). If the tripod legs only have a set angle for their spread, you'll find the tripod harder to use when you're at locations with irregular ground (as you often are when shooting landscapes).

- Look at the number of sections for the tripod legs. Most tripod legs come in three sections. Some tripods designed for travel come in four sections. Three-section legs tend to be sturdiest. If you're considering a tripod with four-section legs, make sure it's sturdy enough. (There are good four-section leg tripods out there.) Avoid tripods with more than four sections.

FIGURE 1.11

The tripod head is also an important part of your tripod decision. Some tripods come with a head; with other tripods, you need to buy a separate head. A sturdy yet lightweight head is important to match a lightweight tripod.

There are two types of tripod heads: ball heads and pan-and-tilt heads. Both work for landscape photography and some photographers prefer one over the other.

A ball head (**Figure 1.12**) uses a ball and socket to attach your camera to the tripod. Because it's a ball and socket, this head allows infinite variation of movement to adjust your camera position. You need to get a ball head that has a large enough ball to firmly lock your camera in place when you're done adjusting it. Many landscape photographers really like this type of head for its quick and easy positioning of the camera.

A pan-and-tilt head (**Figure 1.13**) uses levers that allow you to tilt the camera left and right separately from tilting it up and down. Some photographers prefer this type of head because it allows you to adjust different planes of the camera separately, whereas the ball head is always adjusting every direction it wants. This means, for example, that you can tilt the camera up and down to frame your overall scene and then tilt left and right to correct for crooked horizons.

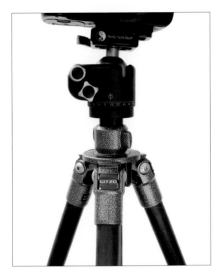

FIGURE 1.12
A ball head is popular with landscape photographers because it can be quickly positioned for the shot.

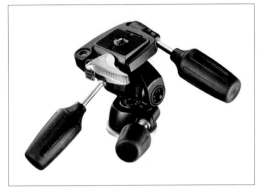

FIGURE 1.13
A pan-and-tilt head offers separate controls for adjusting the angle of the shot as well as leveling the camera.

WHAT'S IN MY BAG

My gear is a little tricky because I've changed some of my equipment. Right now I work with two systems: Canon and Sony. I've shot with Canon for a long time, and I have a system that works for me. A couple years ago I used an Olympus system mainly for the small size. I went back to Canon because I started doing a lot of video in addition to still photography and the cameras I'm using have great video. I just started using the Sony NEX system for its size and video.

Here's what the Canon and Sony systems include:

Canon system (**Figure 1.14**):

- **Camera:** I work with the APS-C size format. I don't like full-frame sensors because the gear is just too big and heavy for my work; plus, for equal quality, it costs me more. I have Canon EOS 7D and 60D cameras. These cameras use the same sensor and basic internal processing, so image quality is the same. Even though the 7D is a more expensive camera and a better-built camera body, I rarely use it. I mostly use the 60D because of the tilting LCD, which is important for my way of working.

- **Lenses:** My lenses for landscape work include three zooms: a wide-angle Canon EFS 10–22mm f/3.5–4.5 (equivalent to 16–35mm), a Tamron 18–270mm f/3.5–6.3 (equivalent to 29–430mm), and a Sigma 120–400mm f/4.5–5.6 APO (equivalent to 190–640mm). I do shoot with all these focal lengths, but I would say that most of my landscapes are done with the wider focal lengths and the telephoto focal lengths.

FIGURE 1.14
My Canon EOS 60D camera and lenses for landscape work.

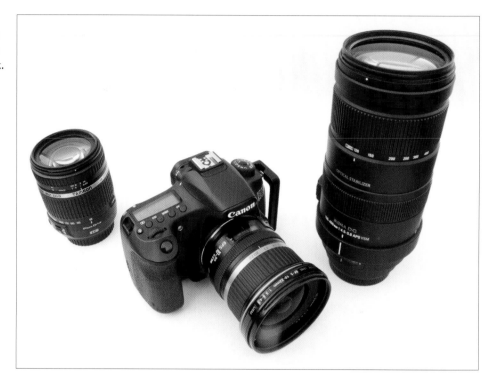

Sony system (**Figure 1.15**):

- **Camera:** I also work with the APS-C size format in my Sony system. I have a SonyNEX 5n camera, which is extremely compact and lightweight but still has an absolutely superb sensor. It also has an excellent tilting LCD that was part of its appeal for me.

- **Lenses:** My lenses for landscape work include the Sony 16mm f/2.8 (equivalent to 24mm), Sony fisheye conversion lens (15mm full-frame fisheye equivalent), Sony 18–55mm f/3.5–5.6 (equivalent to 27–82mm), and 55–200mm f/3.5–6.3 (equivalent to 82–300mm). The difference between 16mm and 18mm may not seem like a lot, but wide-angle focal lengths actually work differently from telephotos, and even 2mm can make a big difference in angle of view. I've always loved the 24mm focal length for landscapes compared to 28mm, which is the same difference as between 16mm and 18mm in APS-C.

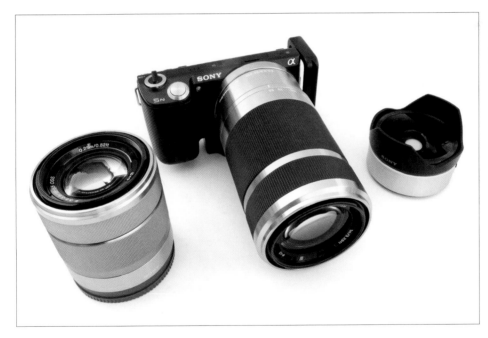

FIGURE 1.15
My Sony NEX 5n camera and lenses for landscape work.

You may wonder about the math for the equivalents for the lenses of these two cameras because they aren't exactly equal. The reason for this is that the two cameras have slightly different sensor sizes. Canon APS-C format uses 1.6x as a multiplication factor for focal-length equivalence, while Sony APS-C format uses a 1.5x multiplication factor.

In addition to my Canon and Sony systems, I have some special gear. I've long been a fan of compact digital cameras (including but not limited to point-and-shoot cameras). My first digital camera was a Canon PowerShot G2, and I've had a number of cameras in the G series. Right now I have a little Sony HX9V (**Figure 1.16**). This is an outstanding little camera that at ISO 100 is very close to my other cameras (if it had raw files, it might match them, and even at higher ISOs, it's quite good). I love to keep a camera with me. And there are many situations where I don't care to carry my full set of gear (or I can't), so these little cameras have allowed me to get landscapes that I otherwise would have missed.

FIGURE 1.16
My handy Sony HX9V compact digital camera.

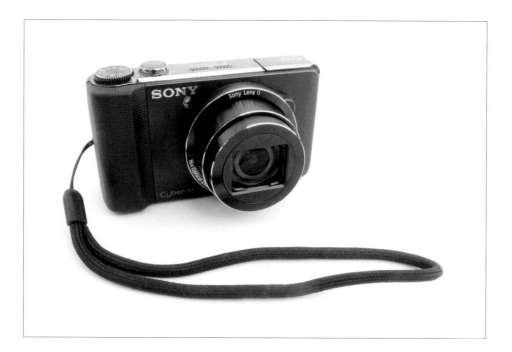

Chapter 1 Assignments

Know Your Gear

No matter what the gear you have, sit down with it and shoot some unimportant scenes just so you get to know the gear. If the subjects really aren't that important to you, you'll pay more attention to the gear. It's very frustrating to be fumbling with controls or even searching for them when you're in front of a beautiful landscape and the sun is going down.

Do an ISO Test

Go out and shoot a landscape with sky at a variety of ISO settings. Shoot with ISO 100, 200, 400, 800, and 1600 to see what your camera does at these particular settings. (If your camera has higher ISO settings, try them, too.) Compare the shots to see what these ISO settings do to noise, tonality, and color. This will give you a better idea of what your camera is capable of. The reason that sky is important for this test is that it will very often reveal noise before other parts of the picture do.

Do a Tripod Test

Find a large-scale subject with a lot of detail in it at a distance from you and your camera. A busy street scene works well for this, especially if it has a lot of signs and other detail. Set your camera to a moderate focal length and ISO 100. Handhold your camera and shoot a series of pictures as you change your shutter speed from at least 1/125 sec. down to 1/30 sec. or slower. Then shoot the same scene with the camera mounted on a tripod so that you know that there is movement. Now enlarge the images and compare them, looking at small detail. This will give you an idea of how important your tripod is for slow shutter speeds.

Share your results with the book's Flickr group!

Join the group here: www.flickr.com/groups/LandscapesfromSnapshotstoGreatShots

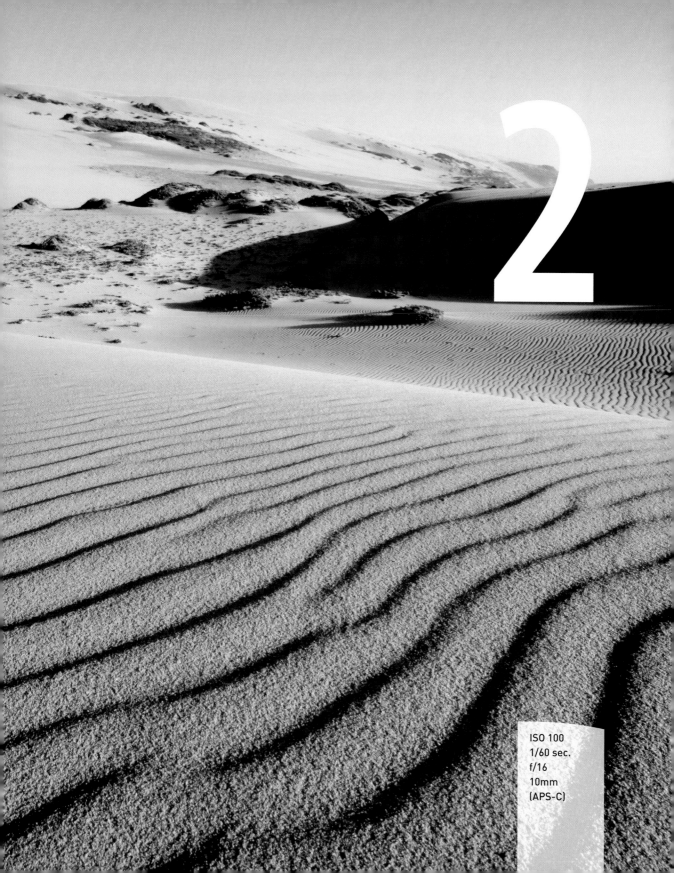

2

ISO 100
1/60 sec.
f/16
10mm
(APS-C)

Seeing as Your Camera Sees

THINKING ABOUT LIGHT AND SHADOW

Landscape photography has a long tradition in photography. In fact, it's how photography got started! Landscapes don't move, so they were perfect subjects for the first photographers, whose cameras required exposures that were hours long.

With modern gear, you won't have that challenge, even if you photograph at night. But one of the challenges of great cameras and lenses is that it's easy to consider them more important than they really are. People believe that cameras do a good job of capturing reality, so if you want a better photograph of that reality, all you need to do is get a better camera. If you or photographers you know have gone that route, you've quickly discovered that this is a fallacy. A photograph and reality are two different things. Now that gear is out of the way, let's get started looking at the photograph.

An important set of visual relationships exists among the foreground flowers, the lower-right flowers, and the sky. They all have bright tones.

I waited until one cloud was in just the right position above the mountain rocks.

The chaparral is a unique landscape in California. It is as distinctive as the redwoods, but it doesn't get the attention it deserves. It has no dramatic large trees; in fact, it's an ecosystem based on shrubs. I photographed this chaparral scene in the Santa Monica Mountains of Southern California one spring when the California lilac *(Ceonothus)* were in bloom. The combination of flowers, mountain, chaparral texture, and clouds in the sky created a special image.

The textures of the chaparral below the rocks creates an interesting juxtaposition of texture with the tree at the left.

By getting in close to the foreground flowers with a wide-angle lens, I created a feeling of depth and space in the image.

ISO 100
1/30 sec.
f/13
18mm
(APS-C)

HOW THE CAMERA SEES DIFFERENTLY FROM OUR EYES

Sometimes you stand in front of a dramatic landscape and just stare in awe. This place has to be a great photo! So, you set up the camera and take the picture. You have a good camera, so you figure you can't miss with such a stunning scene.

Then you get home and open the photo on your computer. You're disappointed. This has happened to all of us. The problem comes from focusing so much on the subject that you lose sight of what you're really doing: creating a photograph. No landscape will fit inside a photograph. Landscapes are too big, and the experience of actually being at the location can never be part of an image (**Figure 2.1**).

FIGURE 2.1
A beautiful scene stretches out in front of you. The photo will be just as great—or maybe not! This image just doesn't give this scene justice. You can't fit a real landscape in your camera.

ISO 100
1/250 sec.
f/8
6mm
(compact)

A CAMERA DOES NOT EQUAL REALITY

Andreas Feininger, a *LIFE* photographer from the peak times of that magazine, once said that the "uncontrolled photo is a lie." This was over 50 years ago, well before Photoshop. What he meant was that if you simply pointed a camera at a subject, no matter how good that subject was, and took the picture, you wouldn't get a photograph that represented how you saw the scene. He pointed out that photographs are interpretations of the world because, by definition, a photograph is not the world.

Feininger also recognized that you could manipulate the image in such a way as to make it lie quite well. The point was not whether you try to control the image, but how you control that image. He wasn't talking about manipulating an image the way that some photographers use Photoshop to totally change an image. He was talking about how photographers use the unique processes of photography to get the most from our images and help us express what we really see and feel about the world around us (**Figure 2.2**).

In fact, as soon as you take a picture, you have an interpretation of the world in your image. That interpretation is based on the limitations of your sensor, the design parameters of the engineers who made the sensor and camera, and the goals of the manufacturer in creating the camera. A challenge that all camera manufacturers have is that cameras today are used by all sorts of photographers, from wedding photographers to photojournalists, from sports photographers to landscape photographers, from fashion photographers to food photographers. In order to make a camera that works for everyone, a manufacturer has to build in compromises that basically allow it to work for everyone.

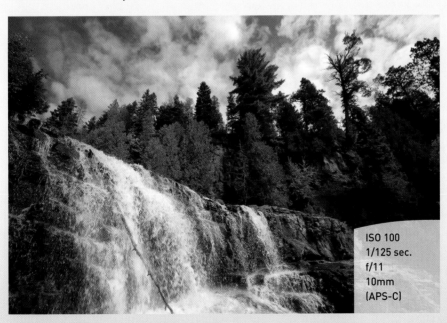

FIGURE 2.2
Many photographers have taken pictures of this section of Gooseberry Falls. But only by controlling how the camera captures this scene can you truly get the most from your image.

ISO 100
1/125 sec.
f/11
10mm
(APS-C)

HOW WE SEE

Our view of the world is affected by many things. First, as photographers, we have a tendency to see the subject. Our eyes are so capable of discerning a subject that the subject will stand out for us even amongst the most confusing of light and conditions.

One of the reasons for this is because of movement. Now, that might seem to be a strange thing for a book about landscape photography, but it actually applies here. When we look at any scene, we don't hold our heads or eyes perfectly still. Because we have binocular vision with our eyes, that subtle movement of our heads means that things within a scene shift their relationships along their edges enough that our brains use that information to help define the edge of an object.

Another thing that happens is that we have a great ability to see a range of tonality and color from dark areas to bright areas. Researchers have found that the human eye can handle a brightness or dynamic range of approximately 1 million to 1, which translates to about 20 stops photographically. That's a huge range, from night black to noon sun. It does take the eye time to adjust to these extremes, so that isn't what you see when you first look at a scene. This "instant" range is considered to be something between 1,000 to 1 and 16,000 to 1, or about 10 to 14 stops photographically. Still, as you examine a scene, things become more revealed to you, increasing the dynamic range of your eyes (**Figure 2.3**).

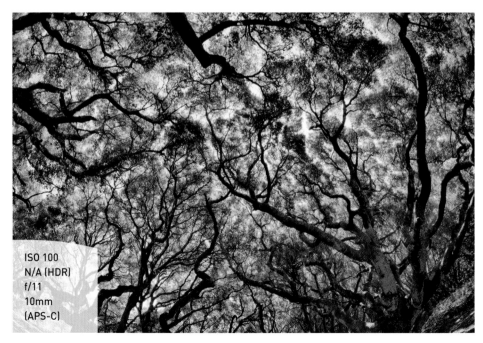

FIGURE 2.3
Our eyes have the ability to see detail in bright sunlit areas and shadows at the same time. This is an HDR shot in California's Los Osos Oaks State Park. You'll learn more about HDR in Chapter 9.

ISO 100
N/A (HDR)
f/11
10mm
(APS-C)

Because we have the ability to readily see into dark and bright areas, we have a tendency to minimize their differences visually and, once again, focus on the subject. A related issue is that our eyes are highly capable of separating tones and colors in dark areas and bright areas at the same time. A strong color will still look strong whether it's in bright sun or dark shade.

Finally, our brains play a big part in how we interpret what we see. This is important because our brains actually have the ability to fill in gaps in what the eyes are sensing from a scene. For example, we fill in details in dark areas that aren't fully revealed by what our eyes see. Even if something is obstructed, our brains will predict what should be there, and this influences how we perceive what's in front of us.

HOW THE CAMERA SEES

The camera doesn't see as our eyes see. Instead of seeing the subject, the camera sees light. But the camera doesn't just *see* the light; it tends to overemphasize the light in a photograph. Of course, the camera is more than just a camera body. A camera "sees" through the interaction among the sensor, lens, and image processing inside the camera. (All images, including raw files, have some processing done inside the camera.)

This is where all photographers struggle. We have to be able to translate in our minds how a landscape is going to be affected by the way the camera sees it. This isn't always easy to do, but the more experience you have shooting landscapes, the easier it gets.

Now think back about how we use slight movement to define how we see what's in a scene and define the edge of an object. The camera can't do that. Everything is frozen in a photograph. This is one reason that a landscape sometimes won't seem to have the definition in the photograph that you thought was there when you took the picture. Truthfully, there was more definition in the scene as you saw it because of the slight movement of your head. That's a big deal. What you see is not going to be automatically translated by the camera into the photograph.

Another immediate challenge is that the camera can't see into dark and bright areas the same way that we can. It has a fraction of the tonal range that our eyes are capable of. One challenge in talking about this is that there is little agreement as to what the true dynamic range of the digital camera is. Partly, this is affected by the fact that some sensors and their accompanying processing are capable of handling more of a dynamic range than others. The other issue is that, just because a sensor can "see" detail in a dark area and a bright area, that doesn't mean that that detail is seen in the same way that our eyes see it, especially if there are strong colors. The ability of the camera to record color properly quickly declines as colors get very bright or very dark.

Regardless of the actual dynamic range of a camera and sensor, there is no question that it is considerably less than what we're capable of seeing (**Figures 2.4** and **2.5**). This is why the camera has a tendency to emphasize the light and its contrast. You can look at a landscape that includes a waterfall in the sun and tree trunks in the shade and see everything just fine. The landscape looks great! Unfortunately, the camera can't see that way and will overemphasize the contrast in the light. If the scene is exposed properly to hold detail in the waterfall, the tree trunks will disappear into black.

FIGURE 2.4
A sunny day in California's redwoods brings high contrast to the woods. To the eye, this is a bright and inviting scene. HDR was used to control the contrast of the scene.

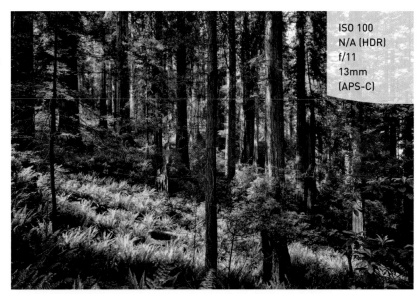

ISO 100
N/A (HDR)
f/11
13mm
(APS-C)

FIGURE 2.5
The camera sees the same scene differently, emphasizing the strong difference between the sun and shade.

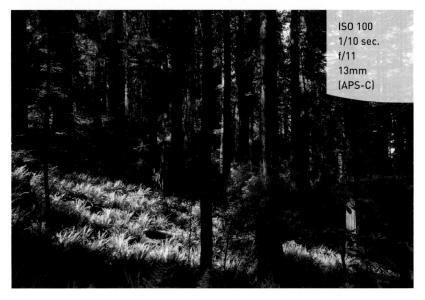

ISO 100
1/10 sec.
f/11
13mm
(APS-C)

Finally, the camera can't fill in gaps in the landscape in front of us the way our brains can. Another thing that the camera has a tendency to do is emphasize everything equally within the area seen by its lens. We don't work that way. Our eye-brain connection helps us focus in on something and minimize distractions around it. The camera can't do that (**Figure 2.6**).

ISO 200
2 sec.
f/16
8mm
(Four Thirds)

FIGURE 2.6
Our eyes and brains focus in on the waterfall of this scene, but the camera shows the bright rocks at the sides and the bright sky just as equally. The camera makes the photo a confusing mess.

FOCUSING ON THE PHOTOGRAPH, NOT JUST THE SUBJECT

As landscape photographers, our challenge is to be able to look at a landscape and think about how the camera is going to translate that into a photograph. It's very important that we go beyond the beginning photographer's idea that the camera is a good way to capture reality. If that were true, you wouldn't need a book on landscape photography—you would just need a better camera! After all, a better camera would capture reality better, right?

Not so much. Camera manufacturers love that photographers are always looking for the Holy Grail of a better camera. It keeps them in business and keeps their profits high. And they know that they're always going to sell cameras in this way, because

they also know that the camera doesn't capture reality any better simply by having more megapixels or the newest sensor. But a photographer who thinks this way is never going to be satisfied—and that means more camera sales.

Your goal is to think about how to focus on that photograph—the image that your camera captures—not simply the subject. Of course, just being aware that your camera is capturing something different from the way you see the world is a big start.

USING THE LCD

The LCD, with its instant review of images shot, is a tremendous innovation for photographers. It's better than the old Polaroid camera that gave you "instant" pictures but took some time to process. Now your instant image is truly instant on the LCD.

The LCD immediately helps you to see the photograph that the camera is taking because that's exactly what you're looking at (**Figure 2.7**). But in order to really see what this photograph looks like, you have to look at your LCD as a miniature photograph and not simply a record of what your camera saw. What I mean is that you have to use the LCD as more than a confirmation of where you pointed the camera.

FIGURE 2.7
Your LCD helps you see the photograph the camera is actually taking.

Look at that image on your LCD (**Figure 2.8**). Do you like it? Is this something that you would put on your wall? Do you think that someone who had never visited this location would understand it? You'll get a lot of other ideas throughout this book on what you should look for in this image on your LCD.

The LCD can be hard to see, especially in bright light. This isn't as big a problem for landscape photography as it is for some other types of photography because a lot of landscape photography is done earlier or later in the day when the light levels are lower. You can learn to use your LCD more effectively so that you can truly look at it as a little picture and decide if you like that picture or not:

- **Change your default display time.** After you take a picture, the image will pop up on your LCD for a brief time. For most cameras, the default length of time that the image displays is way too short to get even a quick look at your image. Go into your camera's menus and find where you change the Review Time. Set it to 8 seconds or longer. This is long enough that you'll get an idea of what your picture actually looks so you can decide whether you need to do more.

- **Shade your LCD.** If the light is bright, use your hand or a hat to shade the LCD so that you can see it better.

- **Magnify your image.** LCDs have gotten bigger and better, but they still aren't as big as most photographs will be seen. Your camera will be able to enlarge what you're seeing on the LCD so that you can look at smaller details in the landscape.

- **Get a magnifier.** You can find a number of magnifiers on the market that will help you better see your LCD. These magnifiers block extraneous light from your LCD, as well as magnify the view so that you can more easily see the details.

SEEING THE LIGHT

The next chapter is entirely about seeing the light. But one of the first things that you can do to better see what your photograph is all about is to look at the light and shadow on your scene and in the LCD. Go beyond simply seeing that subject. Realize that the camera is not going to see the subject as much as it's going to see the light.

Look at the highlights in your scene and the shadows. Where are the highlights? Are the bright areas in the important parts of your composition? Bright areas in an image will always attract the viewer's eye, and if they're in the wrong place, they'll draw the viewer's eye away from what's important.

Where are the shadows? Shadows can not only define your landscape, but also obscure it and make it look really bad. The only way that you'll know the difference is if you really look for them. Looking at your image on the small LCD actually can help because if the shadows are obscuring things in that small view, that's telling you very quickly that the camera is seeing the wrong things for your landscape.

Chapter 2 Assignments

Practice Using Your LCD

Find a sunlit landscape. You don't have to have some fancy, elaborate landscape that can be reached only by a lot of travel. Just look for something nearby that's a big enough scene to have a foreground, middle ground, background, and sky. Take a picture of that scene, and then look at it on your LCD. Press your playback button to make sure that your LCD stays on. Compare what you're seeing on that LCD with what's actually in front of you in the landscape.

Compare What the Camera Captures to Reality

For this assignment, you can use any subject you want. In fact, it can be really interesting to arbitrarily choose a location and start photographing there. Put your camera at chest level so that you can't see through the viewfinder or any live-view LCD. Take four or five pictures as you turn around and look at different parts of this location. Now play back those images on the LCD. How close are they to the reality of the location as you saw it? How are they different? Where are they similar? Notice how much movement plays a part in your perception of the reality in front of you compared to what's in the images the camera captures.

Photograph Extremes of Light in the Same Photo

Find a location with harsh light. Compose an image that frames something very dark with something very bright at the same time. Notice what you can see of this scene with your eyes. Take the picture and compare. Try taking a series of pictures where you change the exposure, both plus and minus exposure. How does that affect what you see or don't see in the photograph? How does changing exposure change emphasis on how the camera sees the scene?

Share your results with the book's Flickr group!

Join the group here: www.flickr.com/groups/LandscapesfromSnapshotstoGreatShots

3

ISO 400
1/60 sec.
f/11
10mm
(APS-C)

Light

LEARNING TO SEE THE LIGHT FOR BETTER LANDSCAPE PHOTOS

Photography is obviously about light. Without light, you can't photograph. Light has a huge affect on how a landscape is translated into a photograph. It can make the difference between a dramatic photo that grabs people's attention and a boring photo that they pass on by. And this can be with the same landscape!

Light is why many photographers are disappointed with their landscape photos. They're at a dramatic and stunning landscape, but the images don't do it justice. A big reason for this is simply that they're at the landscape at the wrong time, with the landscape in the wrong light. You can't move easily around a large landscape to find better light, so if you're there when the light is bad, you're stuck. If you want more than a snapshot, you need to be discerning about the light and how you deal with it in your landscape. As I mentioned in Chapter 2, sometimes you have to say, "No," to a scene in order to find a photograph to which you can say, "Yes."

In this chapter, we explore light. You'll learn to see light and its effects on landscapes. You'll discover a bit about different types of light, from dramatic to gentle, and how they can help you get better photos. You'll learn to go beyond simply seeing "enough" light to finding light that will make your scene come alive.

PORING OVER THE PICTURE

I love being out at a great landscape at sunrise and sunset. This is a sunrise from Castro Crest in the chaparral of the Santa Monica Mountains National Recreation Area in Southern California. This is a stunning location for sunrises. I avoided the sun in the photo because I wanted to focus on the lovely ridges going into the distance. The color comes from the first light coming through a slight haze and a telephoto focal length that concentrates that color.

I had to increase the exposure from what the camera's meter was telling me, because the light of the sky was so bright.

This particular framing allowed me to contrast the rocks at the left with the shrubs of the chaparral at the right.

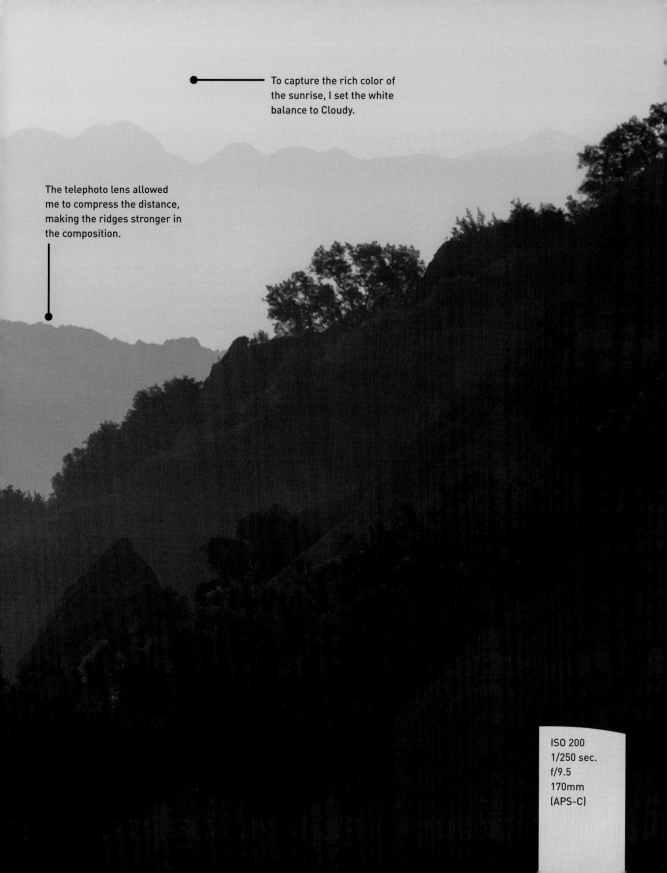

To capture the rich color of the sunrise, I set the white balance to Cloudy.

The telephoto lens allowed me to compress the distance, making the ridges stronger in the composition.

ISO 200
1/250 sec.
f/9.5
170mm
(APS-C)

PORING OVER THE PICTURE

The Mojave National Preserve in California covers a large area of desert and includes the largest Joshua tree forest in the world. This shot was made just after sunset. There is a soft color and dimension to the light that I really like. The light brings out the ridges of the mountains in the distance and gives a gentle side light to give the Joshua trees form and dimension.

Because I was at a distance from the subject and I didn't need the mountains to be as sharp as the trees, I could shoot at f/8, which also helped me choose a faster shutter speed.

I selected ISO 400 to allow for a faster shutter speed because I was shooting with a telephoto lens and there was a slight wind that could have caused vibration during the exposure.

Cloudy white balance allowed me to capture the colors with better rendition and saturation.

The best color for this scene began about ten minutes after sunset.

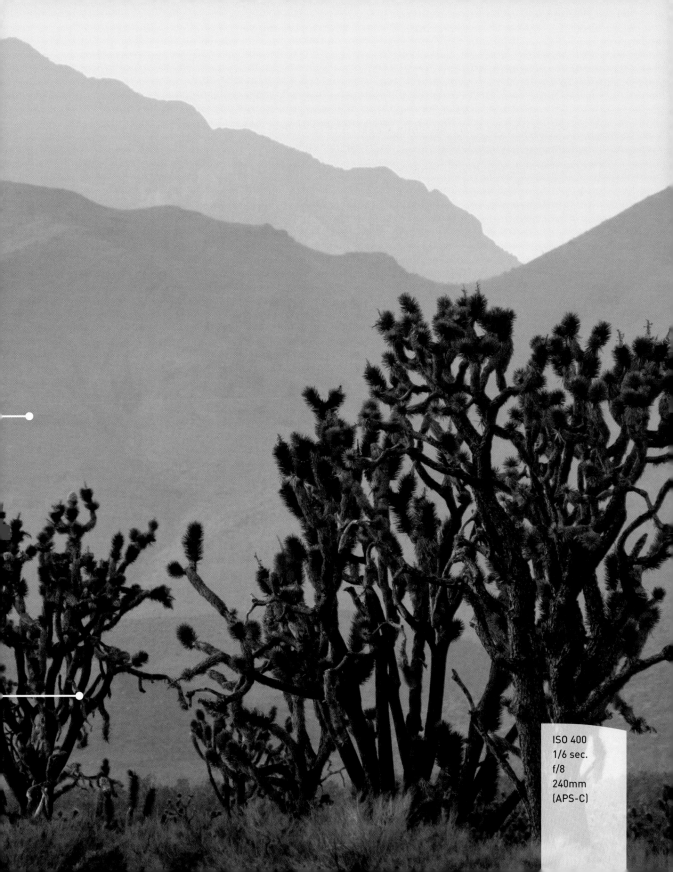

ISO 400
1/6 sec.
f/8
240mm
(APS-C)

SEE THE LIGHT

The old cliché of "seeing the light" could not be more appropriate to landscape photography. This entire chapter gives you ideas on how you can better see the light on your landscape and how to use the light.

You found some hints on seeing the light in the last chapter where you learned that a photograph is never the same as the subject. As soon as you understand that concept, you start looking differently at your subject. You start seeing beyond the subject, including focusing on the light, which includes both the bright light and the shadows.

Light does many things for a landscape besides make it bright enough to photograph. Light can reveal, but it can also conceal. Light can emphasize, and it can deemphasize. Light can create mood and atmosphere, adding emotion and mystery to a scene, or it can simply document and define a setting. You can't change the light on a landscape as you can on many other subjects, but you can see it and understand how to use it to its best advantage.

And of course, shadows show off light. Look for cool shadows that can define your total photo. Explore shapes and forms that exist only as shadows. Discover the shadow world that exists all the time but that we usually don't see.

SEARCH OUT DRAMATIC LIGHT

One way of seeing the light is to start becoming aware of dramatic light. Dramatic light does well for many landscapes, especially the big, open, rocky landscapes of the West. That doesn't mean other landscapes won't do well in dramatic light, but you'll find that small, intimate landscapes can have their details obscured if the light is so dramatic that light and shadow overpower the fine details.

Dramatic light is bold and strong. The highlights are bright and the shadows dark and well defined. The key is "drama." Notice how dramatic the light is in my photograph of Double Arch in Arches National Park (**Figure 3.1**). This light practically makes the arch look muscular. Start looking for drama in the light on the scene in front of you and focus on that.

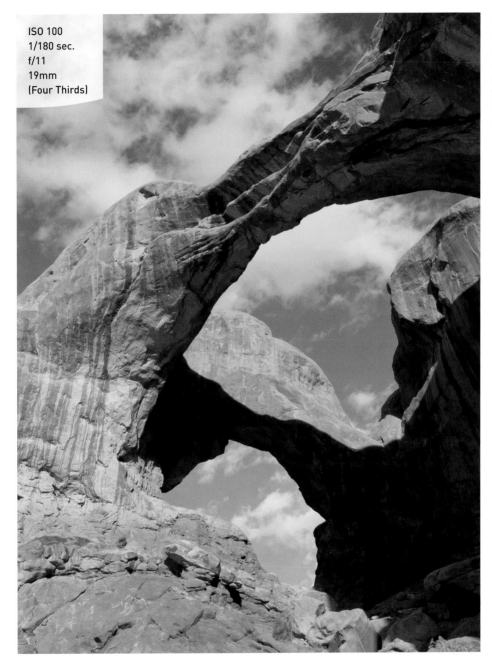

ISO 100
1/180 sec.
f/11
19mm
(Four Thirds)

FIGURE 3.1
Dramatic light uses
strong contrasts
and bold shadows
as the scene for this
view of Double Arch
in Utah's Arches
National Park.

Generally you won't find much drama to the light in the middle of the day. The most dramatic light comes early and late in the day. This is why the pros will often photograph a landscape from sunrise through early morning, and then leave and do other things until they return in the late afternoon and stay through sunset. Notice how the low, dramatic light just before sunset gives the rock cliffs along the Colorado River in Utah very strong shadows and texture (**Figure 3.2**).

FIGURE 3.2
A strong light just before sunset gives this scene along the Colorado River in Utah dramatic shadows.

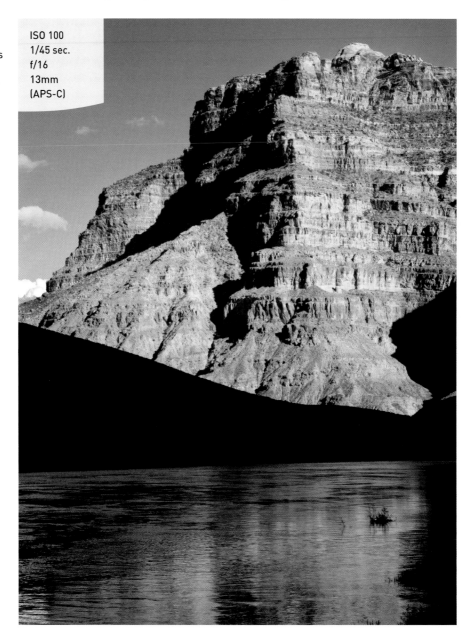

ISO 100
1/45 sec.
f/16
13mm
(APS-C)

I know, sometimes you're only at a location in the middle of the day, and that landscape just looks so great! Well, that may be so, but it often won't photograph great. No matter what you do, no matter what techniques you try from this book, you just won't get a satisfactory image. So, enjoy the view and keep it in your memory! Then look for something that will make a better photograph.

EXPOSURE CHALLENGES

Dramatic light often means big contrasts between dark and bright areas, and that can cause exposure problems. You'll quickly lose the drama and the feeling of light with the wrong exposure. Too much exposure will make the shadows too bright and wash out the sunlit areas. Too little exposure will make the bright areas look dingy and the dark areas murky and muddy; plus, it can increase noise.

To help get the best exposure, watch your highlights, even enlarging them in the LCD to better see them. Important highlights should have some detail, but they still need to be bright. You also can check your histogram; be sure that there is no large gap at the right and no dramatic cliff where the histogram has been cut off. If you're unclear about adjusting exposure, check out Jeff Revell's book *Exposure: From Snapshots to Great Shots* (Peachpit).

USE GENTLE LIGHT

Gentle light is the opposite of dramatic light. A gentle light on the landscape is more subtle than dramatic light, and it has much less contrast. Gentle light can be harder to use for landscapes because you don't have strong light and shadow to work with. Closed-in landscapes with lots of detail, such as the inside of a forest, often work quite well with gentle light. Small, intimate landscapes also have their details revealed by this light.

Gentle light is soft and enveloping. For most landscapes, this means light from an overcast sky or even foggy conditions, as you can see in my shot in the cloud forest of Costa Rica (**Figure 3.3**). Shadows are soft and minimal, but it's important to understand that there often are shadows, especially under objects. The key is to look for *enveloping,* in which the light seems to be everywhere.

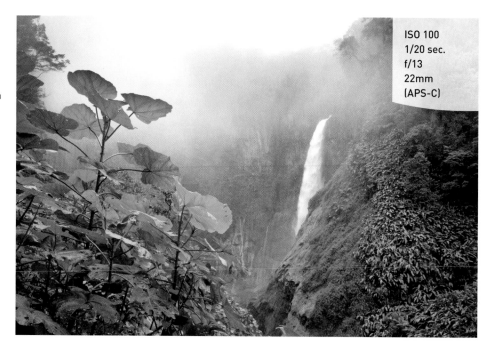

FIGURE 3.3
The soft, gentle light of a cloud forest in Costa Rica envelopes the scene and gives it a quiet mood.

ISO 100
1/20 sec.
f/13
22mm
(APS-C)

When you have a scene with strong color, such as bold greens of a spring forest from the Great Smoky Mountain National Park (**Figure 3.4**) or colorful flowers in the landscape, a gentle light can help emphasize those colors. Sometimes a dramatic light will overpower such colors so they become less important than the drama of light and shadow. Because a gentle light can be very revealing, it helps *reveal* colors.

When the weather is changing, you can get some very interesting light on a landscape because there is varied brightness in the sky. What that means is that the light is stronger, even if only a little, from one direction, which can add some interest to the way the light affects the scene. It can give some dimension to even a soft light.

Gentle light does present some challenges. First, it can make a landscape look gray and not very attractive (**Figure 3.5**). This is especially true if the scene is devoid of strong colors or strong, defining tonalities. You need to have something to help define the composition in gentle light, and if there are no shadows to help, you need something like color or strong contrasts.

Another challenge of gentle light is the very heavy light you get when the clouds are especially thick, such as just before a storm. This light has no form to it, and the landscape seems to want to reflect its heaviness. You may be able to find a scene where such a heavy look works for a mood, but it makes most landscapes look dull.

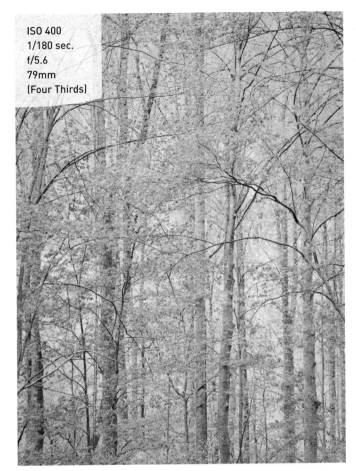

ISO 400
1/180 sec.
f/5.6
79mm
(Four Thirds)

FIGURE 3.4
The soft greens
of spring trees in
Tennessee's Great
Smoky Mountains
National Park look
good with a soft light.

ISO 200
1/250 sec.
f/8
18mm
(APS-C)

FIGURE 3.5
Dull, gray days can
make dull, gray
landscape photos
anywhere.

A dull gray sky is a final challenge with gentle light (Figure 3.5). Since this light usually comes from a cloudy day, those clouds can make a sky unattractive in a photograph. Dramatic, stormy clouds are great, but often a cloudy day just offers a gray mass that doesn't record well in a photo. The easiest way to deal with that is just to avoid it—don't even include it in the composition, or at most, include only a thin sliver of clouds to define the top of your scene.

Once you start noticing dramatic and gentle light on the landscape, you'll start seeing all types of light.

DIRECTIONAL LIGHT

Landscapes have depth, form, and dimension, but a photograph has none of that. It's flat and two-dimensional. In order to get a better landscape photo, you need to recognize that limitation and work to create an impression of depth, form, and dimension in the photo. One good way to do this is to recognize and use directional light.

Directional light is simply light that is brighter in one direction than another. The easiest way to think of this is to consider a low sun just after sunrise, as shown in my image of dunes along the Florida Atlantic Coast (**Figure 3.6**). The light has a very strong directional aspect because of the low sun that creates streaks of light across the land, along with good shadows.

FIGURE 3.6
Directional light brings out the form and texture of these dunes beside the Atlantic Ocean in Florida.

ISO 100
1/45 sec.
f/16
13mm
(APS-C)

The best directional light comes from early and late in the day, which is another reason that pros typically photograph early and late and avoid midday. When the light is high in the sky, shadows shrink and the light grows dull. You quickly lose the impression of direction, and you start to lose the feeling of form and depth that directional light gives.

Notice where the light is coming from and what that is doing to your scene. This will help you size up how best to take advantage of it.

Directional light can do the following for a scene:

- **Define three-dimensional form.** With light on one side of a hill, for example, shadows appear on the other side, and the combination of light and shadow creates form.

- **Add highlights to the scene.** Bright areas attract the viewer's eye in a photo, so the right highlights can help.

- **Create long shadows.** Long shadows can be very useful in a composition because they can help define the landscape.

- **Put highlights on water.** This can be both good and bad. Sparkling water can be very attractive (**Figure 3.7**), but if the light is too strong, that can quickly become a distracting glare of light.

ISO 100
1/160 sec.
f/8
6mm
(compact)

FIGURE 3.7
The light from this Minnesota sunrise on Lake Superior puts sparkle and shine on the water.

SIDE LIGHT

Side light is light that comes from one side of the scene or the other so that the light is directly to your side at your camera position. Side light is a very important directional light for a landscape. Look at any collection of landscapes and you'll see it used frequently.

Side light does the following for a landscape:

- **Offers the most three-dimensional of any light.** Sidelight really pulls out the dimensional qualities of a scene. It gives depth and form to any landscape.

- **Brings out texture.** A landscape can have many textures throughout the scene, and often these contrasts in texture will help define your composition (**Figure 3.8**). A side light, especially a very low side light, will enhance and show off those textures.

- **Makes objects look very solid.** When objects gain form from being lit on one side and in shadow on the other, they also give an impression of being very solid. Trees, for example, start looking very solid and robust with side light.

- **Diminishes the impression of color.** Because there is so much contrast from side light, colors can't record consistently from light to shade. This doesn't mean that color is lost, just that color becomes less important than the light itself.

FIGURE 3.8
Side light shows off the shadows and textures of these dunes in White Sands National Monument in New Mexico.

ISO 100
1/125 sec.
f/11
400mm
(APS-C)

THE COLOR CHALLENGE

Because our eyes can see so well from dark to bright areas, we perceive color very well throughout a scene. The camera can't "see" as well as we do when the light is contrasty, something you'll run into often with side light and back light. In addition, camera sensors don't record colors in the same way as the colors get darker with less light. For these reasons, we can be misled by our eyes into thinking that there is more color in a scene than the camera will be able to capture and hold.

For both back light and side light, look for color in the bright areas, but don't assume that you'll capture significant color elsewhere in your photo.

BACK LIGHT

Back light is light that is coming right at you when you're behind the camera. It's the most dramatic of lights, glancing off everything in front of you as it hits the backside of your subject.

Back light scares many photographers because it can cause some problems, including flare and exposure issues. Be bold and try it anyway! Sure, sometimes you'll get some flare, and not every exposure will be perfect, but you'll also get dynamic and interesting landscapes that other photographers won't have.

Back light does the following for a landscape:

- **Creates separation.** Back light helps you define different parts of your scene by separating them visually. Tops of ridges, trees, and so forth pick up light that contrasts with the shadows in front of them, which creates visual separation.

- **Changes its effect on shape and form.** If the light is low, your landscape will have silhouettes that emphasize two-dimensional shapes. If the light is high, your landscape will gain highlights and shadows to feature three-dimensional forms.

- **Brings out texture or minimizes it.** When the backlight is high and skimming across the scene, texture will show up along the tops of the elements of your landscape. When it's low and creating silhouettes, textures disappear.

- **Makes translucent colors glow.** The light shines through flowers (**Figure 3.9**), spring leaves, and other colorful, translucent objects, giving the impression that they're glowing when dark shadows are around them.

- **Diminishes the impression of other colors.** Solid colors don't always fare so well with back light. They may become hidden by texture or silhouette.

FIGURE 3.9
Back light in
California's
Montana de Oro
State Park makes
these flowers glow
and brings out
their texture.

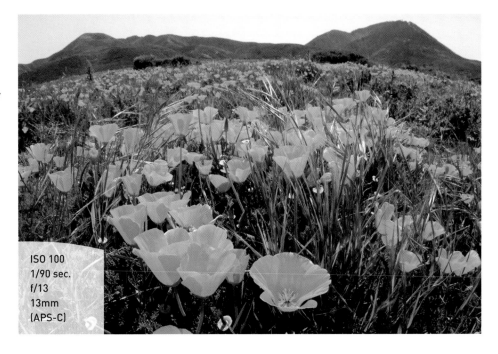

ISO 100
1/90 sec.
f/13
13mm
(APS-C)

FRONT LIGHT

Front light (light that heads over your shoulder and hits the front of the subject as it lies in front of you) is the problem child for light on the landscape. It can be beautiful, but it can also be very ugly. Because it is hitting the front of the subject, shadows fall behind the subject, resulting in few distinctive shadows for your photograph. Texture and form may disappear. In the wrong front light, this just looks flat and dull.

The key to good front light is low, low, low (**Figure 3.10**). That means sunrise to midmorning at the latest, and then late afternoon to sunset. Midday front light is the worst sort of light you can use for a landscape. Because the sun is low in winter, you have the chance to photograph with low light through much of the day; conversely, the high light of summer really limits how long the light stays low.

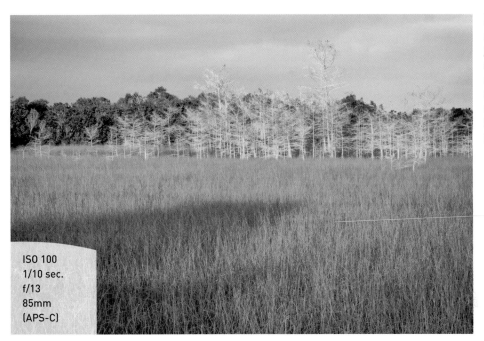

ISO 100
1/10 sec.
f/13
85mm
(APS-C)

Front light does the following for a landscape:

- **Shows off shapes.** Because shadows are less important with front light, shapes become more important, especially when you can show them off against a contrasting background, such as trees against the sky.

- **Brings out color.** Solid colors look their best with front light because the light is fully revealing them. One challenge is that very low light at sunrise or sunset will be so colored that the subject colors will be obscured.

- **Makes objects look very solid.** Even translucent objects look solid with front light.

THE PROBLEM WITH TOP LIGHT

Summer brings a big problem for the landscape photographer: top light. When the sun is high in the sky, you get a strong top light for the landscape, regardless of whether the sky is clear or has light clouds (moderate to heavy clouds make the entire sky the light source). Top light results in small shadows close to the objects, which doesn't give them much dimension or form, nor do they gain the magic of a low front light.

On most landscapes, top light is simply ugly (**Figure 3.11**). In addition, it tends to add an unwelcome bluish cast to the scene that makes the situation even worse. Summer is when most people are on vacation, out at midday at great locations, hoping to get a great shot. Unfortunately, they usually don't because of top light's problems.

Most of the time the answer is to look for something other than a landscape to shoot. However, there are a few things you can do to work with top light:

- **Look for something that catches the light and casts shadows.** Cliffs being raked with a top light create a pattern of light that brings out texture and makes it act like a "side light." Also, pay attention to shadow patterns under trees.

- **Use a polarizing filter and emphasize a beautiful sky.** A polarizing filter will cut down some of the blue haze of midday; plus, you can use it to bring out the clouds.

- **Shoot in black and white.** You can sometimes create contrasts in black and white that won't work in color. (You can find more on black and white in Chapter 8.)

FIGURE 3.11
A midday top light is distinctly unattractive in this big Utah landscape.

ISO 100
1/400 sec.
f/8
30mm
(compact)

THE COLOR OF LIGHT

Light has color, but we often don't see it, unless that color is very strong. Our eyes are so adaptive that they compensate for small changes in the color of light all the time. The camera doesn't do this; it sees color in light quite distinctively, as you've probably already noticed in many of the photos in this chapter. This issue isn't unique to digital cameras. Films have always had specific biases to how they see the color of light.

Cameras see colors differently in daylight, in the shade, on cloudy days, or inside under fluorescents or incandescent bulbs. If you photograph a piece of white paper under each of those conditions and don't change your film or white balance, the paper will change color under every light—even though, to your eyes, the paper will appear to be the same white under all these lights.

There are two things you can do to deal with the color of light:

- You can change the response of the camera by adjusting the type of film you use or by adjusting your digital camera's white balance. (See "The white balance challenge," later in this chapter, for more on white balance.)

- You can recognize that these colors can be interesting and offer some excellent possibilities for better color landscapes.

Either way, you need to be able to recognize the colors of light on the landscape and know how to control it.

BEYOND SUNLIGHT

The color of daylight changes constantly from morning to night. It's affected both by the time of day (which relates to how high the sun is in the sky) and by the weather and atmosphere conditions. These color changes can be important aspects of your landscape photos because they offer uniquely photographic interpretations of mood and atmosphere for a landscape. In addition, they can give a strong feeling of time of day for the scene.

Here's a look how the color of light changes throughout the day:

- **Sunrise** light is usually crisp and yellow to somewhat pink, with much less atmospheric color than a sunset (**Figure 3.12**). With more atmospheric haze or moisture in the air, the color can be more orange.

- **Early morning** light tends to be crisp and yellowish. Shadows have a distinctly blue cast to them all through the morning. This blue cast is strongest with a cloudless blue sky. As the sky gains clouds, some warmer sunlight is reflected into the shadows.

- **Midmorning** light becomes less colored and more neutral. Then it starts to get bluish.

- **Midday** light tends to range from rather colorless to bluish.

- **Afternoon** light starts gaining color, usually shifting to a softer, warmer light than morning. A lot of this color is affected by how much haze or moisture is in the air.

- **Late afternoon** light tends to be softer-edged and orange. Shadows have a distinctly blue cast to them through the evening, but they tend to be less blue than morning shadows.

- **Sunset** light is usually soft-edged and more orange than sunrise light (**Figure 3.13**).

Remember: Clouds will change the light, usually making it bluer, but the time of day and the thickness of the clouds will affect the color as well. Colors are affected more by time-of-day light with thin clouds than they are with thick clouds.

FIGURE 3.12
Sunrise in the Santa Monica Mountains of California gives a crisp light without the strong color of sunset.

ISO 100
1/60 sec.
f/5.6
22mm
(APS-C)

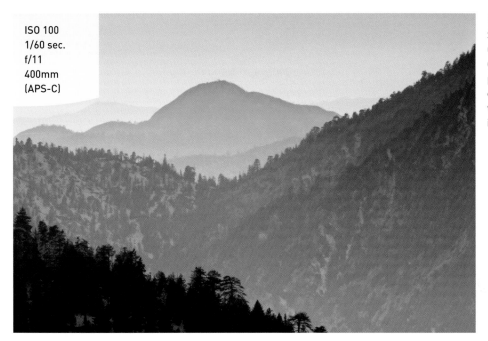

ISO 100
1/60 sec.
f/11
400mm
(APS-C)

FIGURE 3.13
Sunset in
California's San
Gabriel Mountains
provides a strongly
colored light that
fills the entire
image with color.

THE WHITE BALANCE CHALLENGE

White balance is a camera control that affects how the camera perceives and translates the color of light in a photograph. Auto white balance (AWB) is an automated camera control that tries to evaluate the color of the light and then set a white balance for the camera that will give "neutral" colors. That seems like a good idea, in practice, but it causes some problems for landscape photography.

First, as you've just learned, colors change through the day. There are natural color casts to the light that we expect from photographs at certain times. The last thing you want to do is remove those color casts to create some "neutral" colors that don't really look right for the time of day. That can mean sunrise and sunset colors that are "neutralized" and don't give a true feeling of the time. In the bold sky sunset shots you see here (**Figures 3.14** and **3.15**), the only difference is white balance. The AWB shot loses much of the color of the scene.

FIGURE 3.14
This sunset was shot with white balance set to Cloudy, which tends to render sunsets with better color and with a warmth that we expect from a sunset shot.

ISO 100
1/60 sec.
f/11
400mm
(APS-C)

FIGURE 3.15
The same sunset was shot with AWB, which removed much of the color and added a bluish cast.

ISO 100
1/60 sec.
f/11
400mm
(APS-C)

[Ch03 inline 15.tif]

Second, AWB is inconsistent. It's designed to constantly change depending on the conditions. Unfortunately, when you're outside, AWB will "recognize" a change in the conditions when all you did was change focal length or shoot with a composition that includes more or less sky. That creates a problem because your photos will change in color even though the landscape hasn't changed.

Finally, AWB on most cameras tends to give a bluish cast to outdoor scenes, especially in shade and under cloudy conditions. You can see it in the AWB sunset shot here, too (Figure 3.15). (It does make the sky look more like blue sky, but the sky doesn't really look like that during an intense sunset.) This bluish cast is really odd because, long ago, film manufacturers discovered that people prefer slightly warmer renditions of a scene. We would have expected the camera manufacturers to work for a warm bias, if anything, rather than a bluish bias, but alas, that is not the case. This blue cast can wreak havoc with colors in a landscape because it gives them less saturation.

BUT I SHOOT IN RAW

Of course, I shoot raw—and you should, too—but that doesn't mean that I don't set a white balance. AWB is a setting that comes into the program you're using for raw processing. Now you have two workflow problems:

- You'll always have to check and set your white balance, but if AWB is inconsistent, what white balance do you use? The "settings" that appear in your software that look like the settings on your camera are not the same and won't give the same results.

- Because our eyes adapt so easily to color changes, we often accept poor color from AWB because we don't see anything different on our screens to match.

HOW TO CHOOSE YOUR WHITE BALANCE

So, if AWB is not ideal for landscape photography, what should you do? The best approach is to set a specific white balance because that locks in the camera's response to the light. You can choose the white balance setting based on two options: matching the conditions or creative control. Creative control doesn't mean you're going to go wild and crazy with colors. It simply means using white balance to control the color of the light in a very specific way.

Here are some ways to control the color of light with white balance:

- **Match the conditions.** Simply choose a white balance that fits the conditions, such as Daylight for daylight sun (**Figure 3.16**), Cloudy for cloudy conditions, or Shade for shade.

- **Warm up the scene.** Choose a white balance that creates a warmer feel than the condition match would do. For example, use Cloudy for daylight or Shade for cloudy. You may need to test this approach—the effect may look good at certain times of day but not others.

- **Cool down the scene.** Use Daylight for shade or Tungsten for sun. This approach can be effective with a moody scene, adding more mood. It can also make a winter landscape look even colder.

- **Play with white balance.** Try different settings in different conditions and see what you get. Don't be afraid to try something crazy, such as Fluorescent for sunset.

FIGURE 3.16
The easiest way to handle white balance is simply to match the conditions with the white balance choice, such as Daylight for daylight sun on this Eastern Sierra fall scene in California.

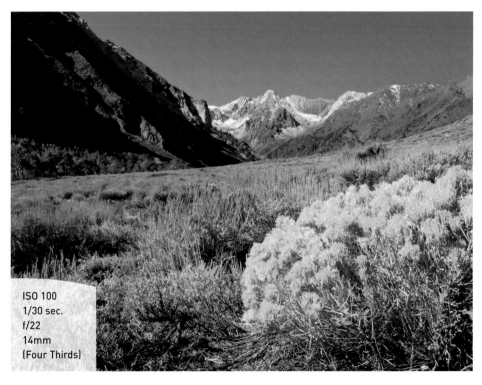

ISO 100
1/30 sec.
f/22
14mm
(Four Thirds)

LIGHT AND EXPOSURE

A whole book could be written about light and exposure—and there are such books, including Jeff Revell's *Exposure: From Snapshots to Great Shots* (Peachpit). But let's keep it simple and direct. You'll hear from many photographers that you have to shoot manual exposure (in other words, setting your camera's aperture and shutter speed yourself). Certainly, manual exposure works, but is it the only way to expose? Nonsense! You don't have to do anything of the sort. I only shoot manual exposure when I have to; otherwise, I shoot in Aperture Priority mode. Aperture Priority is ideal for landscape work. You set an aperture, or f-stop, for needed depth of field (which will be covered in more detail in Chapter 5), and the camera chooses an appropriate shutter speed.

Modern autoexposure is very, very good. Most of the time, it gives you good exposures. Of course, it helps to remember that your camera doesn't know the difference between a dark scene and low light or a bright scene and lots of light. What happens is that the camera sees a dark scene (**Figure 3.17**) and guesses that there isn't enough light, so it wants to overexpose it. The result will usually be a too-bright landscape and washed-out highlights. You need to give less exposure for dark scenes, so simply dial down to a minus number on your exposure compensation dial.

When the camera sees a bright scene (**Figure 3.18**), it guesses that there is a lot more light and it wants to underexpose. The result is that you get a muddy, murky looking image that doesn't reflect the brightness of the scene. So, you need to give more exposure for bright scenes. Simply dial up to a plus number on your exposure compensation dial.

FIGURE 3.17
When the camera sees a dark scene like this shadowed small landscape in the redwoods, it doesn't see the scene as dark. Instead, it sees it as having too little light, so it overexposes the image, which washes out bright areas.

ISO 100
1/60 sec.
f/11
320mm
(APS-C)

FIGURE 3.18
A camera won't see a bright morning fog like this one over Casco Bay in Maine as a bright fog; instead, it sees it as "too-bright light," so it underexposes the image and makes it look gray and dingy.

ISO 100
1/250 sec.
f/11
310mm
(APS-C)

EXPOSURE MODES

Your camera comes with a number of choices for exposure called *exposure modes*. Each mode tells the camera to handle exposure in a different way. The exposure modes can be divided into two main categories: Manual and Auto.

Manual exposure (M) is controlled by the photographer. In this mode, you examine the scene, look at what the camera or other meter is suggesting for exposure, and choose the aperture and shutter speed that you think are appropriate.

Auto exposure is exposure that is controlled by the camera. The camera's metering system examines the scene and sets the camera for an appropriate exposure. There will be multiple modes of auto exposure on your camera:

- Program mode (P) has the camera choosing both shutter speed and aperture. Program mode is very limiting for landscape photography. Many cameras have special variations of Program modes for things like sports, close-ups, night, and even landscape. The challenge with these settings is that the camera is controlling all parts of the exposure, so you may not be getting the choices you really need for a scene.

- Shutter Priority mode (S or Tv) has the camera choosing the aperture after you select a shutter speed. This mode has limited use for landscape photography because you'll rarely need a specific shutter speed (you're not trying to stop motion).

- Aperture Priority mode (A or Av) has the camera choosing the shutter speed after you select an aperture. This mode is the most useful autoexposure mode for landscape photography.

When your camera is challenged by exposure, there are two simple rules to follow:

- Never underexpose your scene.

- Never overexpose important bright areas.

Here's a simple exposure technique to try when you're shooting:

1. **Set your camera on Aperture Priority mode and choose an appropriate aperture.** You can choose the right aperture based on what you need from depth of field (see Chapter 5). Then you can change your exposure with the exposure compensation control on your camera. Give less (or minus) exposure immediately for dark scenes and more (or plus) for bright scenes. Start with a full step of exposure compensation for these scenes and increase it as needed based on what you find from how your first exposure affects highlights as shown on your LCD.

2. **Take a picture.** Are the highlight warnings blinking on your LCD screen in Review mode? Change your exposure until they just disappear from the image, but no further. (***Important:*** Bright sun and other bright spots in a photo will always have highlight warnings, so ignore them.)

3. **Learn to read your histogram.** It doesn't have to be hard. A histogram is a visual representation of the brightness values of all the pixels in your image. There is no "right" or "wrong" shape to the hills that make up this graph—they'll vary depending on the scene. What is important is that the histogram should have no large gaps at the right side (which indicates underexposure) and no chopped off "hill" at the right side (which indicates overexposure and lost detail). Adjust your exposure accordingly.

4. **If you aren't sure, just take the picture and check your LCD.** You can't completely judge exposure by the look of a photo on the LCD, but you can check for highlight warnings and the right side of the histogram.

Chapter 3 Assignments

Find the Direction of Light

For this first assignment, you need to find a small landscape that is well exposed to the sky and sun. Shoot early or late in the day. Avoid midday light. Shoot a series of five to ten photos as you walk around that landscape, experiencing the light on the scene, as well as capturing images of it. Now compare those photos to see how the direction of light has affected your photos of the location.

Photograph Light

A great exercise that I guarantee will help you see the light is to go out and photograph the light. Take your camera outside and start looking for light as your subject! You don't need to care what the actual subject is. You don't even have to have a landscape. You're just looking for and photographing light. This might mean a streak of light across a grassy field, or maybe the glow of light that appears when the sun is behind a translucent tree.

Capture Shadows

Shadows are extremely important for dramatic light. The shadows themselves can create interesting shapes and forms or provide a background for the sunlit parts of the scene. Try photographing shadows without trying to capture anything else. Try a scene that has a spot of light on a key part of the landscape, while the rest of the scene is dark in shadow.

Shoot a Scene from Morning to Night

You may not be able to do this with a dramatic, popular landscape, but there probably is some sort of landscape near you that you can visit at different times of day. You need a landscape that is totally open to the sky because that will affect your results from this exercise. Start shooting that landscape as the sun comes up, and then continue shooting through the morning, midday, afternoon, and all the way to sunset. Try to shoot with approximately the same composition so that it will be easier to compare the shots. Then compare the shots to see how the light changes and affects the landscape through the day.

Experiment with Exposure and Dramatic Light

Dramatic light has contrast and often a big difference between the darkest areas and the brightest areas. This can make a good exposure hard to get for those conditions. Try different exposures—both more and less exposure—to see how they affect different proportions of light and dark in the scene.

Share your results with the book's Flickr group!

Join the group here: www.flickr.com/groups/LandscapesfromSnapshotstoGreatShots

4

ISO 100
1/100 sec.
f/16
15mm
(APS-C)

Composition

STRUCTURING YOUR IMAGE TO COMMUNICATE ABOUT A LANDSCAPE

A lot of things have been written and discussed about composition for as long as people have made pictures, way before photography. Composition is simply about the organization of an image within the image frame, from edge to edge, but exactly how you organize a photo is not so simple.

Ultimately, composition is about communication. What you include in your photo, what you exclude, and how you arrange what's in the frame tell a viewer what you think is important about a landscape.

In this chapter, I cover many possibilities for composition. You'll learn why it's so important to get things out of the middle, as well as when the rule of thirds helps (and when it doesn't). You'll learn about foregrounds and backgrounds, the importance of edges, and what to watch out for in distractions.

PORING OVER THE PICTURE

The composition has some abstract qualities from the way the textures on the left and right create shapes that contrast with the water in the tidepool.

Because the tide had gone out, small tidepools formed in the sand. That, combined with patterns in the sand from wave action, is what makes the scene interesting.

This is a photograph about light, pattern, and texture on Florida's Atlantic Coast. It was shot before dawn, when there can be some beautiful light. (You never know what you'll get until you're on-site, of course.) If I had waited until the sun rose in the sky, I would've missed this beautiful beach scene. The clear sky and slight clouds at the horizon resulted in a much less interesting sunrise than the time just before it

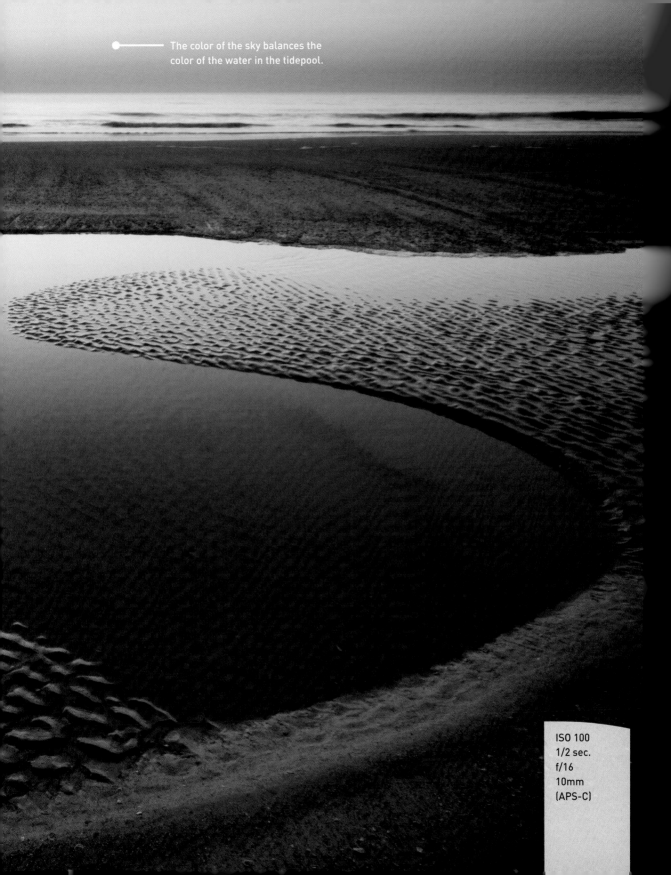

The color of the sky balances the color of the water in the tidepool.

ISO 100
1/2 sec.
f/16
10mm
(APS-C)

PORING OVER THE PICTURE

I happened to be in northern Minnesota just after a week of rain, so the streams going into Lake Superior were full. I grew up in Minnesota, and the North Shore of Lake Superior is still one of my favorite places for landscape photography. For me, the photograph wasn't simply about capturing this part of Gooseberry Falls; it was also about water—and lots of it—rushing over the falls. That's what I wanted my composition to communicate.

I used a wide-angle lens, but I didn't step back to show the whole falls. I got in close to emphasize its drama.

I shot with a fast shutter speed to reveal the pattern in the water and add that to the composition.

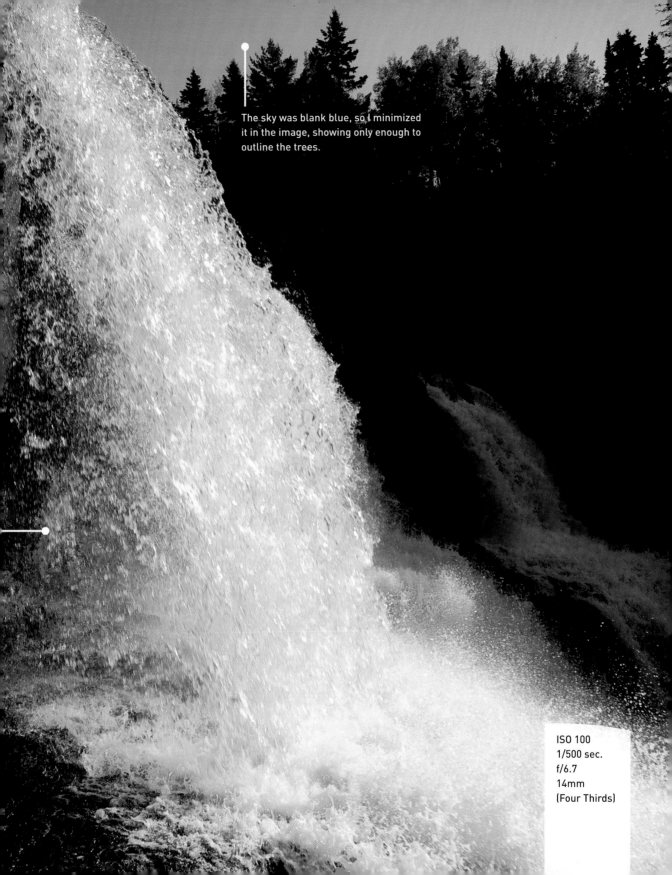

The sky was blank blue, so I minimized it in the image, showing only enough to outline the trees.

ISO 100
1/500 sec.
f/6.7
14mm
(Four Thirds)

GETTING OUT OF THE MIDDLE

One of the deadliest traps for good landscape composition is to center things within your viewfinder. This can mean a centered horizon, a centered boulder, a centered tree, centered flowers, whatever is a strong visual element in the middle of your picture area. I won't tell you that a centered composition will *never* work—sometimes it does. But most of the time it's a lazy way of composing a landscape, and it isn't very effective.

Researchers have actually done some studies on how people look at images. They used cameras to map the eye movement of a viewer across different images that were used for the test. The researchers discovered that when an image was strongly centered, viewers had a tendency to look at the most centered part of the scene and not look much at the rest of the image; they quickly got bored with a photograph and wanted to move on. When the image had strong pictorial elements (such as a horizon or a strong subject) away from the center of the picture, researchers discovered that viewers tended to look all over the picture; they spent more time with the image and liked the picture better.

So, you can see immediately that one of the ways that you can improve your landscape pictures is to make sure that you don't have your landscape all lined up and centered in your composition (**Figure 4.1**). In this section, I'll give you some ideas on how to think about getting less-centered images, but as soon as you even start *thinking* about getting things out of the middle, your pictures will improve.

FIGURE 4.1
A glorious sunrise over Utah's LaSalle Mountains doesn't need a big chunk of black mountains covering the bottom half of the photo. The photograph is about the sky, and its connection to the mountains needs only a sliver of mountains across the bottom of the photo.

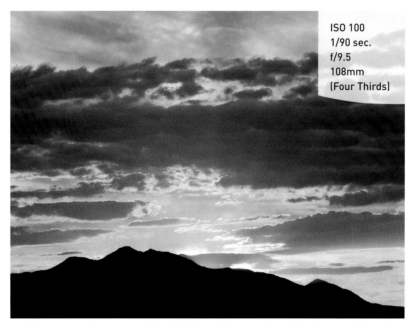

ISO 100
1/90 sec.
f/9.5
108mm
(Four Thirds)

THE RULE OF THIRDS: WHEN TO FOLLOW IT AND WHEN TO IGNORE IT

Once you start studying a bit about composition, you'll hear about the rule of thirds. The rule of thirds is a guideline that is designed to help you get your subject and strong visual elements such as horizons out of the center of the picture. It gives you a framework to simplify your choices for strong positions within a composition.

The rule of thirds starts by dividing your picture into horizontal thirds (**Figure 4.2**). This results in two lines at the intersection of the thirds. Visually, these lines work very well as positions for horizons. When the horizon is placed at the bottom-third line, you have a very strong emphasis of sky in the photograph with less of the ground (**Figure 4.3**). When the horizon is placed at the top third, the ground is emphasized and the sky is deemphasized.

FIGURE 4.2
The rule of thirds starts by dividing the picture horizontally into thirds.

ISO 100
1/30 sec.
f/8
250mm
(APS-C)

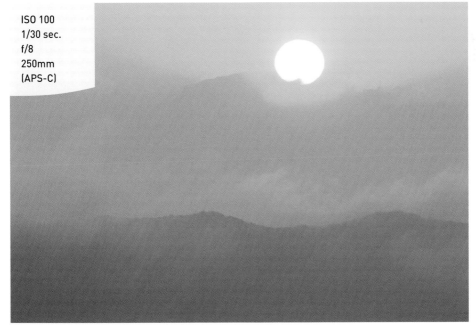

FIGURE 4.3
In this image of sunrise over California's Santa Monica Mountains, strong horizontal elements of the picture line up closely with the rule of thirds.

The rule of thirds goes further by dividing the picture into thirds from left to right (**Figure 4.4**). This results in two vertical lines at the divisions, which become useful places to put strong verticals in a landscape. Which side you put your photographic element on will depend a lot on the scene, but because we look at things from left to right in the Western culture, there is a difference in the way that a composition looks when the strong element is on the left versus the right. In **Figure 4.5**, there is a strong visual element on the right which creates a dynamic image that goes against our Western way of looking.

FIGURE 4.4
The rule of thirds
then divides the
picture vertically
into thirds.

FIGURE 4.5
Here the strong
vertical of Balanced
Rock in Arches
National Park lines
up closely with the
rule of thirds.

ISO 100
1/125 sec.
f/8
115mm
(APS-C)

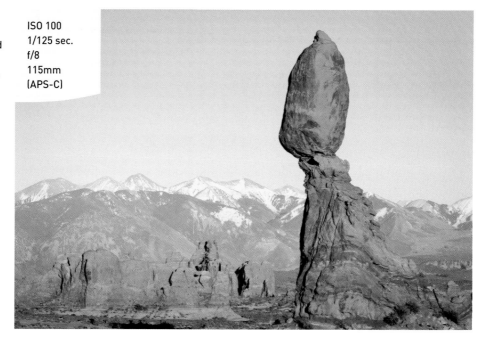

Next, put the two horizontal lines and two vertical lines together over the picture (**Figure 4.6**). They intersect at four points and are very strong positions for composition (**Figure 4.7**). Landscapes often have things that are larger than these points, such as a horizon or Balanced Rock, but when there is something that has a strong presence in the picture that can work at one of these points, this can create an attractive composition.

FIGURE 4.6
Now the horizontal and vertical lines come together to help with placement of a strong visual element in the landscape.

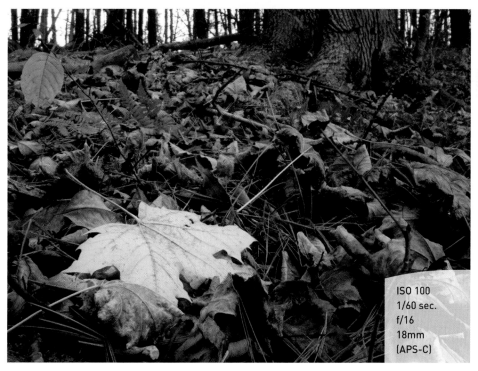

FIGURE 4.7
In this small-scale landscape, the yellow maple leaf contrasts strongly with the late fall landscape and is placed at one of the intersections of the horizontal and vertical lines.

ISO 100
1/60 sec.
f/16
18mm
(APS-C)

A lot of the ideas about composition come from the art world where they've been refined for centuries. The rule of thirds has been taught to painters and other artists for a very long time because it works. However, there are two challenges that come from the rule of thirds:

- **You lose the subject.** If you start paying too much attention to the "rules," you can lose sight of the actual subject. The rules become more important than what's being painted or photographed.

- **Photography is not painting.** Art forms like painting and sketching are very different from photography. They start with a blank canvas where everything is added to the composition as appropriate.

Let's look at those two ideas in a little more detail because they have a strong effect on composition. I once had a student in one of my workshops show an interesting landscape photograph for a critique. This image had about one-third sky, one-third trees, and one-third ground with grass and garbage. That's right—the bottom part of the picture actually had trash in it that didn't seem to fit the rest of the picture at all. So, I asked the student why she had included the trash in the composition. She said she had to because of the rule of thirds!

That little story points out how the subject can be lost when distractions take away from the subject. Sometimes people try so hard to find a rule of thirds for their landscape that they don't fully see the subject itself. It's easy to miss important things that should be in the photograph simply because they don't fit the rule of thirds.

It's also important to understand that photography is not like painting or sketching. As landscape photographers, we have to deal with what's in front of our lenses (**Figure 4.8**). We can't simply place rocks, flowers, and trees where we want, as we could if we were working with a blank canvas. Sure, some photographers use Photoshop to change a scene, but even that is difficult to do compared to what the painter does in creating his or her work.

Sometimes a scene just needs a different composition. The sky might be so fabulous and so outstanding that all you need is the barest sliver of landscape with it (**Figure 4.9**). On the other hand, the sky might be awful, so you'll need to show only the top edge of the landscape so that the viewer can understand something about the place.

I like to look at a scene and try to understand what's truly important about the scene, not what's important about my art technique. Then I compose the image to show off what's important about the scene, making sure I'm using my composition to clearly communicate this for a viewer.

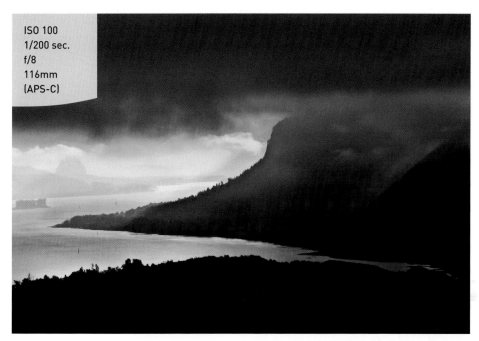

ISO 100
1/200 sec.
f/8
116mm
(APS-C)

FIGURE 4.8
Storm clouds
breaking over the
Columbia River
between Washington
and Oregon makes
a dramatic land-
scape that isn't
easily put into the
rule of thirds. The
contrasts of land,
clouds, and light
are what matters.

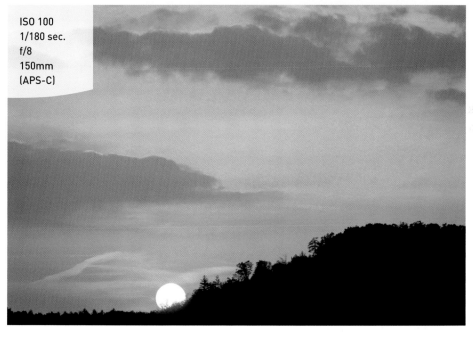

ISO 100
1/180 sec.
f/8
150mm
(APS-C)

FIGURE 4.9
The landscape
here at Cades
Cove in the Great
Smoky Mountains
National Park
would be pure black
against the sunset,
so there is little
need to include
more land than
needed because
that would mean
loss of the sky.

WHAT'S YOUR PHOTOGRAPH ABOUT?

One thing that can really help the photographer is to ask this very important question: What's your photograph about? The answer isn't simply the subject that's in front of you. It's more than that. And the question shouldn't be seen as a challenge, but as an aid to looking at your composition.

This also can help you clarify and refine your composition to what's really important. **Figure 4.10** isn't simply a photograph of the redwoods; it's about tall trees in a dense forest, and the composition uses the trees at the edge, as well as the light, to show that. There is no ground showing because the photo is not about the ground.

FIGURE 4.10
This photograph is about tall trees in the redwood forests of Northern California, and the composition is designed to reflect that.

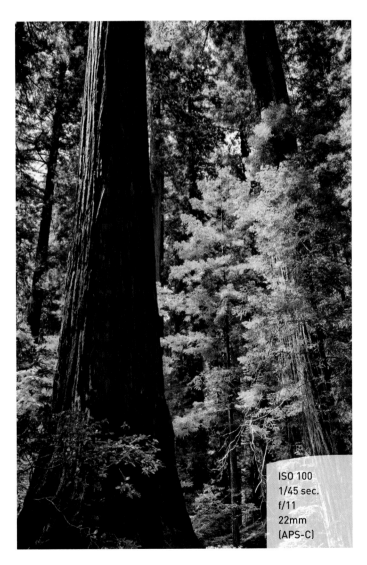

ISO 100
1/45 sec.
f/11
22mm
(APS-C)

Too many photographers try to throw everything into their compositions of the landscape. They see this beautiful scene in front of them and try to capture the entire scene in the photo. The image is often disappointing because you can't put an entire scene into a small picture. You have to decide what's truly important about that scene and then make sure that your photograph reflects that.

What's your photograph about? With experience, you'll answer this question very quickly and intuitively. But if you've never asked yourself this question before, you should stop, pause, and really think about it. Your landscape won't be moving so if you take a moment to figure out what your picture is really about and what you want to emphasize about it, you'll find that your composition will come together much more readily.

PAYING ATTENTION TO RELATIONSHIPS

Relationships are important, whether you're talking about life or landscape composition! As soon as you start thinking about things like the rule of thirds, you're thinking about visual relationships within the image frame. But visual relationships go beyond simply getting things out of the middle of your picture. How picture elements within your composition relate to each other affects how clear your composition is and how well it will communicate to your viewer.

Painters learn all sorts of ways that these relationships can help structure and define the composition, and these techniques apply to photography as well. For example, leading lines are strong visual lines that lead the eye through the photograph. Diagonals and S-curves are other ways of defining a composition with lines that help the viewer understand the relationships in a picture.

Balance is something that you hear a lot about with composition. Balance is about the relationships of visual elements within your landscape photograph. The rule of thirds uses a very simple sort of balance, where two-thirds of the image visually balance one-third of the image or a subject at an intersection of the thirds balances the space around it.

Balance is much more than simply the rule of thirds. Images will look in balance or out of balance based on how the objects within your composition relate to each other. This concept can be hard to explain because it's so visual. One thing that can really help you with balance is to look at your image on your LCD as a photograph. Do strong visual elements of your image overpower the rest of the picture? That can put the composition out of balance. Do strong visual elements seem to have something balancing them in another part of the picture? That can help put the composition into balance.

All this comes down to how you structure and define a composition to control the viewer's eye (**Figure 4.11**). In Figure 4.11, there is a strong relationship between the simple bottom of the photo and the highly detailed top part of trees. Then, as you look closer, notice the relationship of the background trees to the larger, more defined leaves, which also create a visual relationship to the falls. In addition, there is a strong relationship to the rocks on the right, both to the falls and to the trees.

Remember: As soon as you get key parts of your picture out of the center, you're encouraging your viewer to look over the entire photograph. How you create visual relationships within that photograph affects the way that people look at your image.

FIGURE 4.11
The falls in Tennessee's Frozen Head State Park have a strong relationship with their surroundings in this image.

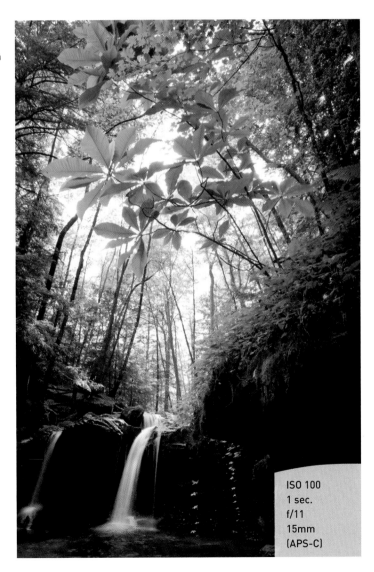

ISO 100
1 sec.
f/11
15mm
(APS-C)

CONSIDER THE FOREGROUND, MIDDLE GROUND, AND BACKGROUND

Foreground, middle ground, and background are three very important parts of any landscape composition and are critical to the visual relationships of any photograph. Not all landscape photographs will have all three—for example, a mountain against the sky doesn't have any foreground—but how you work with these areas has a big effect on what your picture looks like.

Foreground is the area immediately in front of you that sets the stage for the main part of the landscape. Background is that part of the landscape that is the most distant from you. Middle ground is everything in between.

Relationships between these three areas are largely affected by how much space you devote to each area within your photograph (**Figure 4.12**). This space is strongly affected by your height and angle of view toward the landscape. I think it's fun to see some of the old photographs of Ansel Adams standing on top of his car. He actually had a platform there where he could set up a tripod and get some height to the landscape. He did this deliberately to spread out the relationships of foreground to middle ground to background.

FIGURE 4.12
This image is totally about the relationship of foreground to background with a strong middle ground in between.

ISO 100
1/100 sec.
f/16
15mm
(APS-C)

Landscapes don't always look their best at our eye level. Changing your height to the landscape changes relationships in the composition. Sometimes even a slight change in height, whether that's lower or higher, will make a huge difference in how much shows up in the foreground, middle ground, and background of the picture.

Getting a higher view like Ansel Adams did might help you get better foreground-to-background relationship (**Figure 4.13**). Sometimes that, indeed, does give you the most interesting view of your landscape. Look around—you don't need a platform on top of your car. Sometimes a rise of only a couple feet can change what appears in your foreground. That can help you get rid of something that's distracting in the foreground or create more of a visual distance between foreground, middle ground, and background.

If conditions are right, you can even do a neat little trick with your camera and tripod to get a higher angle. Turn your self-timer on, and then hold your camera and tripod over your head to gain some height. This works pretty well with digital because you can quickly look at what you shot and decide if you need to change the positioning of the camera and tripod head to get a better photograph. It does require shooting with a fast enough shutter speed that you don't have problems with camera movement during exposure, though.

FIGURE 4.13
Climbing to the top of some rock-covered hills gave a great perspective on the Buttermilk Area near Bishop, California.

ISO 100
1/8 sec.
f/16
14mm
(Four Thirds)

Getting a higher view is not necessarily the only way to change these relationships. Sometimes it's more interesting to get a lower view, especially if you want to emphasize something unique in the foreground (**Figure 4.14**). So often, you'll see groups of photographers at a scenic location with their cameras all set up on tripods at eye level. That's convenient, but it isn't necessarily the best way to compose the scene. Sometimes the camera needs to be as low to the ground as possible.

You also can do another neat little trick with your camera in some locations where you think a low angle might be really great, but you can't actually get there. Instead of raising the camera and tripod up high, try it down low. I've put my camera on self-timer and then held my tripod over the edge of a bridge to get a lower angle.

The point is that you need to look for angles as a way of affecting your foreground, middle ground, and background relationships. And go beyond height. Often it helps to move left or right, either avoiding certain things in the foreground or adding other interesting foreground elements to your composition.

FIGURE 4.14
A low angle emphasizes the penstemon flowers in the foreground of this stark Yosemite National Park granite dome.

ISO 200
1/350 sec.
f/13
12mm
(Four Thirds)

USE YOUR EDGES EFFECTIVELY

The edges of your composition are critical because they provide a window for how the viewer sees the landscape. Often photographers think of the rule of thirds as simply the thirds lines and their intersections, but those thirds don't exist without the edges of your picture.

The edges of a composition are easily neglected. Because we have a tendency to focus strongly on the most important parts of the scene, we don't always look at the edges. Yet what happens at the edge is visually quite important because the edge of your picture is such a dominant part of it—after all, it defines where the picture begins and where it ends.

Frequently what happens is that things just end up somewhere near the edge without your making a conscious decision as to how to place visual elements relative to that edge. That can be a mistake because visual elements can be weaker or stronger depending on their relationship to the edge.

Use edges deliberately. Check the edges of your photograph and see what's happening there. If you have an important visual element in your composition, watch what happens to it as it gets close to the edge. Usually you want to give a little bit of space so that the object floats free of the edge (**Figure 4.15**), or you want to use the edge to deliberately and definitively cut through the object at the edge (**Figure 4.16**). These two different ways of relating an object to the edge of the image give very different results.

A very awkward way of using an edge in a composition is to have a visual element just touching or being close to touching it (**Figure 4.17**). That uncomfortably ties the visual element down to the edge because the viewer isn't sure how to look at it. It also can tie part of the picture to the edge of the picture where it shouldn't be attached. Viewers want you, as the photographer, to help them understand your landscape, and you'll communicate most clearly if you use the edges very deliberately.

One way of seeing this is to look at a patch of flowers in the foreground of a landscape. If you make sure to show the entire patch of flowers (using a distinct space around the flower patch between it and the edges of the composition), you'll be telling your viewer to look at these flowers as a distinct patch. The viewer will see the flowers as a contained area of flowers. But if you get in closer to these flowers and cut off the bottom left and right sides of the flower patch with the edges of your composition (**Figure 4.18**), the flowers will fill the foreground of your image. The viewer won't know that this is a small patch of flowers and you're giving an impression of lots of flowers. These two very different ways of handling the same patch of flowers change the way that the viewer perceives this landscape.

ISO 100
1/10 sec.
f/22
12mm
(Four Thirds)

FIGURE 4.15

In this desert scene in the Lake Mead National Recreation Area outside of Las Vegas, the cacti are separated from the edge of the frame to create a distinct visual group that then relates to the background.

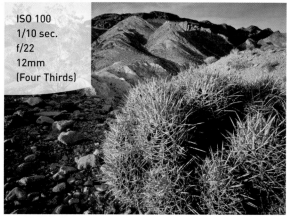

ISO 100
1/10 sec.
f/22
12mm
(Four Thirds)

FIGURE 4.16

For this image, the cacti are deliberately cut by the edge of the composition, creating a dramatic and bold look at this stark landscape.

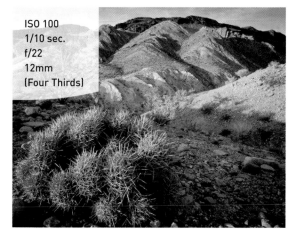

ISO 100
1/10 sec.
f/22
12mm
(Four Thirds)

FIGURE 4.17

This is the same photo as Figure 4.15, but now it's cropped to show an awkward relationship of the cacti to the edge.

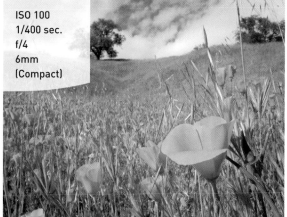

ISO 100
1/400 sec.
f/4
6mm
(Compact)

FIGURE 4.18

Is this landscape filled with California poppies? By using the edges to cut into the patch of poppies, the photo gives that impression.

WATCH FOR DISTRACTIONS

Sometimes when we concentrate on a beautiful scene, we see the impression of the scene but we don't see small distracting details (**Figure 4.19**). This can be a problem especially around the edges of the photograph, yet distractions along the edges can be extremely challenging for a composition. Things end up there and start pulling our eyes toward them instead of toward what is really important in the picture. All of a sudden, the composition has changed because the viewer is seeing relationships very differently. Unfortunately, the viewer starts to see relationships of those distractions to the rest of the picture.

When I see distractions coming in around the edges of the picture in my LCD review, I'll usually retake the picture by reframing the composition to get rid of them. Yes, I could crop out those distractions later when the picture is in the computer. But my feeling is that if I miss the distraction, what else might I have missed when I was taking the picture? Therefore, I want to reframe and more carefully look at the picture to be sure that I really do have the composition I want.

Two things to be especially careful of when you're looking for distractions are bright areas away from important parts of your composition and high-contrast areas along the edges of the picture. Bright areas and contrasty areas will always attract the viewer's eye away from anything else in the picture.

FIGURE 4.19
A bit of out-of-focus branch along the edge of the photo is a big distraction for this scene.

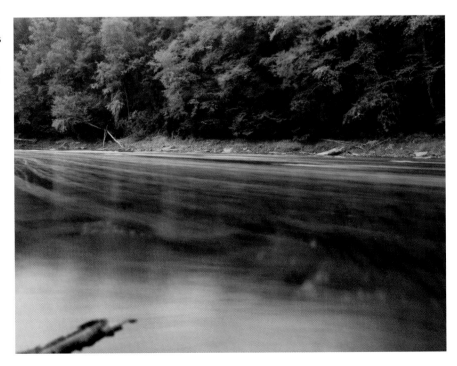

Long ago, I had an instructor who was very tough about looking at edges. I had to learn to always scan the edges of my image as I took the picture or I would definitely hear about it. Edges are frequently where those distractions come in, but as you read earlier, edges also are important for the way they interact with the overall composition. You can teach yourself to quickly scan the edges of your photograph and make this a habit.

Distractions for your composition don't just come from the edges. Any really bright or contrasty area, for example, is going to attract attention from your viewer. If you don't want the viewer's attention in that part of the picture, that's a problem.

Another distraction for composition is a sign. Sometimes photographers will deliberately include signs from a location in the picture to identify the location, or a sign creeps into the composition because the photographer wanted to show a big area. Signs are a problem because they're designed to attract attention. And anytime you have a sign in a photograph, viewers will try to read it. If you need a sign for a location, focus on the sign and don't try to include it with the landscape.

VALUING YOUR POINT OF VIEW

I've watched photographers come to a beautiful landscape in a national park and simply set up their cameras and tripods in the most direct view of the scene. Simply setting up in the most obvious spot is why so much landscape photography looks the same.

You have a unique view of the world—I believe that everybody does. Yes, I understand that some photographers like to go out and "trophy-hunt" landscapes. They just want to go to famous landscapes and take their own pictures of that landscape.

I don't have a problem with that basic idea. I love to go to beautiful locations that I've seen in other photographs, too. But I have a unique way of looking at the landscape and so do you. There are things that impress us about a particular landscape that may or may not impress someone else. I think this unique point of view is important.

Think about this: Not everyone will go to the landscapes that you photograph. As a landscape photographer, you're showing off the world that excites you. You and I are the eyes of so many other people. If all we do is duplicate images that other photographers have taken, our eyes and our points of view are diminished. The world has lost the opportunity to see something special that you and I can offer.

I know, you might be thinking, "But I'm just a simple photographer—I'm not a pro. What difference does it make?" I think it makes all the difference in the world. You see the world differently from the way I see it, differently from the way anyone else

sees it. And your point of view is valid and important because it enriches all of us when we have a diversity of views of our landscapes. It makes you and the landscapes more important.

So, just being aware that you have the potential of seeing this landscape with fresh eyes will help you start seeing your compositions better. Your choices about composition define both how you see the landscape for your photograph and how any viewers of your photograph will see that landscape. You're influencing other people's views of the world.

Chapter 4 Assignments

Get Out of the Middle

A great way to help you avoid middle compositions is to go out and spend some time photographing a scene where every picture keeps "important stuff" out of the middle of the photograph. Work at it. Consciously place things in your composition that are away from the center of the frame. As you do this, watch your background, too. Be sure that you don't have a horizon going through the middle when you've worked so hard to put a tree on one side of the image or the other.

Sky versus Ground

For this assignment, find a location where you have a strong horizon between sky and ground. Take a series of pictures of this scene as you vary the position of the horizon. Try taking a picture with the horizon at the bottom of the frame, and then try the same scene with the horizon at the top of the frame. Take a look at your images and see how that changed composition affects how you feel about and perceive the location.

Big Foreground

One way to help you explore the relationships of foreground to the rest of the picture is to find a location with a very interesting foreground. Take a series of pictures of this scene as you move closer to or farther away from that foreground. What you're trying to do is change the relationship of that foreground to the background because of the size of the foreground in your photo. You may need to use a wide-angle lens when you get very close to your foreground.

Work the Edges

Years ago, I took a workshop with the great Ernst Haas. He suggested an exercise that is excellent for learning to check your edges; plus, it's a bit of a challenge. Go out and look for compositions that use only the edge for important pictorial details. In other words, the middle is the only space to support those detailed edges. This isn't an easy exercise to do, but even if you fail to find perfect edges, you'll succeed in becoming a better photographer because you'll be learning to work better with edges.

Share your results with the book's Flickr group!

Join the group here: www.flickr.com/groups/LandscapesfromSnapshotstoGreatShots

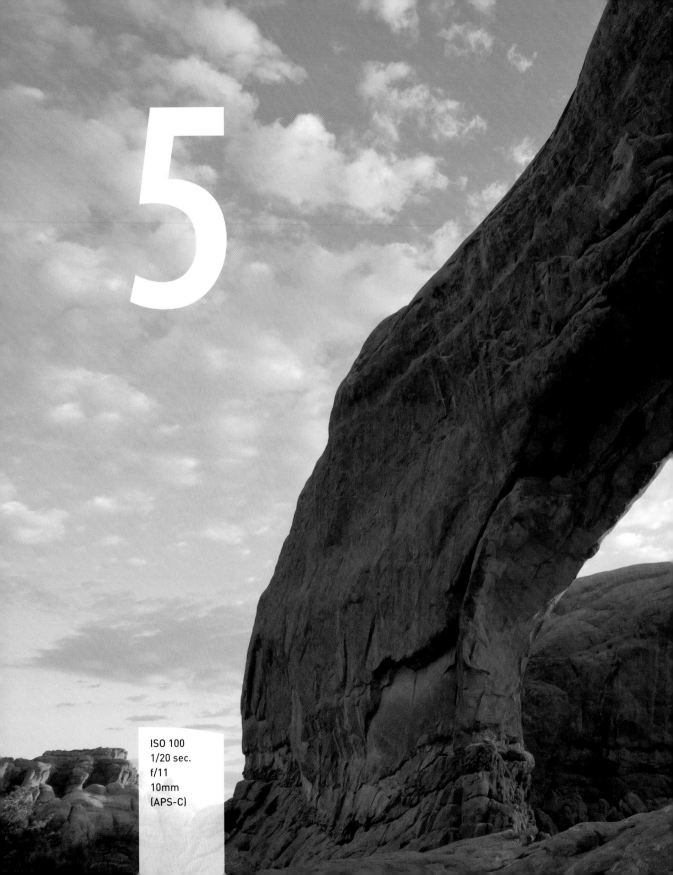

5

ISO 100
1/20 sec.
f/11
10mm
(APS-C)

Perspective, Space, and Depth of Field

GAINING CONTROL BY CHANGING LENSES, POSITIONS, AND APERTURES

The zoom lens has been a great boon for photographers. It lets you quickly change focal lengths to zoom in or out of your scene. This allows you to get the framing you want for your composition quite readily.

But the zoom also may have become a drag on creative picture control. Before zooms, photographers had to move their position and change lenses. Changing your camera position so you can use a particular focal length is very different from simply standing in one place and zooming in or out. Zooming is essentially cropping, and you could get similar results by cropping your photo in the computer. You can't get anything similar to a change in both camera position and focal length.

In this chapter, you'll learn about how you can use focal length creatively to control your view of the landscape, why it matters where you are in relationship to the landscape, and how lenses and other factors affect depth of field.

PORING OVER THE PICTURE

The Santa Monica Mountains are a great location for landscape photography close to the large population of Los Angeles, yet you see few photographers there. It's a "secret" location for stunning landscapes, and it's exceptionally accessible. This shot was made at dawn from Castro Crest. This color lasts only for a brief time, just as the sun rises. The photo isn't simply about the location. It's also about color, tone, and form, defined by the use of a telephoto lens.

The sun stays at the horizon very briefly as it rises, so you have to shoot quickly as the colors change.

The nearly black foreground ridge helps give a three-dimensional quality to the image.

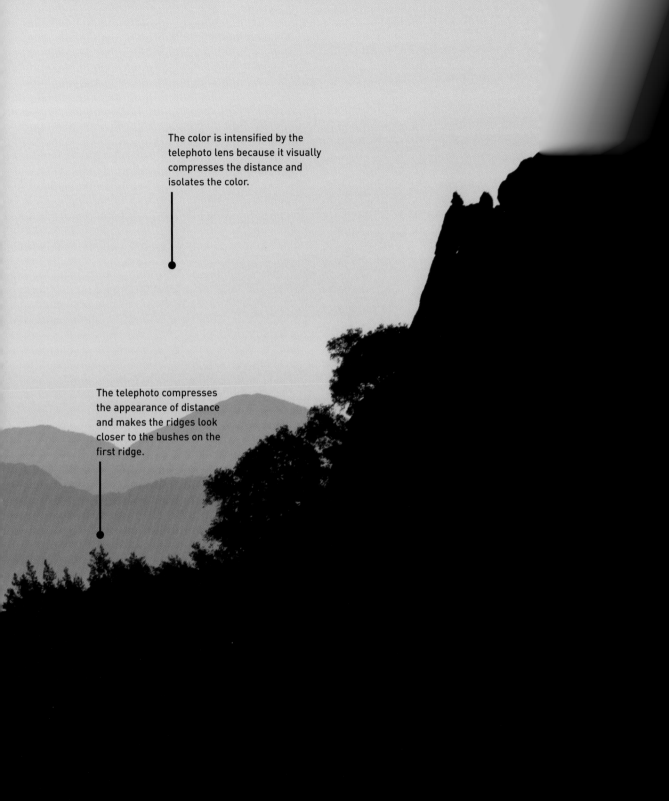

The color is intensified by the telephoto lens because it visually compresses the distance and isolates the color.

The telephoto compresses the appearance of distance and makes the ridges look closer to the bushes on the first ridge.

PORING OVER THE PICTURE

This is another photo from the same area of the Santa Monica Mountains to offer a distinctly different view of the place. Here, I used a very wide-angle lens to expand my view of the landscape and to give this wonderful feeling of space. In this image, the "distant" ridge is half a mile away, at the most. In the previous photo, the distant ridges truly are distant, many miles away. These two images show the expressive power of lens choice.

The lower part of the scene, the more distant part of the landscape, is kept deliberately very low in the image to give a more expansive feeling to the space.

A wide-angle lens stretches the distance from foreground to background.

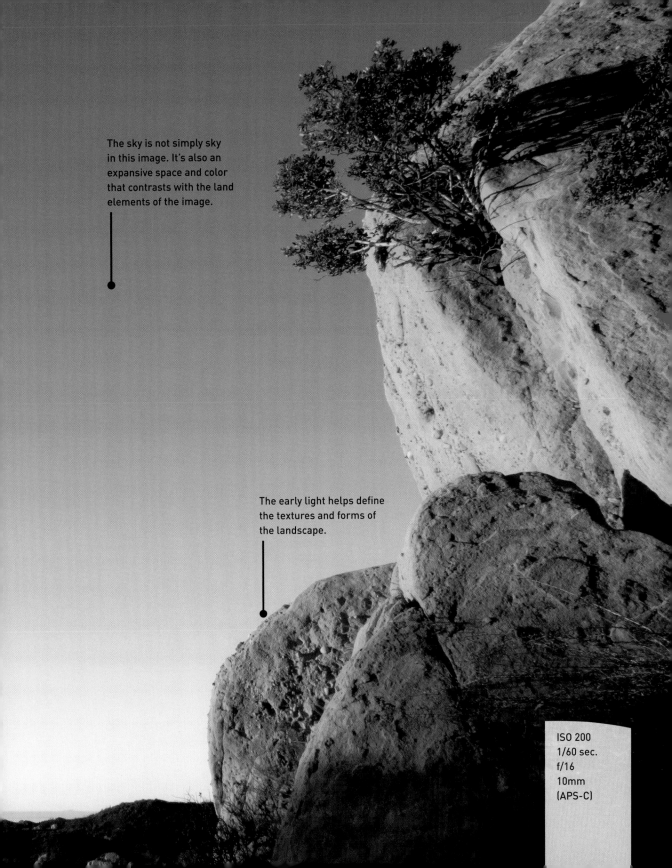

The sky is not simply sky in this image. It's also an expansive space and color that contrasts with the land elements of the image.

The early light helps define the textures and forms of the landscape.

ISO 200
1/60 sec.
f/16
10mm
(APS-C)

PERSPECTIVE

Perspective has long been an important part of landscape painting and other art. It's well understood in the art world, but it's less often discussed in photography. And yet perspective is a very important part of landscape photography.

According to the *Oxford English Dictionary,* perspective is "the art of representing things in the picture so that they seem to have height, width, depth, and relative distance." Basically, this means that objects in a picture have a feeling of dimension and appear to be in some sort of spatial arrangement, which is a challenge for any two-dimensional medium.

You can quickly see perspective when you look at size relationships of things in a landscape. If two rocks are the same size and they're right next to each other, they'll look to be the same size. If you move one of those rocks away from you, the closer rock will now appear bigger than the more distant rock. The farther you move the rock away, the smaller it appears.

The relationship between sizes is an important way that we discern distance when we're at a landscape, and it's something that helps us define distance within the photograph. The classic example of this comes from telephone poles alongside a road heading off into the distance. We know that these telephone poles are the same size, but we also know that they're heading off into the distance because they appear to get smaller.

Another aspect of perspective is something called receding lines. Imagine you're standing in the middle of some railroad tracks and looking toward the distance. The tracks where you're standing will have a certain width, but they quickly narrow to a point as they extend toward the distance. Of course, the tracks are always the same distance apart, but they appear to narrow to a point because of the way they recede into the distance.

Perspective goes beyond receding lines and relative size for the photographer. If you get closer to a foreground object, such as flowers (**Figure 5.1**), that foreground object will appear much larger. It also will look like that object is closer to you relative to the rest of the scene (because, of course, it is), but what's important about this is that it makes more distant things look farther away.

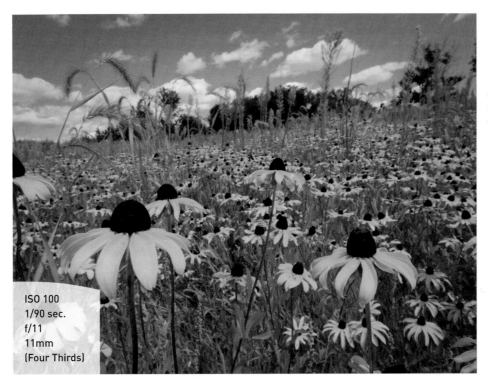

ISO 100
1/90 sec.
f/11
11mm
(Four Thirds)

FIGURE 5.1
In this image of
Black-eyed Susans
in a Minnesota
prairie, the flowers
appear to change in
size from foreground
to background
because of
perspective.

HOW TO CHANGE PERSPECTIVE

As a photographer, you can change the perspective of a landscape in your photo. This is an important control that today's photographers usually don't use enough of. Yet it offers such amazing results when you understand how to change perspective in your images.

Perspective changes when you change your angle to the scene and when you move closer or farther away from prominent pictorial elements in your photograph.

CHANGING YOUR ANGLE TO THE SCENE

In any landscape, you might have things such as the line of a river, groups of trees, rocky cliffs, and so on. You can photograph any of these things straight on—in other words, with your camera parallel to the scene in front of you so that everything is at about the same distance.

That creates a flat perspective because you don't see things changing in depth. For example, if you photograph a cliff that crosses left to right in front of you at the same distance, there is no feeling of perspective with that cliff because it doesn't go off into the distance (**Figure 5.2**). On the other hand, if you change your camera position so that you can see the landscape going off into the distance (**Figure 5.3**), you get a distinct perspective change. The same thing would happen with a stand of trees, a river, a band of flowers, and so forth.

FIGURE 5.2
This cliff along Lake Superior's North Shore in Minnesota has a flat perspective because it's all at a similar distance from the camera position.

ISO 100
1/125 sec.
f/8
200mm
(APS-C)

FIGURE 5.3
Here's a different view showing rocks at dawn's first light along Lake Superior's North Shore. This landscape has a deep perspective because there is a strong change from foreground to background as the rocks go off into the distance.

ISO 100
1/20 sec.
f/8
6mm
(compact)

There is no right or wrong for dealing with this aspect of perspective. What do you want from your photograph and your scene? You create a flatter-looking, sometimes abstract-looking composition when you're flat on to your subject so that there is no feeling of going off into the distance. On the other hand, you gain that feeling of depth and space when you change your position so that you can see something from foreground to background that's changing as it goes into the distance.

CHANGING YOUR DISTANCE TO THE SUBJECT

The other way that you change perspective is by getting in closer to your foreground or farther away. As you get closer to your foreground, you'll need to use a wider-angle lens in order to keep seeing the same foreground. If you back up from your foreground, you'll need a telephoto lens in order to maintain the same size of your foreground.

That's important to keep in mind: You're changing perspective by both changing your camera position relative to the scene and changing your focal length. You can't simply do one or the other. You'll use a wide-angle lens up close and a telephoto lens farther away.

This offers you tremendous control over what the landscape looks like. You can greatly affect the feeling of space as you change your perspective. When you get in close with a wide-angle lens, you create a feeling of great depth **(Figure 5.4)**. When you back up and shoot the landscape from afar with a telephoto lens, you flatten perspective and make things seem much closer together **(Figure 5.5)**.

ISO 100
1/90 sec.
f/16
10mm
(APS-C)

FIGURE 5.4
By showing the close parts of this scene with a wide-angle lens, I was able to give a strong feeling of depth going back to the photographer at Kelso Dunes in the Mojave National Preserve in California.

FIGURE 5.5
In this image,
I used a telephoto
lens to work with
a foreground-
background rela-
tionship that was
farther away from
me. The distance
makes a difference,
as does the use of
a telephoto lens.

ISO 100
1/90 sec.
f/16
80mm
(APS-C)

It is important to understand that this perspective change doesn't mean simply using a wide-angle or telephoto lens. There must be a relative change in camera position in order for you to gain the change of perspective that occurs from getting closer to or farther away from your foreground. From one camera position, for example, you may be able to use a telephoto lens to create a flatter perspective on a distance scene. A wide-angle lens from that same position won't show you the same scene in your camera so you don't get a change in perspective on that scene.

THE CHALLENGE OF THE ZOOM

Zoom lenses are wonderful accessories for photographers. As you saw in Chapter 1, they're an important part of my equipment. However, they've caused a problem for photographers: Zoom lenses make it easy to change your composition of a scene from one camera position. That tool can be very important for your composition, but it doesn't allow you to gain the perspective controls that I'm talking about here.

In the days before zooms, photographers had to change where they stood in order to properly frame a particular scene. They got used to moving. Their feet were their zooms! They also quickly learned that, as they moved their camera positions, they also changed how perspective was captured by their cameras.

I've seen so many photographers at great landscape locations simply set up their cameras in one place and then zoom until they get the pictures they like. They're missing such a great opportunity to control the perspective and depth of the image!

To get started in thinking differently about your use of focal length, think of it this way:

- **Use a wide-angle lens up close.** Use a wide-angle lens when you're up close to a foreground that's important to your composition (**Figure 5.6**).

- **Use a telephoto lens from a distance.** Use a telephoto lens when you're far away (**Figure 5.7**).

- **Look for perspective changes.** If you start looking for perspective changes because of your camera position and focal length, you'll find that you'll have a very different look with even a single zoom lens by simply getting in close with the wide-angle setting and then backing up with the telephoto setting.

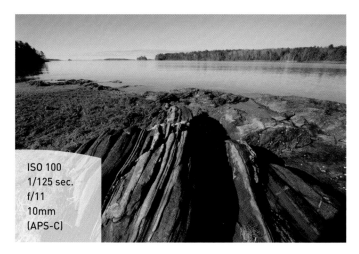

ISO 100
1/125 sec.
f/11
10mm
(APS-C)

FIGURE 5.6
I was within feet of the rocks of the shoreline of this Maine ocean bay. I used a wide-angle lens to help capture a deep perspective.

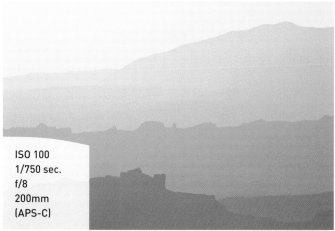

ISO 100
1/750 sec.
f/8
200mm
(APS-C)

FIGURE 5.7
For this photo, I used a telephoto lens, but I was miles from the closest part of this dawn scene in Utah's Canyonlands National Park. Even though the ridges are much farther apart than the shorelines from Maine, the perspective is flattened, making them visually closer.

So often, photographers simply use a wide-angle lens to show a lot of the scene and a telephoto lens to show just a little piece of the scene. There's nothing wrong with that, but that's about cropping your scene for composition—you can get the same effect if you crop your image in the computer. It isn't a perspective change because you aren't actually changing any perspective in the picture. The perspective stays the same whether the image is cropped or not. (Of course, I don't recommend that you simply crop instead of zooming because you'll have a quality loss the more you crop.)

HOW TO SHIFT THE EMPHASIS ON THE FOREGROUND

Foregrounds are very important to landscape photography. You learned a bit about using foregrounds in Chapter 4. With your ability to control space and perspective in a photograph by changing your lens and camera position, you can have a great effect on how the foreground is emphasized in your composition.

Wide-angle lenses pick up more foreground (**Figure 5.8**). This is something that you'll immediately notice as you use wide-angle focal lengths more—an important reason for using a wide-angle lens. As you zoom out wider, look at what's happening to your foreground. This often means that you need to tilt your camera down more so that you can use this new emphasis on the foreground.

FIGURE 5.8
The foreground dominates this desert landscape in the Mojave National Preserve because of my use of a very wide-angle lens and because I put the camera down low to the foreground.

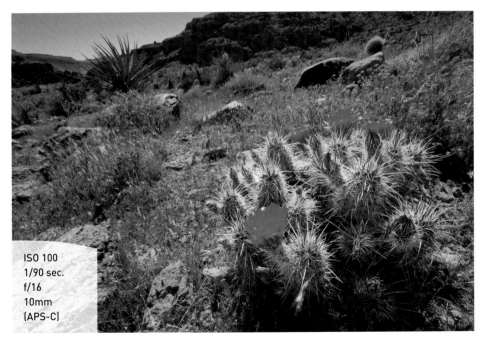

ISO 100
1/90 sec.
f/16
10mm
(APS-C)

When you're using a wide-angle lens, make sure that you don't inadvertently pick up too much sky. Big, spacious skies can be very interesting if the skies deserve the attention. But often, it's that dramatic relationship of foreground to background that makes a wide-angle lens so effective with landscapes.

Telephoto lenses tend to deemphasize foreground (**Figure 5.9**). They strongly emphasize distance relationships, compressing them so that distances don't seem as great. It's possible to have foreground in a shot with a telephoto, but there are some challenges, including depth of field. One effective way of using a foreground with a telephoto lens is to use that foreground as a frame for the rest of the scene.

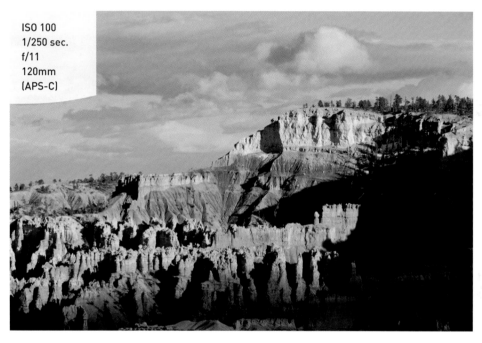

ISO 100
1/250 sec.
f/11
120mm
(APS-C)

FIGURE 5.9
In this image of Utah's Bryce Canyon National Park, there is no real foreground. Everything looks to be at about the same distance from the camera even though it actually isn't. The telephoto lens creates this type of relationship from foreground to background.

As you change focal length from wide angle to telephoto, watch how the emphasis on the foreground starts to decline, no matter what you do. Be aware of that and use it as a way of controlling your composition.

HOW TO MAGNIFY AND SHRINK BACKGROUNDS

You might have thought that Photoshop manipulation was the only way to control the size of a background relative to the rest of the picture. But lenses and an understanding of perspective let you do just that without Photoshop! This is another important control for you to use in creating an effective landscape image.

Briefly, it works like this:

- Wide-angles shrink backgrounds.
- Telephotos magnify backgrounds.

Of course, you can figure that out intuitively. Put on a wide-angle lens, and the whole scene gets smaller so that more of it fits into your image area. Change to a telephoto focal length and the whole scene gets bigger so that less of it fits into your image area.

Now add in the idea of perspective—the idea that foreground and background relationships change and matter. When you decide that you like a foreground, change your camera position to affect the relative size of the background. Put on a wide-angle lens and get close to that foreground. The foreground can stay the same size, but the background will shrink dramatically.

On the other hand, if you put on a telephoto lens and back up so that the foreground is about the same size as it was to start, your background will look dramatically larger—and you'll see less of that background.

This is why I find results like what you see in Figures 5.10 and 5.11 so fascinating. You can see from **Figure 5.10** that this is at the edge of a big drop into a canyon. You can't get physically closer to the rock formations in the background. But in **Figure 5.11**, you still see the foreground (the rocks at the lower left are an extension of the same rocks as in Figure 5.10), but the background looks like it's much closer because it has been magnified so much in relation to the foreground.

FIGURE 5.10
You can see that it's impossible to get any closer to the background in this image of Canyonlands National Park.

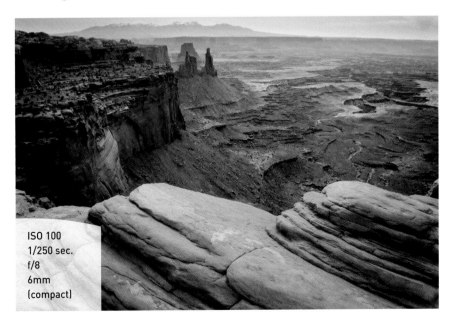

ISO 100
1/250 sec.
f/8
6mm
(compact)

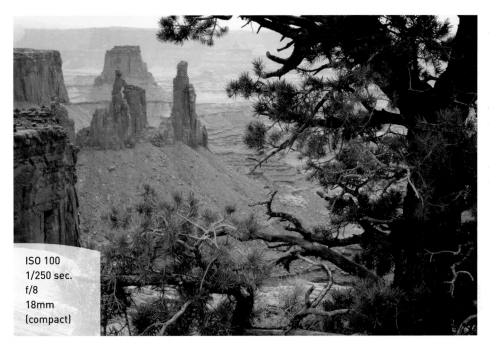

ISO 100
1/250 sec.
f/8
18mm
(compact)

FIGURE 5.11
Yet, in this image
taken just to the
right of Figure 5.10,
the background is
magnified as if I
were much closer
to it. These two
images clearly show
how lenses change
the visual size of
the background.

Simply showing the background of both shots without foreground wouldn't give you this impression. By including the foreground in both images, the distance relationships—the perspective—change because of the change in focal length.

DEPTH OF FIELD

Another important control for landscape photography is depth of field, the amount of sharpness in a scene, from close to the camera into the distance away from the camera (**Figure 5.12**). It's sharpness in depth. (It isn't called depth of sharpness because *depth of sharpness* is a technical term used in optics that means something different.)

Many photographers know that more depth of field comes from a smaller aperture. Using a smaller aperture is one way of getting depth of field, but it isn't always the best choice for the landscape photographer. Automatically setting something like f/16 or f/22 won't necessarily give you the best results.

Depth of field is affected by three main things:

- Aperture (f-stop)
- Distance to the subject
- Focal length

FIGURE 5.12
The deep depth of field in this scene from Nevada's Valley of Fire State Park holds sharpness from foreground to background.

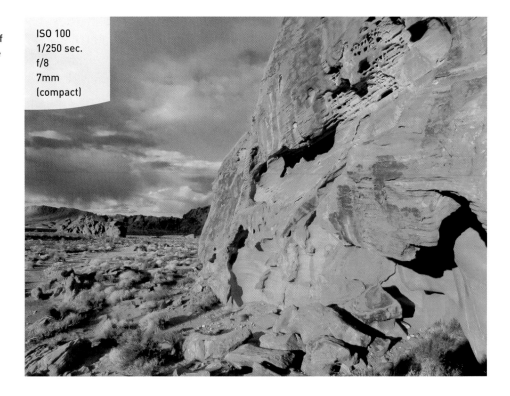

ISO 100
1/250 sec.
f/8
7mm
(compact)

APERTURE

Your choice of aperture has a big influence on depth of field in the picture. However, it's important to keep in mind that there are times when changing your f-stop will have no effect on the depth of field of the landscape. (I'll explain this concept in the sections on distance and focal length.)

An f-stop represents an opening inside the lens that allows light to pass through the lens. Technically, aperture is the actual opening inside the lens, whereas f-stop is the label for that aperture. However, in common usage, the terms *aperture* and *f-stop* are used interchangeably.

On all but a few specialized lenses, you can change f-stops to control how much light is allowed to go through the lens. The sharpness of a lens is affected by how it controls the light going through the lens and is influenced by the f-stop.

Exposure is based on the relationship between f-stop and shutter speed. The relationship is direct: If you add more light through the lens (with a larger aperture), you have to shorten the time the light hits the sensor or film (shutter speed) to keep exposure consistent. If you limit the light coming through the lens with a smaller aperture, you have to increase the time the light hits the sensor or film.

Shutter speed is fairly intuitive. You choose it based on using a setting that's fast enough to stop action, slow enough to blur action, or to balance an f-stop that you want. Unfortunately, aperture isn't quite so intuitive. Because f-stop seems to have a strange set of numbers, many photographers, understandably, get confused by them. Small numbers are used for large apertures and large numbers are used for small apertures. A big aperture (small number) lets through more light and gives less depth of field. A small aperture (big number) gives less light and more depth of field.

Here's a set of f-stops from f/2 to f/22:

f/2 f/2.8 f/4 f/5.6 f/8 f/11 f/16 f/22

Each of those is a full stop difference. The largest aperture is f/2, and the smallest is f/22. As you move from f/2 to f/22, you halve the light coming through the lens with each step. Move from f/22 to f/2 and you double the light coming through the lens with each step.

DISTANCE TO THE SUBJECT

Changing an f-stop alone does not necessarily mean you're going to get great depth of field. Nor does it mean that you need a small f-stop in order to get deep depth of field. You also have to factor in distance to the subject.

Distance to your focus point has a strong bearing on depth of field. As you focus closer to the camera, depth of field decreases dramatically. There is nothing you can do about this—it's simply how lenses work. You need to know about it, though. If you have an important foreground that's very close to you, you need to understand that it may not be possible to get everything from that foreground to the background in focus if you're focused on that foreground.

On the other hand, if you're far away from your subject—say, you're photographing a landscape at a distance—depth of field will always be deep, no matter what f-stop you use (**Figure 5.13**)! That's important to remember because it means you can use a moderate f-stop, such as f/8 or f/11, which then allows you to use a faster shutter speed or lower ISO setting. Lenses are typically at their sharpest at f/8 or f/11, so this is the best way to shoot such a scene.

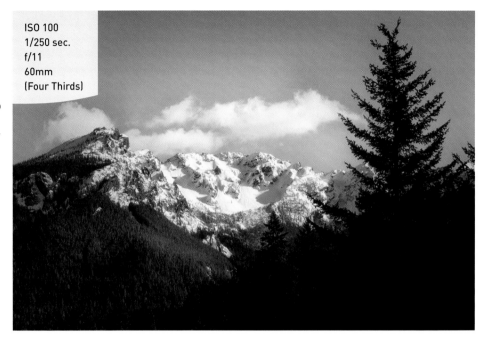

FIGURE 5.13
Nothing in this scene of Washington's Olympic Mountains is close to the camera, so any midrange f-stop gives the same results as a smaller f-stop.

ISO 100
1/250 sec.
f/11
60mm
(Four Thirds)

FOCAL LENGTH

Depth of field is strongly affected by focal length. You can even see it on your lens if your lens has distance markings. With a wide-angle lens, for example, you'll find that there are no distance markings beyond 10 feet or so. That's because once you go beyond such distances, focus and depth of field don't change much, regardless of the aperture used. On the other hand, with a telephoto lens, you'll find distance markings that go out to as far as 50 feet because now you have to focus much further out to reach this point of little change for focus and depth of field.

Remember: Telephoto focal lengths have less depth of field at any given setting, while wider focal lengths have more depth of field. This is true even if you're using a zoom lens. Your zoom at its wide-angle settings will have more apparent depth of field than the same lens at its telephoto settings. You can use that information to control depth of field in combination with the setting of f-stops and your distance to the subject (**Figure 5.14**).

The important thing to keep in mind is that small apertures will give you more depth of field. But wide-angle focal lengths have inherently more depth of field for an image regardless of aperture, compared to a telephoto. You often can get away with a wider aperture with a wide-angle lens than you can with a telephoto and still get a lot of depth of field.

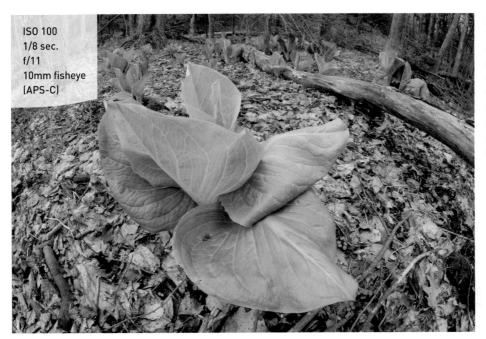

ISO 100
1/8 sec.
f/11
10mm fisheye
(APS-C)

FIGURE 5.14
This spring land-
scape of skunk
cabbage in Maine
was shot with a
very wide-angle
lens, which gave
an interesting per-
spective and deep
depth of field.

GOING FOR A DEEP DEPTH OF FIELD

Deep depth of field happens when most of your photograph is in focus, from the foreground to the background. Landscape photographers commonly use a deep depth of field, because it allows them to highlight detail throughout the photograph. They can capture the flowers in the foreground sharply, as well as the mountains in the background, for example.

Deep depth of field allows you to show off the complexity of a location. You can really emphasize textures, fine details, things up close, and things far away so that the viewer can understand more about the location (**Figure 5.15**). In many ways, deep depth of field is often about location and setting.

In order to get deep depth of field, you need to choose a small f-stop (typically around f/16). This aperture will give a maximum amount of depth of field with any lens you use. But—and this is a very important but—this is not the correct aperture for *all* landscape photography.

How small an f-stop you need depends a lot on both the format of your camera and the focal length of your lens. You may have a compact digital camera that fits in a pocket or small bag. When you look closely, you may notice that you have no choices

for f-stops less than f/8. This doesn't mean that you won't get deep depth of field. The very small, compact cameras use a very small lens, with a very short focal length, and the shorter the focal length, the more depth of field that you get. In addition, the lenses on these cameras are so small that f-stops get really tiny for settings such as f/16—so tiny that they *diffract* (bend) the light and cause unsharp images. That's why you rarely see f/16 on these cameras.

FIGURE 5.15
Deep depth of field is important for this summer landscape of yellow lupine in Northern California. It allows you to see the foreground plant, as well as location details equally.

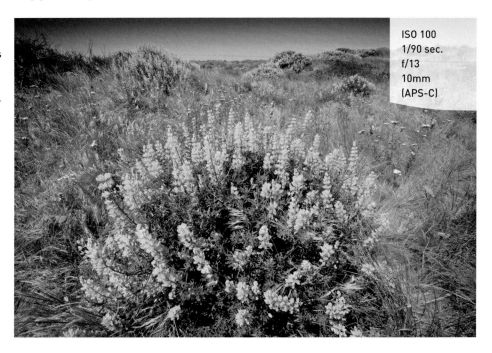

ISO 100
1/90 sec.
f/13
10mm
(APS-C)

In fact, diffraction effects have always caused problems with lens designers. Over the years, 35mm-camera lenses often have been made with very small apertures, yet those apertures often are more marketing gimmicks then usable controls. The lenses simply aren't sharp at something like f/32. This isn't to say that it isn't *possible* to make a lens with such an f-stop and have it be sharp; it's just not *easy* to do that with focal lengths used for formats of 35mm size and smaller.

Don't assume that your lenses work well at very small apertures even though you can set them to such apertures. I've had lenses that were sharp up to f/16 and then significantly lost sharpness when smaller apertures were used. I have a Sony lens for my NEX camera that is excellent to f/16. Even though it has a setting of f/32, that f-stop looks bad and is unusable. The only way of knowing how this applies to your gear is to test your lenses and see what they can do (**Figures 5.16** and **5.17**).

FIGURE 5.16
At the small size these images are reproduced here, you don't see much difference between them. The image on the left was shot at f/16; the one on the right at f/32.

FIGURE 5.17
These images don't have to be enlarged by much in order to see the difference. The f/32 image on the right is significantly softer than the f/16 image on the left.

THE SHUTTER-SPEED PROBLEM

There is a downside to using deep depth of field: you must use slower shutter speeds or higher ISO settings. With slower shutter speeds, you must have your camera on a tripod. Even on a tripod, you may have problems with movement of the subject, such as wind in a field of flowers. You may have no choice other than to shoot with a lot of depth of field and blur from wind, which can be a creative effect if used carefully (**Figure 5.18**), or else shoot with very little depth of field and at least have something in the scene sharp.

FIGURE 5.18
I shot this image of a Maine stream in twilight 20 minutes after sunset with a shutter speed of 30 seconds. That gave an interesting and attractive look to the water.

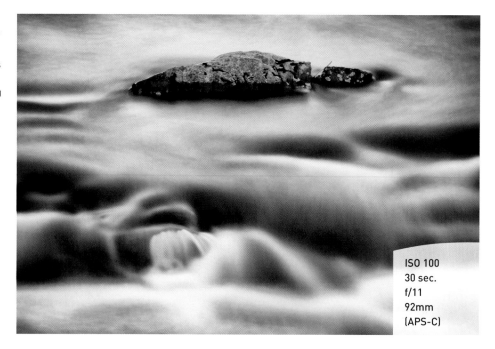

ISO 100
30 sec.
f/11
92mm
(APS-C)

Higher ISO settings are important, but they also come with the challenge of adding noise to your photograph. Still, if you really have to have depth of field and stop a moving subject, you may have no choice other than to use a higher ISO setting.

WHERE TO FOCUS

Depth of field starts one-third in front of your focus point and extends two-thirds behind. If you simply allow your camera to focus all by itself, it may focus on something inappropriate in your scene. I usually try to decide what's the most important part of the scene—that's what I want to be absolutely sure is in focus (**Figure 5.19**). This becomes more critical the closer you are to your focus point.

Sometimes I try focusing on a point and then use the Depth of Field Preview button on the camera to see where depth of field is working in the image. I know some people have trouble with the Depth of Field Preview, so you also can take a picture and look at the playback of that image to see if the depth of field covers the important parts of the subject.

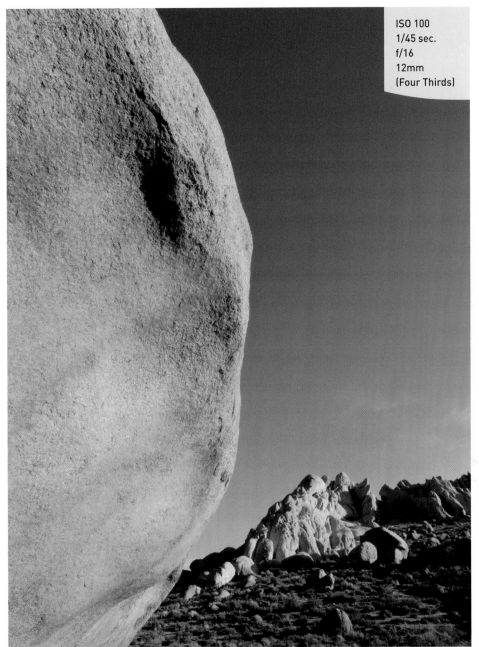

ISO 100
1/45 sec.
f/16
12mm
(Four Thirds)

FIGURE 5.19
The most important part of this landscape is the large boulder in the foreground, so I focused on it. I then used a wide focal length and a small aperture to ensure that the background also would be in focus.

HYPERFOCAL DISTANCE

You may hear the term *hyperfocal distance*. This is a distance that you can set your focus to that will give you the maximum depth of field going to infinity at a given aperture with a particular focal length. You used to be able to use the idea of hyperfocal distance with all lenses that had a depth-of-field scale engraved in the barrel of the lens, but lenses aren't built that way anymore. The only way that you can get a hyperfocal distance is to use a chart. This chart is even available as an app for an iPhone.

Hyperfocal distance may be a little too techie for most photographers (I find it a nuisance to work with), but it's a way of dealing with focus and deep depth of field.

Chapter 5 Assignments

Do the Perspective Shuffle

Find a landscape with a prominent foreground and background. Now take a series of photographs of this scene where you alternate between a wide focal length and a telephoto focal length for each shot. But don't stop by simply zooming from wide to telephoto and back. Instead, change your camera position. Get closer to the foreground with your wide-angle lens and then move back with your telephoto. Try to keep the same foreground even though the background changes. Then look at how much the background is changing in your photos.

Play with the Foreground

Change your focal length as you work with a landscape that has a strong foreground. Use a wide-angle lens to really emphasize that foreground and make it dominate the image. Then use a telephoto to either deemphasize or eliminate the foreground from the image. Notice how much control you gain over your landscape photograph by how you emphasize or deemphasize your foreground.

Experiment with Aperture

Find a distant landscape with little or nothing in the foreground. Shoot the scene with varied f-stops and look at the results. There will be little difference except you may find you get reduced sharpness at smaller apertures because you have to use a slower shutter speed that allows more camera movement during exposure. Then find a landscape with a prominent and interesting nearby foreground. Now shoot with a series of f-stops and again compare images. You'll see a difference this time.

Share your results with the book's Flickr group!

Join the group here: www.flickr.com/groups/LandscapesfromSnapshotstoGreatShots

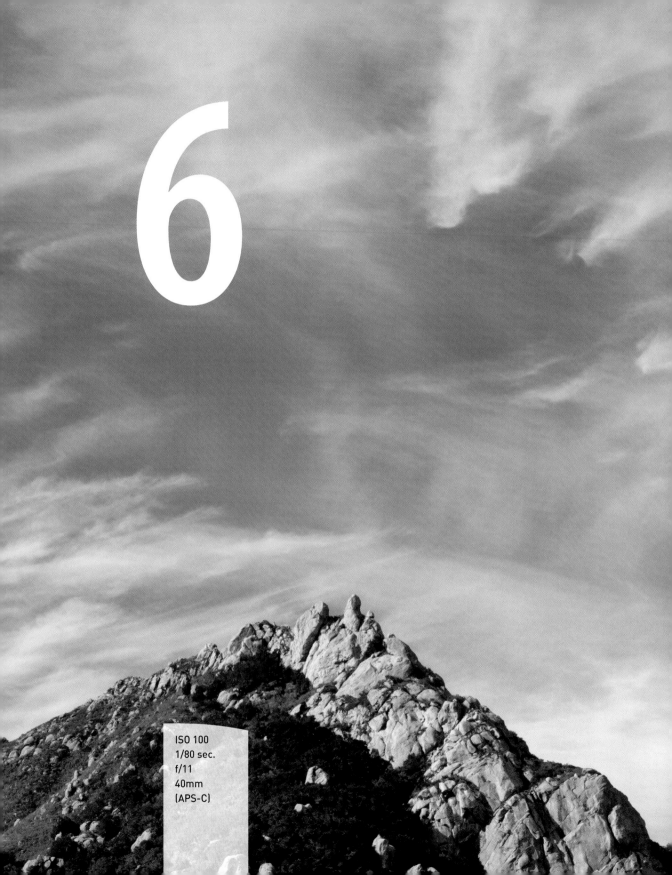

6

ISO 100
1/80 sec.
f/11
40mm
(APS-C)

Sky

WORKING TO BRING OUT THE BEST IN THE SKY

Landscapes are rarely just about the land. Often, the sky is as important as the rocks, mountains, trees, water, or whatever else is below the horizon. This isn't simply "having something interesting" in the sky, though that can help. It's also about a feeling of place. The sky interacts visually with the ground, affecting shadows and colors. The sky doesn't exist in isolation from the ground. That's why when people "add" a sky to a photo in Photoshop, it often doesn't look right.

In addition, weather isn't the same across the country, so skies vary dramatically over landscapes in different locations, giving those landscapes their unique visual nature. The sky over North Dakota will be different from the sky along the coast of California, which will be different from the sky over the Everglades in Florida, and so on.

In this chapter, I'll explore skies and landscapes so you can get better skies with your photos. I'll fill you in on how to bring out the best in skies, how to work with them in your composition, and when a sky just isn't worth the effort.

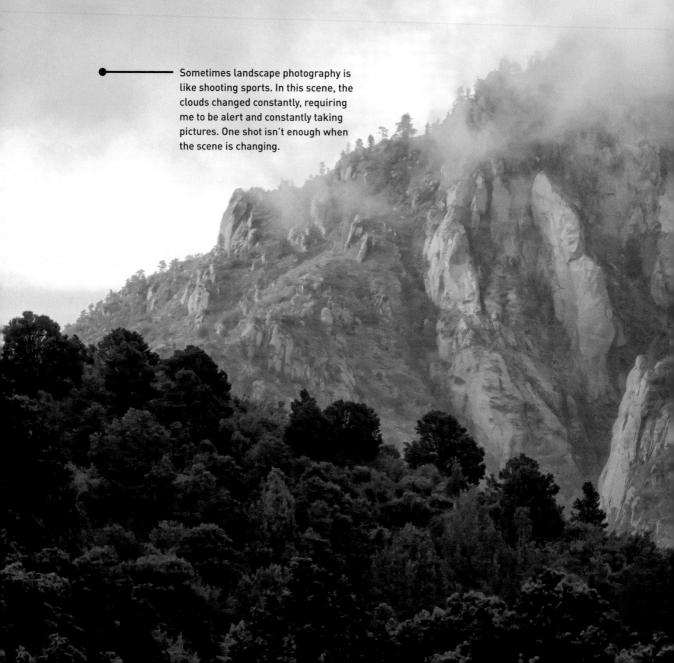

PORING OVER THE PICTURE

Utah's Zion National Park is a wonderful landscape location. In spring and fall, weather can change quickly, making it uncomfortable if you're not prepared, but also offering some amazing skies. This image was shot in the Kolob Canyon part of the park. This area is much less visited than the main section is, and it offers scenes of towering rock mountains and sky. This shot was taken as a rainstorm passed through the area.

Sometimes landscape photography is like shooting sports. In this scene, the clouds changed constantly, requiring me to be alert and constantly taking pictures. One shot isn't enough when the scene is changing.

The image here is about a mood created by weather and clouds as much as it's about the trees and rocky mountain.

Because everything is at a considerable distance from the camera, I could shoot at f/11. This allowed a faster shutter speed to ensure no camera movement during exposure, even though there was some wind causing vibration of the camera and lens on the tripod.

ISO 100
1/125 sec.
f/11
120mm
(APS-C)

PORING OVER THE PICTURE

The light on the fall cottonwoods and the sky really gave this scene in Castle Valley, Utah, a lively and dramatic look. This area is not far from Arches National Park and has a number of dramatic rock formations that look great contrasted with a bold sky. The image could have been limited to the rocks and sky, but the light allowed me to balance the lower part of the scene quite nicely with the sky.

The light also gives dimension and form to the clouds in the sky.

A small aperture was used to hold sharpness from foreground to background.

The shapes and textures of the trees are similar to the shapes and textures of many of the clouds, which also ties the top and bottom parts of the photo together.

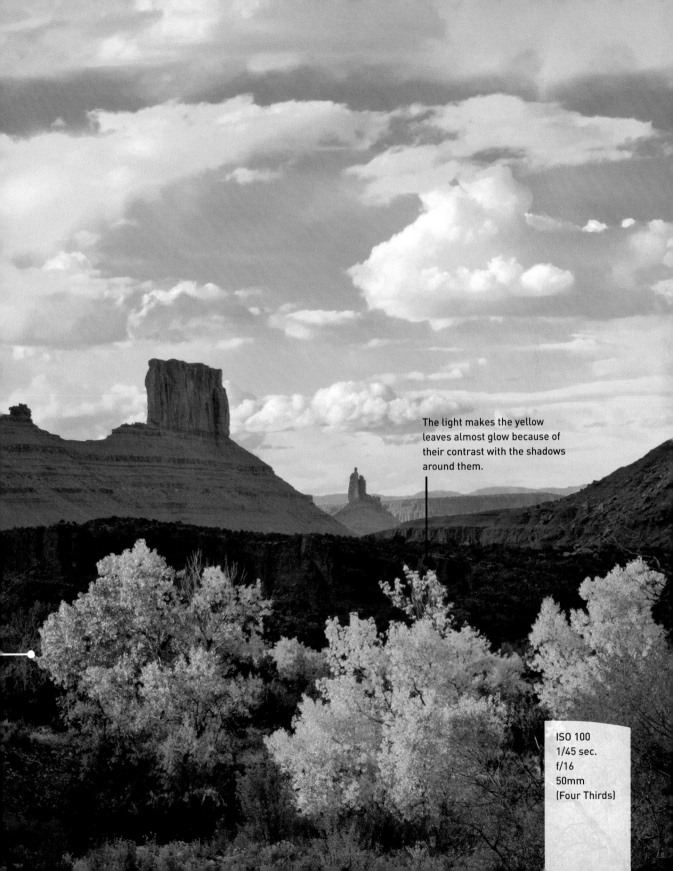

The light makes the yellow leaves almost glow because of their contrast with the shadows around them.

ISO 100
1/45 sec.
f/16
50mm
(Four Thirds)

DECIDING WHETHER THE SKY IS WORTH THE EFFORT

Sky can be a very important part of your landscape photography. But sky is not always the best thing for the photo. Skies can complement a landscape, but they also can detract from it. The wrong sky can be terribly distracting for an important landscape. On the other hand, the *right* sky can make a landscape lively and bold (**Figure 6.1**).

The key is to look at your sky and ask yourself two things:

- Is the sky appropriate for your landscape?

- Can your camera capture the sky?

ISO 100
1/30 sec.
f/11
30mm
(APS-C)

IS THE SKY APPROPRIATE FOR YOUR LANDSCAPE?

Sometimes it's easier to identify when skies are *not* appropriate for a landscape:

- **Blank skies:** Sometimes skies are just blank and boring (**Figure 6.2**). There's nothing interesting about the sky. This is especially true when you have neither a bright blue sky nor bold and defined clouds. Avoid blank skies whenever you can. Sometimes you need a sliver of sky to define the top part of a landscape, but don't use any more than you have to.

- **Bright areas along edges:** One thing to remember is that very bright and high-contrast areas will always attract the viewer's eye away from other parts of the picture (**Figure 6.3**). If bright clouds are along the edges of the composition but nowhere else, they'll be a distraction and keep the viewer from experiencing the landscape the way you composed it.

- **Dull clouds:** Dramatic clouds can be a great addition to a landscape photograph. But dull, ill-defined clouds create an unappealing backdrop for your landscape. Days with such clouds also give poor landscape light.

ISO 100
1/15 sec.
f/9.5
300mm
(APS-C)

FIGURE 6.2
A blank sky takes away from this oak-tree landscape in Central California.

ISO 100
1/125 sec.
f/16
100mm
(APS-C)

FIGURE 6.3
The bright cloud at the lower left is distracting when compared to the rest of the photograph of a mountain in Utah's Zion National Park.

CAN YOUR CAMERA CAPTURE THE SKY?

The other challenge for skies is that we can see skies perfectly fine in all kinds of light, but our cameras can't. In Chapter 2, you learned about the difference between the way that cameras see the world compared to the way we see the world. This can be especially true of skies. You have to be careful that you're seeing something that the camera is capable of recording. Check your LCD to be sure that the sky is actually looking reasonable as a sky.

Remember: You don't have to include a sky in a landscape picture if it doesn't work for your landscape (**Figure 6.4**). In fact, including a bad sky with your landscape will make the whole landscape picture look worse.

Consider this: As a photographer, you make many choices—from what lens to use to how to compose the image to your aperture choice, and so forth. A very important choice that you need to make is whether to take the picture. Some scenes simply won't work well as a landscape photograph. As a photographer, you always have the choice to say no to the scene in front of you. When you realize that you have the ability to say no to that scene, no matter how attractive it looks in real life, that will free you to find the photographs that you can say yes to.

FIGURE 6.4
This pastoral landscape in southern England needs no sky, which is a good thing since the original scene had a dull, gray, formless sky.

ISO 400
1/750 sec.
f/4
90mm
(Four Thirds)

USING SKY EFFECTIVELY IN A COMPOSITION

In Chapter 4, you learned a lot about composition and landscape photography. Skies can play a key role in composition. All the things that you learned about the rule of thirds and use of space in the composition are quite important when you're considering how to use the sky in your composition.

Be careful that you don't arbitrarily use sky to fit the rule of thirds so that one-third of your picture is landscape and two-thirds are sky. I'm not suggesting following the rule of thirds is wrong—sometimes it's exactly right. I'm just suggesting that arbitrarily trying to put every landscape into that formula will yield less-than-optimum skies in your landscapes or even less than an optimum composition.

Decide what the sky means to your image. If the sky is bold and beautiful and dominates the scene, use it. Don't be afraid to fill up your composition with sky (**Figure 6.5**) and use only a small part of landscape to show the viewer where the picture is from. This is one place where you don't want to be blindly following the rule of thirds because you may be losing some great sky.

On the other hand, if it's truly the landscape and all its detail that's important, don't show much sky. That's true even if the sky is bold and beautiful. In fact, a bold and beautiful sky can be distracting from the landscape if the landscape itself is what matters most.

ISO 100
1/30 sec.
f/16
10mm
(APS-C)

FIGURE 6.5
A cypress swamp in southern Florida at sunrise looks good with most of the image, a glorious sky.

You can even totally remove sky from a landscape photograph. Sometimes the landscape just looks better that way. However, you'll often find that having even just a little sliver of sky, especially if it's toward one corner or the other of the composition, will give the composition a greater feeling of depth (**Figure 6.6**). The great color landscape photographer of the mid-twentieth century Eliot Porter often shot intimate landscapes on cloudy days where the sky was not attractive, but he often would include a little piece of sky somewhere near the top of the image because that gave the composition a feeling of depth.

Of course, there are all sorts of compositions in between these two extremes. The important thing is to look at your scene and get a feel for how the sky relates to the landscape for your particular photograph. Digital photography is great in this situation because you can look at a playback of your shot on your LCD to decide if the sky is right for your composition.

FIGURE 6.6
A small sliver of sky gives this flower landscape at Point Dume, California, more depth.

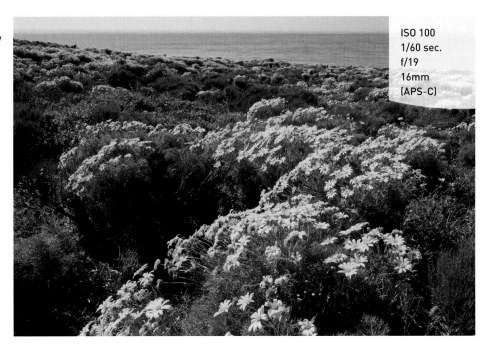

ISO 100
1/60 sec.
f/19
16mm
(APS-C)

TACKLING EXPOSURE CHALLENGES
FOUND IN THE SKY

Sky often brings exposure challenges for photographers. Clouds can be extremely bright, and forests can be quite dark, for example, presenting a scene that can be beyond the capabilities of the camera to capture detail. This can be very misleading to us as photographers. No matter how bright a sky is or how dark the ground is, your eyes can see both just fine. It takes experience to start to be able to see that a sky is way out of balance in brightness compared to the ground. Don't be afraid to take the picture, but check it on your LCD to be sure that you aren't having problems with exposure.

Skies are typically brighter than the ground. They should look bright in the photograph if they are, indeed, bright. Your landscape photo will never look its best if white clouds look a dingy gray because of underexposure. White clouds should look white without being washed out. That's something to look for in your LCD.

Often, your camera will underexpose the sky because the camera's metering system can't tell the difference between a bright sky and a scene with a lot of light that needs less exposure. It defaults to the scene with a lot of light and gives a bright scene less exposure than it should have. If your sky is bright and it's starting to look dark in your image, add exposure (**Figure 6.7**). You can add exposure by using the plus compensation on your compensation control; if you're shooting manual, increase your shutter speed.

ISO 100
1/45 sec.
f/8
11mm
(APS-C)

FIGURE 6.7
Camera meters will underexpose a scene like this one of sky over Tennessee's Great Smoky Mountains National Park. You have to be sure to add enough exposure to make the clouds truly bright but not so much that subtle colors are lost.

If your camera has exposure highlight warnings, look for them to appear in clouds in the sky, and then give slightly less exposure until they disappear. However, it can be misleading if your LCD shows no highlight warnings at all because that may mean that you don't have enough exposure. Both a severely underexposed image and an image almost at the right exposure, for example, will not show highlight warnings, yet only one of these will give a good exposure for the landscape.

Unfortunately, there are scenes that are impossible to photograph with the right exposure. There is no right exposure because the range of brightness is beyond what the camera is capable of. Sometimes you can use high-dynamic range (HDR) photography to handle these conditions (see Chapter 9), but that doesn't always work. Sometimes you just have to look for a different composition.

One reason pros shoot early and late in the day is to deal with this challenge. Early and late times include moments when the sky and ground balance out in certain directions, but you have to be aware of this and look for it.

Still, sunrise and sunset bring unique challenges for exposure. When you're shooting toward the sun in these conditions, it's impossible to expose for both the sky and the ground at the same time (unless you're shooting HDR). Your best bet is to expose for the sky to be sure that it looks good, and then find something in the landscape that can be used as a silhouette against the sky (**Figure 6.8**). This doesn't mean that your landscape has to fill the image with the silhouette. You can emphasize the sunrise or sunset sky and just use a little bit of the landscape to give the photograph a sense of place.

Having the sun in the sky can be dramatic and interesting, but the bright light of the sun can overinfluence your camera's metering system so that you don't get the right exposure. You need to increase the exposure from what the meter wants to give to the sky with sun in it—but exactly how much will depend entirely on the sky and the conditions. You can try metering the sky without the sun and using that exposure with a manual setting. Sometimes the best thing is just to take a series of photographs, changing your exposure each time so that you have a variety of images to select from when you get back to the computer.

ISO 100
1/350 sec.
f/5.6
165mm
(Four Thirds)

FIGURE 6.8
The palm trees are not a large part of this sunset landscape, but they definitely tell you this is a Florida location.

THE GRADUATED NEUTRAL-DENSITY FILTER

The graduated neutral-density filter was very popular with landscape photographers back in the 1990s. This filter is half-clear and half-dark, with a gradient through the middle to blend the two areas. A photographer would use this filter by putting the dark area over the sky and the clear area over the landscape, which would help balance the exposure of bright sky with the ground.

This filter is still a useful tool for photographers. The challenge is that not all landscapes look good with it. Because there is essentially a line through the middle of the filter where it changes from clear to dark, it also puts a line between the areas affected by the filter and the areas unaffected by the filter. Not all landscapes have that clean a division between sky and ground. For example, it can look odd to have a mountain starting to appear darker halfway up the slope.

I used to use this filter all the time, but today I use it much less. I know that there are things that I can do in the computer to control and balance the brightness of sky and ground if I've done my exposure homework correctly when taking the picture.

BRINGING OUT THE CLOUDS

Clouds often are a key part of the sky over a landscape (**Figure 6.9**). Clouds look different over different landscapes, and these differences can enhance and enrich your landscape to give it a stronger feeling of place.

Sometimes the clouds look great in front of you, but not so great when captured by the camera, which can be very disappointing. In part, this goes back to the challenge of how we see the world versus how the camera sees the world (see Chapter 2).

Another important aspect of making clouds look like clouds in your photograph is exposure. As discussed earlier, you need to be sure that you're neither overexposing nor underexposing your clouds. Overexposing clouds washes them out so they look like blank blobs of white. Underexposing makes them look gray and murky, not at all the way most clouds look like unless they're filled with rain.

There are other things you can do to bring out the clouds. An important filter for the landscape photographer is the polarizing filter—which could just as easily be called the "sky filter" because it often enhances and brings out clouds in the sky (**Figure 6.10**). A polarizing filter does not, however, automatically give you better sky. Here are some tips for getting the most out of a polarizing filter:

- **Rotate the filter.** A polarizing filter is designed to rotate in its mount. As you rotate it, its effect on the sky changes. Before putting the filter on your lens, hold the filter up to the sky and rotate it to get an idea of what it will or won't do. If it doesn't have much effect, don't use it because it just cuts exposure to your sensor without any benefit.

- **Use a circular polarizer.** A circular polarizer is a specific type of polarizer that works best with modern cameras and their exposure meters.

- **Turn so the sun is at your side.** A polarizing filter has its maximum effect on sky at 90 degrees to the sun. That's where you'll get the most dramatic darkening of the sky and separation of clouds. If you shoot toward the sun or away from the sun, you may see no effect on the sky at all.

- **Be careful of wide-angle lenses.** Because a polarizing filter changes its effect on the sky as you turn toward or away from the sun, a wide-angle lens can overemphasize this. The result can be very uneven skies when you're using a polarizing filter.

- **Be wary of black skies.** Under certain conditions, the polarizer can make the sky too dark. This is especially common when you're up in the mountains at altitude. Just be sure that, as you rotate the filter for effect, the sky still looks like sky.

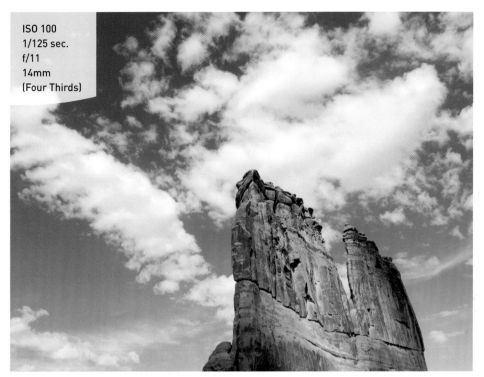

ISO 100
1/125 sec.
f/11
14mm
(Four Thirds)

FIGURE 6.9
Courthouse
Rock in Arches
National Park is
a dramatic and
well-photographed
landscape feature.
The clouds in this
image allowed
me to capture a
different look for
this place.

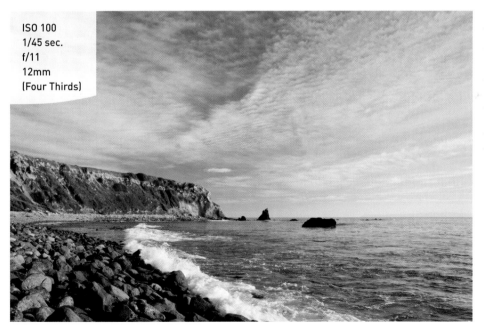

ISO 100
1/45 sec.
f/11
12mm
(Four Thirds)

FIGURE 6.10
The clouds in this
sky over the Pacific
Ocean near Los
Angeles, California,
had great potential,
and it was the
polarizing filter
that really helped
them stand out.

A polarizing filter offers another benefit for landscape photographers besides affecting skies. It can remove glare. By removing glare from leaves, for example, a landscape featuring a forest can have a richer green. You also can remove glare from water—although you need to be careful (otherwise, very clear water can seem to disappear).

An important way of dealing with clouds is to work on your image in the computer. This isn't about Photoshop or digital manipulation—it's exactly what Ansel Adams did when he worked on his beautiful images in the darkroom. This is a traditional dark-room technique for photography, and it's very important because the camera simply doesn't always capture clouds the way we see them.

DIGITAL DARKROOM TOOLS

In general, this book isn't about working on images in the computer, although the final chapter does include some things that I think are important to consider if you're really interested in landscape photography. Landscape photography has a long tradition of dark-room work and programs like Adobe Photoshop Lightroom really help you do some of the same things that Ansel Adams did, but now in the computer.

However, for clouds, I recommend programs such as Viveza and Silver Efex Pro, both from Nik Software. These programs, and some others in the Nik lineup, include the Structure control, which has a huge effect on skies. This single slider will do more for you than any camera or lens purchase to improve your landscape images (**Figure 6.11**).

FIGURE 6.11
The clouds for the opening shot in this chapter were processed in Vivesa 2 with the Structure slider.

Chapter 6 Assignments

Silhouettes at Sunset

Silhouettes at sunset are such an important part of landscape photography with skies. This is something that you really should experiment with before there is an outstanding sunset in front of you. Find a landscape with some trees that can be clearly seen against a sunset sky. Shoot a series of compositions of those trees against the sunset. Use your zoom lens to make the trees big in the frame in some pictures and then just a small part of the scene at the bottom of the composition. Try all sorts of positions for those trees against the sunset.

Check out a Blank Sky

Go out and deliberately photograph a landscape with a blank sky. I'm not talking just about a sky that has no clouds—a rich blue sky can be an interesting sky. Instead, look for a sky that doesn't have much color and doesn't have much in the way of clouds (or if it does have clouds, the clouds have no definition). Try a variety of compositions where the sky fills up most of the frame all the way down to the sky being barely visible. Notice how much that blank sky will dominate the picture.

Sky King or Pawn

Find a pleasant landscape nearby that you can photograph easily. Go out to that landscape when there are nice clouds in the sky. Capture the scene in a variety of compositions, constantly changing how much sky is actually in your picture. This exercise forces you to look at how a sky can interact with the rest of the scene. The sky can be the king of the composition or just a pawn.

Share your results with the book's Flickr group!

Join the group here: www.flickr.com/groups/LandscapesfromSnapshotstoGreatShots

7

ISO 100
1/90 sec.
f/11
10mm
(APS-C)

Connecting with a Landscape

FINDING DEPTH IN A LOCATION

Some photographers see a landscape as just another thing to photograph. I understand that. Photography can be a lot of fun, and when you're looking for more ways to photograph, new subjects can be a great way to expand your use of that hobby.

In my experience, though, photographing a landscape can be something deeper and richer. When you connect with a landscape beyond its ability to serve as a photo subject, you're connecting with our world. You begin to see something beyond capturing an image. The natural world is an amazing place, filled with wonders that beg to be understood, photographed, and shared so other people can understand it, too.

This chapter gives you some ideas on how to connect with a landscape beyond simply seeing its photographic possibilities. When you start seeing a landscape as more than a photograph, you'll begin to find better photographs. I've found that when photographers look at a landscape only as a subject for compositional design, they often miss possibilities for photography because they aren't seeing the landscape fully.

PORING OVER THE PICTURE

This is one of my favorite landscape photos from Florida. The West gets so much attention, especially with the tradition of Ansel Adams and Edward Weston, that photographers forget they can make excellent landscape images across the country. This particular image was shot at sunrise in the Merritt Island National Wildlife Refuge. You often get very rich colors like this when you shoot with a telephoto lens just as the sun rises or sets.

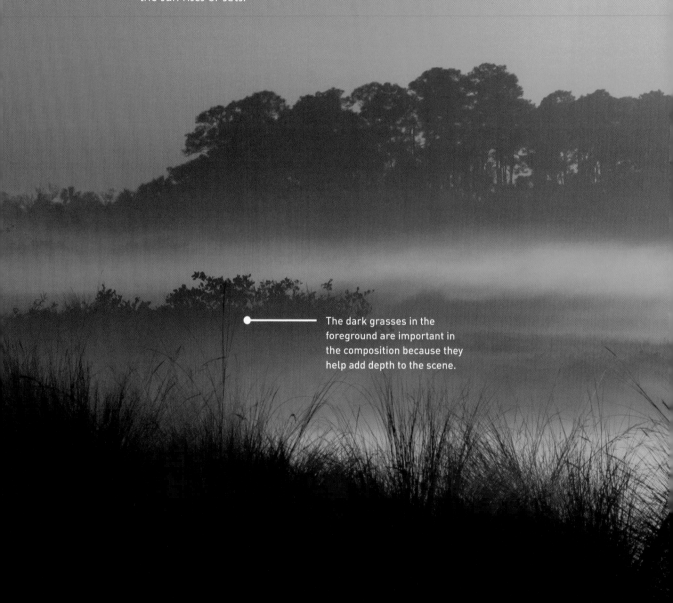

The dark grasses in the foreground are important in the composition because they help add depth to the scene.

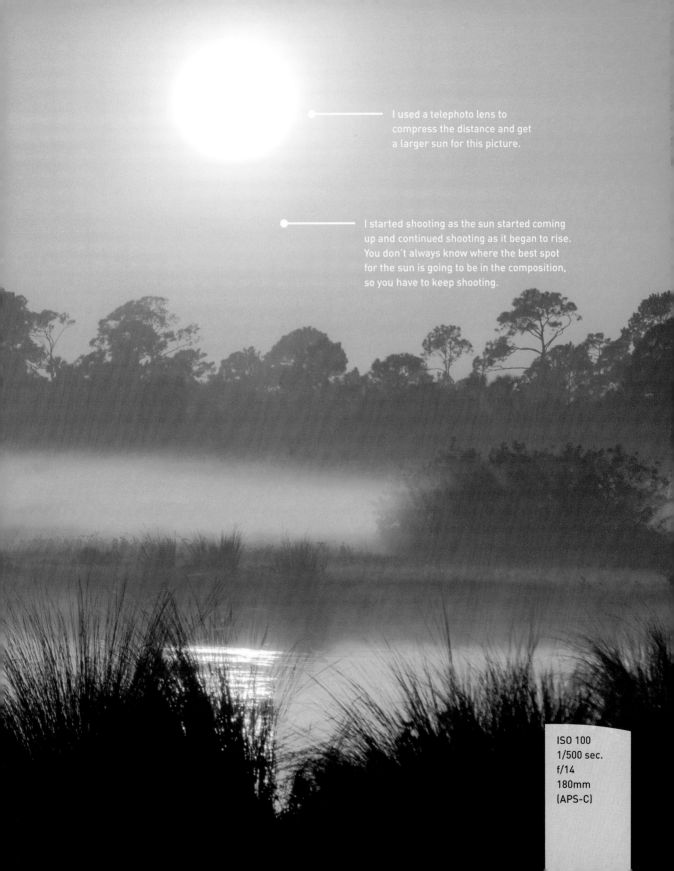

I used a telephoto lens to compress the distance and get a larger sun for this picture.

I started shooting as the sun started coming up and continued shooting as it began to rise. You don't always know where the best spot for the sun is going to be in the composition, so you have to keep shooting.

ISO 100
1/500 sec.
f/14
180mm
(APS-C)

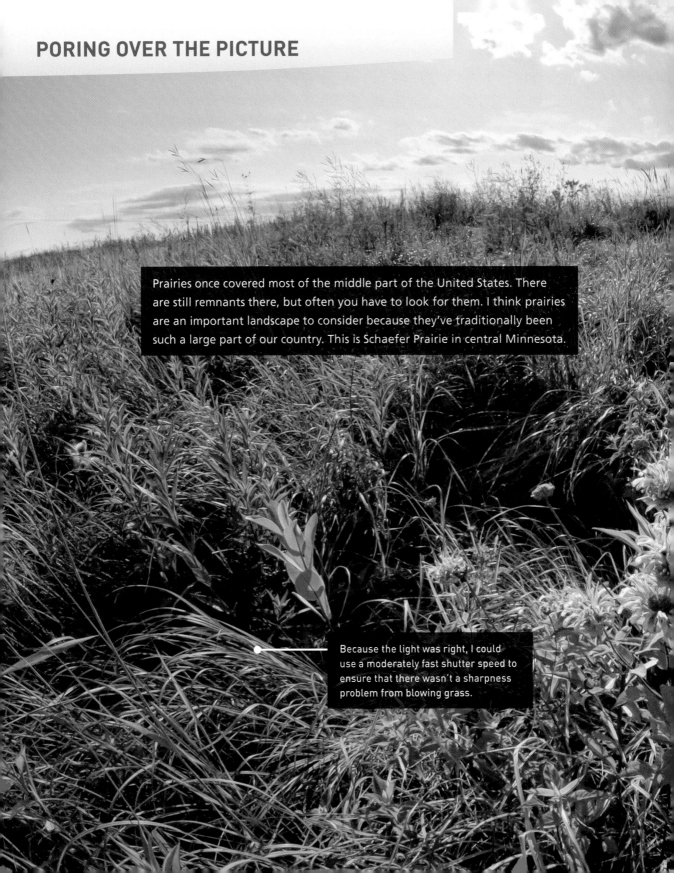

PORING OVER THE PICTURE

Prairies once covered most of the middle part of the United States. There are still remnants there, but often you have to look for them. I think prairies are an important landscape to consider because they've traditionally been such a large part of our country. This is Schaefer Prairie in central Minnesota.

Because the light was right, I could use a moderately fast shutter speed to ensure that there wasn't a sharpness problem from blowing grass.

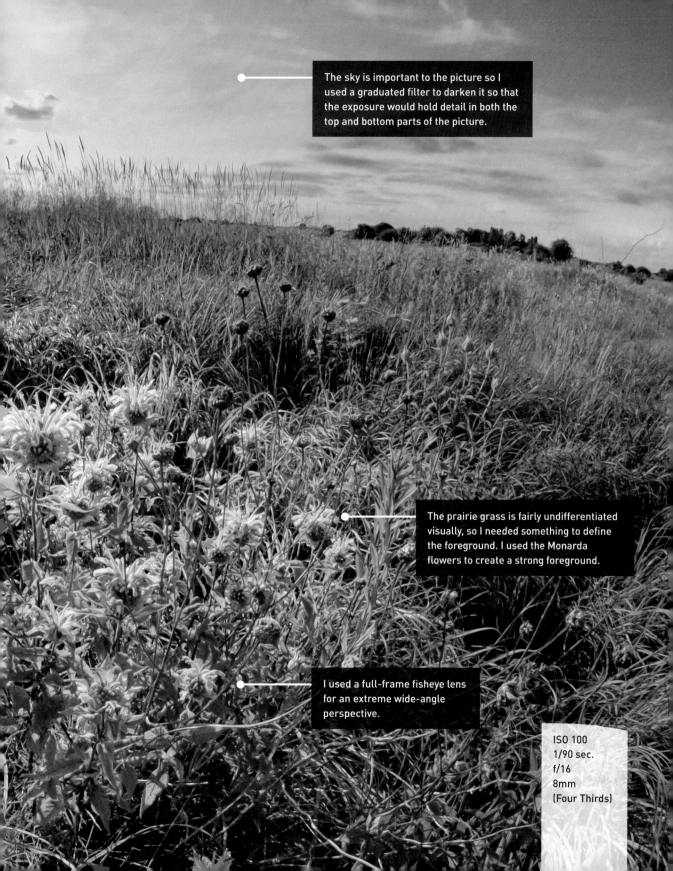

The sky is important to the picture so I used a graduated filter to darken it so that the exposure would hold detail in both the top and bottom parts of the picture.

The prairie grass is fairly undifferentiated visually, so I needed something to define the foreground. I used the Monarda flowers to create a strong foreground.

I used a full-frame fisheye lens for an extreme wide-angle perspective.

ISO 100
1/90 sec.
f/16
8mm
(Four Thirds)

UNDERSTANDING WHAT'S IMPORTANT

A key question that we always need to ask ourselves as photographers is, "What is the photograph about?" Superficially, the answer to that is obvious: The picture is about the subject. But that's not a very good answer, and it won't help you get better photographs.

Rarely is a photograph simply about the subject. If good photography were simply about getting the best image capture of a subject, then everyone who bought an expensive camera would automatically get better photographs. Most photographers quickly (and sometimes expensively) discover that this idea isn't true.

Landscape photography also is rarely just about the subject. In fact, with a lot of landscapes, what really is the subject? The clouds? The mountains? The river? I know, you may be thinking that the answer to that question is all of it. But that's also not a very good answer to help us get better photographs.

Often when a photographer simply looks at a scene and says, "I just want to get all of this in my photograph," the photograph becomes less interesting, more confusing, and without focus. Viewers of photographs expect us, the photographers, to help define the scene for them, to help them know what this photograph is about. Capturing "all of it" doesn't give any emphasis to what's important in the scene.

Understanding what's important to your landscape helps you define your image and create the proper emphasis to make it clear and more effective. Sometimes you can't photograph what is intellectually important to the landscape because of the conditions—meaning that you may know something about the landscape, but the weather won't reveal it. You won't get a better photograph by forcing a shot to do something it can't do and then having to explain it to your viewer later, "Well, over there, but you can't see it…." You have to find what's most important that can be revealed in the photograph.

I can't tell you exactly what will be most important to your landscape. You have to spend some time looking at that landscape and thinking about what's important and what your photograph is about. This will help you decide what needs to be defined and emphasized in your photograph.

Here are some possibilities to consider:

- **Key subject details:** In some landscapes, you'll see certain details that just jump out at you as being key to understanding the landscape (**Figure 7.1**). For example, there might be a unique grouping of rocks that shows up strongly in the light that can be used to define the image.

- **What is unique to the location:** Many landscapes have certain aspects to them that clearly identify the landscape as something unique and special (**Figure 7.2**). This might mean a certain type of tree, such as an evergreen in a northern landscape that would never show up in a southern landscape. Or it may be a certain type of flower that's typical of this landscape that needs to be shown in order to feature the landscape as what it is.

- **Light:** Light itself can be an interesting aspect of a landscape. Ansel Adams was known for photographing the light, as well as the landscape, in many of his images. Often, photographers get hung up on the subject and don't always see the light as well as we should. Yet that light may be exactly what gives the image a special quality.

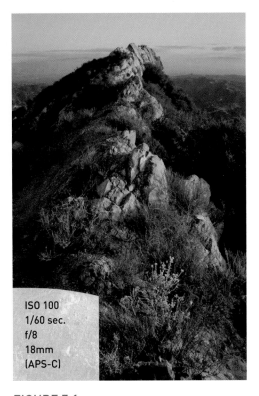

ISO 100
1/60 sec.
f/8
18mm
(APS-C)

FIGURE 7.1

This landscape image is clearly about early light on a rocky ridge in California's Santa Monica Mountains. The key subject details are the rocks and the ridge.

ISO 100
1/60 sec.
f/11
12mm
(Four Thirds)

FIGURE 7.2

This Maine scene is unique because of its abandoned home and field of wild lupine.

- **Form:** The form and shape of objects in a landscape can take on particular significance in certain scenes and light (**Figure 7.3**). Edward Weston was known for his ability to see and capture very strongly dimensional images that showed off forms in the landscape.

- **Unique moments:** If you spend any amount of time outdoors, sooner or later, you'll come across a very unique moment in the "life" of a landscape. This could be light breaking through a rainy landscape (Figure 7.3), a fresh snow in a desert scene, still water that offers reflections, and so forth. When these moments occur, focus your camera and mind in on them and don't try to capture everything else.

- **Emotion:** Some landscapes stimulate a certain emotion or feeling about the setting (**Figure 7.4**). Such emotion can be as simple as the place being dramatic. Other emotions that can be invoked from a landscape include things like relaxation, power, calm, and so forth. Each one of these emotions is highlighted when you keep your image's emphasis on that concept.

FIGURE 7.3
Breaking and swirling clouds allow light to define this Zion National Park landscape and show off its forms.

ISO 100
1/80 sec.
f/8
180mm
(APS-C)

FIGURE 7.4
Can a landscape of brightly colored California poppies offer anything except an emotion of joy? When they bloom like this, you can almost *feel* the color!

ISO 100
1/320 sec.
f/8
7mm
(compact)

WORKING THE LANDSCAPE

A limiting factor for many photographers in getting better landscape images is that they see the landscape in one way and approach it photographically from that mental place. This can keep you from really finding the best photographs of your landscape.

Often, the first way that we see a landscape is not the best, but it captures our attention because that's the first way we see it. A good way to get around this is to do something that professional photographers often do: Work the subject.

Working the subject simply means finding different approaches to seeing that subject for your photography. It's an effort to find something different so that you discover and then capture better ways of photographing the landscape. For some photographers, this means taking a lot of different photographs as they explore the possibilities. For others, this may mean not taking certain images but continuing to look for a unique shot that really resonates with them.

One of the challenges of working a subject comes from photographing a very large landscape that has limited locations to photograph. I've been to locations such as Bryce Canyon National Park when there were hundreds of photographers waiting for the first light on the amazing rock formations there. Admittedly, there really weren't a lot of different places that you could photograph. That doesn't mean, though, that I couldn't work the landscape.

For example, I found a pine tree that overlooked the canyon where no one was standing (**Figure 7.5**). The sky didn't have interesting clouds to it, but by playing around with the tree, I could put it in the sky and create an interesting and unique look at this location. It was obvious from the way that most photographers were shooting that they used a few limited approaches to this scene and didn't try to find much else. But by working the subject, I was able to come up with something exciting.

FIGURE 7.5
By working the landscape at Bryce Canyon National Park, I was able to find a unique morning view.

ISO 100
1/60 sec.
f/11
15mm
(APS-C)

Working a landscape can be done in many ways (**Figure 7.6**). Here are some changes you can do that are worth thinking about:

- **Position:** Move around as much as you can and take pictures from different angles to your landscape. On some landscapes, this might not make a big change to things that are at a distance, but it can make a huge change in what's in the foreground.

- **Height:** Go to any location where there are a lot of photographers photographing landscape and you'll see that they all have their cameras on tripods that are at eye level or close to it. Try some different heights. This can also have a big effect on what's happening in the foreground. And remember that you don't have to stand on a ladder to get a high angle with a digital camera. Set your camera on a tripod, use the self-timer, and then hoist the camera up high as the self-timer counts down. Check your shot after it's done to see if you need to retake it.

- **Focal length:** Almost everybody has zoom lenses today, and many photographers have multiple focal lengths. Yet, often, they choose one focal length and continue to use that as they shoot a particular landscape. Make a dramatic change in your focal length, and see what you find. For example, zoom in to a strong telephoto focal length, and then start looking around to see what that does to the landscape.

- **Light:** Okay, I know you can't actually change the light on the landscape very easily…or can you? Sometimes it's worth waiting for the light to change. As the sun comes up, you'll see many changes in color, light, and shadow. Keep shooting. At any time of day, waiting for the shadows to change as the sun moves across the sky can be a great way of experiencing the location. If there are clouds in the sky, you also can wait until cloud shadows change positions in the scene.

- **Composition:** Changing composition might seem obvious, but I've seen many photographers locked into one composition for a particular location and vary little from it. Try both vertical and horizontal. See what happens when sky fills most of the composition, and see what happens when it doesn't. Compose with the mountain on the left, and then compose with it on the right.

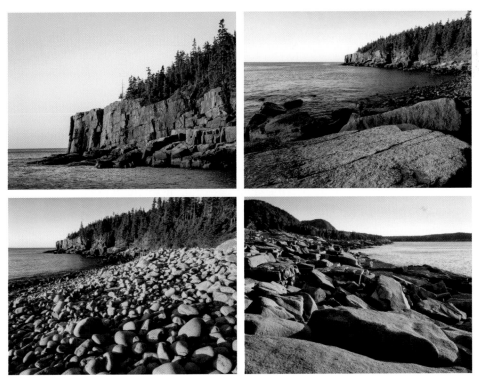

FIGURE 7.6
Here is a whole series of images from the same Acadia National Park location and morning, all shot within a half-hour after sunrise. The shots use different focal lengths, compositions, light (from timing), and angles to the shoreline, but my location didn't change much.

Finally, here are two important things to keep in mind about working the subject:

- When you get back to the computer with all the great shots that you've taken at a location, the only shots you'll have are the shots on your memory card. If you haven't taken those extra shots, obviously you don't have them. Working the scene gives you more options back at the computer.

- By working the subject and going after multiple views of a landscape, you'll often discover shots that you never would've found any other way. If you keep asking yourself, "What other pictures are here?" You'll find additional photographs— often more interesting and better ones.

GOING BEYOND THE COMMON LANDSCAPE

As I was writing this chapter, a friend and I were talking about going to Death Valley. I had been once before, years ago, but I hadn't spent a lot of time there. It's definitely a place of stunning landscapes. We talked about which places we wanted to visit, and a lot of very familiar names came up. I said that I wasn't sure how much I wanted to visit places that everyone else went to.

There are a number of reasons for that. Partly, I'm sure, it's due to my sometimes rebellious nature that simply doesn't want to do what everyone else wants to do. I used to blame that on growing up in the 1960s, but it's probably just my personality.

I also could blame it on having worked so long as editor of *Outdoor Photographer* magazine. I saw a lot of submissions of images, and frankly, many photographers sent in photographs of the same old locations. So, I'm probably a bit tired of that.

I think there is something deeper, however, that affects all of us who care about the world around us. If all that we photograph are the popular places that everyone goes to, no matter how dramatic they are, that's all that most people will see of the natural world. As nature photographers, we are the eyes of the public. I don't care who you are, how advanced you are, whether you're amateur or pro, your pictures will be seen by others and they'll influence how those people see the world.

So, what happens when everybody keeps photographing the same places, flowers, and wildlife, but other nature isn't included? People start seeing nature as restricted to a few things and the rest of it is unseen. Or nature starts looking like it can only be certain things and isn't inclusive at all.

I thought about Schwabacher's Landing (**Figure 7.7**), a location in the Grand Teton National Park that has an outstanding view of the mountains at sunrise. Unfortunately, it has a very limited area that you can actually photograph from. Photographs from

this location largely look the same with most variation from weather and season. How many pictures of Schwabacher's Landing do we really need? I'm not suggesting you or I won't want to visit—it's a great place to go. What I'm talking about is photographing there and not seeing and sharing the rest of nature in the area (**Figure 7.8**). Is Grand Teton National Park restricted to Schwabacher's Landing (or a limited number of other iconic, but limiting views of the park)?

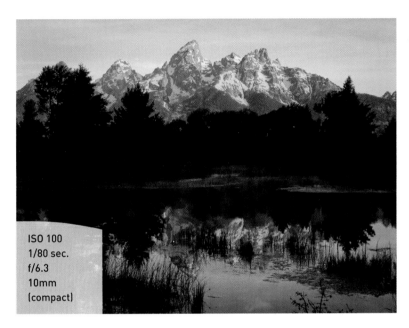

ISO 100
1/80 sec.
f/6.3
10mm
(compact)

FIGURE 7.7
Scwabacher's Landing and the Grand Teton National Park. Most photos from this location look pretty much like this.

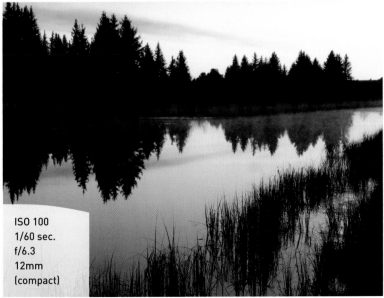

ISO 100
1/60 sec.
f/6.3
12mm
(compact)

FIGURE 7.8
A ways down the road revealed a totally different, dramatic landscape that adds to our perception of the location.

A few years ago, environmentalist and author Bill McKibbon wrote an article that annoyed many wildlife photographers. He said that there was a lot of photography available for certain species and asked whether we really need more pictures of those same species? I think his position was a little extreme and he couched his piece too much as a challenge. After all, the same thing could be said about writing—there is plenty of writing on those subjects, too, so do we need more of that? But the question is a good one to think about. Do we need more and more pictures of the same old locations that we've seen time and time again? Or can we add more photos of the variety of life that is nature?

What I'm suggesting is that we need to go beyond the obvious and the over-photographed in nature. There is such a huge wealth of nature available that needs our attention, deserves our attention, and needs to have the public see it. And the public will see it when we photograph it.

I'm suggesting a possibility for photography that is not simply of nature, but in service of nature. There is no question that photography can affect people and move them to change the way they see the world. When nature is unseen, people tend not to care about it. I think that the health of our planet is important and that starts with seeing what our planet is made up of: nature. Without a living planet, without a healthy and varied nature, nothing else exists.

Nature is important. We are important. We are part of nature. And one thing that can help us stay connected is when we can use our skills as photographers to help people understand and appreciate the true and amazing extent of the natural world.

FINDING OUT ABOUT LOCATIONS

There are wonderful landscape photo opportunities all across the world, anywhere you live. Sometimes photographers start thinking that the only landscapes are those of Ansel Adams and the West. That's simply not true. I've photographed throughout the United States and loved landscapes that I've found everywhere. As you look through this book, you'll find locations from Washington to Maine to Florida to California and lots of places in between.

So, how do you find interesting landscapes to photograph? Part of this comes from being willing to just get out and explore the location you're in. Get a map and get off the main highways. Give yourself some time to do this. You don't have to take time off from work and spend weeks on it. Just take your time going through whatever location you're in and really look for landscape possibilities.

Before going to any new location, I search the Internet to see what might be interesting in the area. I look for things like parks and refuges to see what might be there. Then I check out the websites of those locations to see what types of landscapes are present. This can start to give me an idea of what I might be seeing. Big parks, especially national parks, often have well-crafted websites that will give you a great deal of information about the location, maps, and important landmarks.

Whenever I go to a location for more than a few days, I try to find local bookstores. I almost always find local guides there that give an idea as to places and times to go, types of landscapes to look for, and sometimes full information about the geology, biology, and history of the location. I try not to buy too many books because my library gets a little full anyway, but I always seem to leave with at least a couple.

Visitor centers are another great source of information about landscapes (**Figure 7.9**). They usually have specific maps to the area that can be extremely helpful, as well as gift and book shops with more resources. You'll also be able to talk to rangers and naturalists who can point you to some very specific locations. I've found the staff at nature centers to be consistently helpful—they love their location and sharing it with visitors. They can point you to all sorts of great places for landscape photography. Sometimes I've totally changed my plans based on talking with these people because they give me such great ideas.

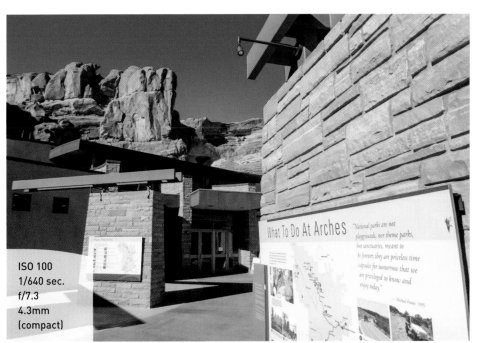

ISO 100
1/640 sec.
f/7.3
4.3mm
(compact)

FIGURE 7.9
Visitor centers offer a wealth of information about any location that can help you find better landscape photo opportunities.

Chapter 7 Assignments

It's All in the Emphasis

Ask yourself, "What's my photograph about?" What you emphasize has a huge effect on how you answer that question. Find a landscape that's easy for you to access. It doesn't have to be anything fancy, but it should have some variation of features in it. Photograph it early or late so that the light creates nice shadows. Now take a series of pictures where each one changes the emphasis as to what's most important for your photo. Don't move to a different location—change how you frame your image to change the emphasis in what's seen in your photograph.

Practice Working a Subject

Working a subject can be such a great way of exploring a scene. It opens up options, in addition to adding more variety to your photography. But if you aren't used to working a subject, you may find that you forget to do it when you're in front of a stunning scene in a distant location. That's why it's important to practice working a subject on a small scale on a landscape that isn't as important to you. Find a simple landscape that's near where you live, a place that you can easily access. Photograph it early or late in the day so that you get nice light. Now try photographing it in as many different ways as you can think of. Change your position, your height, your focal length, and so on. Develop a way of working that will give you practice in working a subject.

Random Acts of Photography

One way of breaking up old patterns is to do something completely different. This little exercise will open your mind to new possibilities. Once again, go to an accessible location, but this time find a smaller landscape where you can walk around at least part of it fairly easily. Find a spot to start where you can photograph an interesting landscape and take that shot. Now either hold your camera just below chest level or put it on a tripod that high. Keep your camera low enough that it isn't easy to look through the viewfinder. Now go through your landscape taking pictures in a very specific way: Every 20 feet, stop and point your camera toward something that looks interesting for a landscape, but don't look through your viewfinder. Point your camera toward the subject the best you can, take the picture, and then go another 20 feet and find a new landscape. You'll get some awful pictures, but you'll also get some very interesting pictures you probably never would've thought of. Shoot at least ten photos this way.

Share your results with the book's Flickr group!

Join the group here: www.flickr.com/groups/LandscapesfromSnapshotstoGreatShots

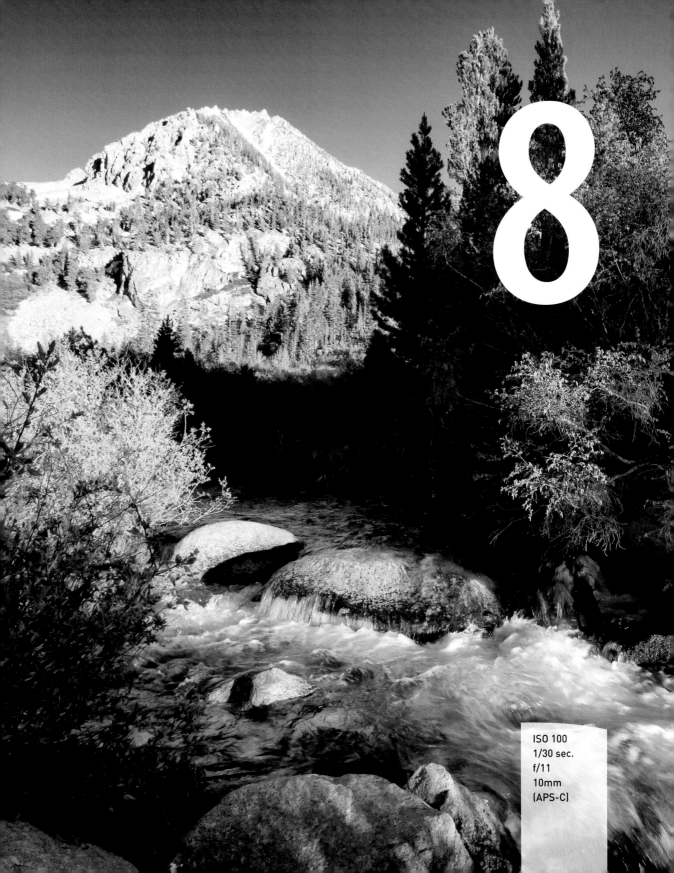

8

ISO 100
1/30 sec.
f/11
10mm
(APS-C)

Black-and-White Images

EXAMINING THE RICH TRADITION AND TODAY'S POTENTIAL OF BLACK-AND-WHITE LANDSCAPES

Black-and-white photography has a long and important tradition because it's where photography began—there was no other option. Black-and-white images were the "standard," something everyone shot. When color appeared, the black-and-white medium became the "special" way of shooting and gradually became the poor relation to color. Today, color is the standard and usual way of shooting, and black-and-white photos are special.

Black-and-white photography has experienced a resurgence as an elegant and rich way of interpreting a subject, and that's especially true for landscape photography. But it isn't simply about removing color. In fact, just removing color can give you a blah, unappealing black-and-white landscape.

In this chapter, I show you what black-and-white photography really means beyond the removal of color, how you can get better black-and-white images as you photograph, and how to translate color to black and white in the computer. Black-and-white photos start when you first take the picture, not when you go to the computer.

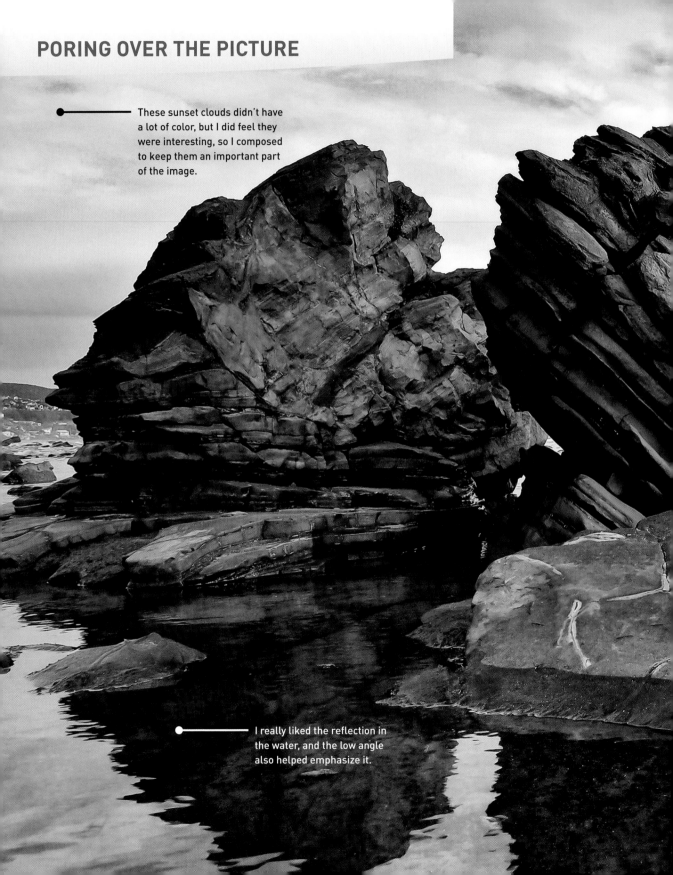

PORING OVER THE PICTURE

These sunset clouds didn't have a lot of color, but I did feel they were interesting, so I composed to keep them an important part of the image.

I really liked the reflection in the water, and the low angle also helped emphasize it.

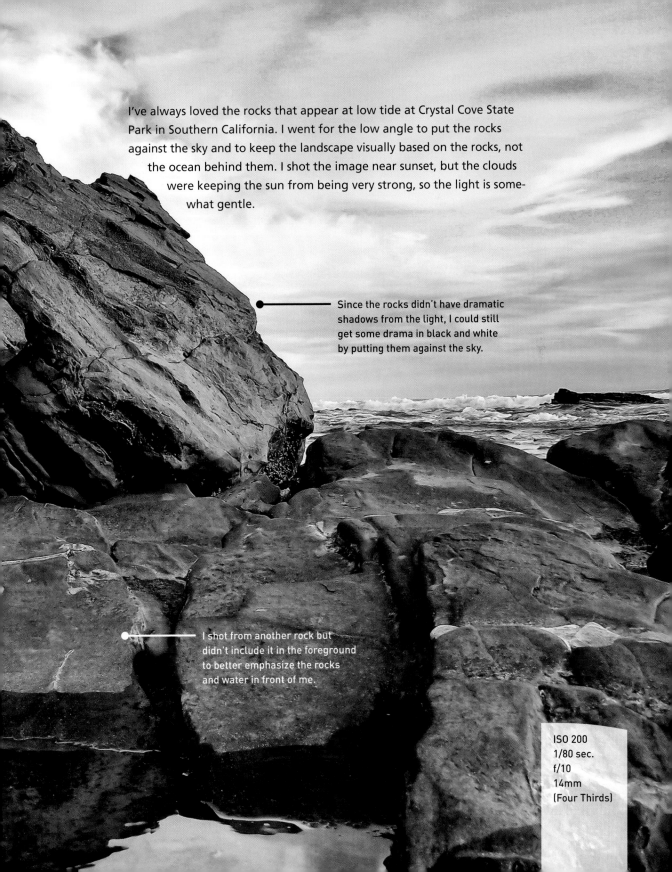

I've always loved the rocks that appear at low tide at Crystal Cove State Park in Southern California. I went for the low angle to put the rocks against the sky and to keep the landscape visually based on the rocks, not the ocean behind them. I shot the image near sunset, but the clouds were keeping the sun from being very strong, so the light is somewhat gentle.

Since the rocks didn't have dramatic shadows from the light, I could still get some drama in black and white by putting them against the sky.

I shot from another rock but didn't include it in the foreground to better emphasize the rocks and water in front of me.

ISO 200
1/80 sec.
f/10
14mm
(Four Thirds)

PORING OVER THE PICTURE

I used a telephoto lens to compress distance and create an almost abstract pattern of the mountains' tonalities.

There is a very interesting progression of dark foreground to lighter middle ground to darker distant hills.

ISO 100
1/180 sec.
f/11
300mm
(APS-C)

Early morning in California's Santa Monica Mountains may include a morning marine layer at certain times of the year. That's what is creating the unique pattern of light and dark in this image. The marine layer is fully visible in the background in front of the distant mountains. It's also creating the haze on the nearby hills. It was this pattern of light that attracted me to the scene.

Exposure is really critical for a scene like this because you need to hold detail in the clouds of the marine layer in the distance, yet keep them bright.

The lower hill in the foreground helps create a sense of scale and perspective for the composition.

THE EARLY HISTORY OF LANDSCAPE PHOTOGRAPHY

Landscape photography began with black-and-white images. In fact, there is a wonderful tradition of black-and-white landscapes that started over 150 years ago with some of the original photographers, such as Henry Fox Talbot and Gustave Le Gray. Their "film" was so slow, so lacking in sensitivity, that landscapes made perfect subjects because they didn't move during the long exposures needed.

In the early 1870s, after the Civil War, William Henry Jackson joined an expedition to the West that explored what would become Yellowstone National Park (**Figure 8.1**). Before this trip, many people thought such a place was based on wild stories of mountain men and not on reality. Jackson showed the reality of the place, and his photographs so influenced Congress that Yellowstone became the first national park.

Landscape photography became an important way for people to discover the world as it was explored. The late 1800s were a time of exploration of all sorts of places that were celebrated in books and photographs. People couldn't travel around easily, so photography gave them a chance to see the world.

FIGURE 8.1
This image is one of William Henry Jackson's black-and-white photos from his trip to Yellowstone in the early 1870s. This is a mud geyser erupting.

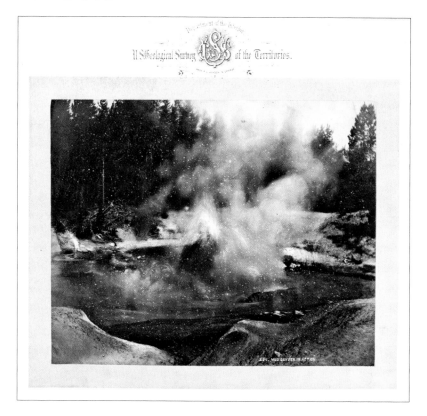

There were many challenges to landscape photography at the time, not the least of which was that photographers had to use very large cameras and glass plates for "film." I can't imagine what photographers of the time would've thought about my little NEX camera. My whole system is smaller than their camera alone. Timothy O'Sullivan photographed throughout the West in the late 1800s and needed a covered wagon for all his gear and glass plates.

One important challenge that these early photographers faced is that their "film" had a very different sensitivity to color than either film or sensors do today. One result of this was that blue skies were rendered white, and it was difficult to get skies that actually looked like dark blue skies or to get clouds to show up in them. This is one reason why a lot of the old photography shows very little sky.

Landscape photography took a strange turn in the early 1900s when photographers thought they had to be like painters and make pictures that didn't look so real. This movement was called pictorialism, but by the 1930s, photographers like Ansel Adams, Paul Strand, and Edward Weston were taking black-and-white images that deliberately used the sharpness and attention to detail that photography was capable of in their landscapes.

If you become more interested in black-and-white landscape photography, you may find it very instructive to look at the photography of Adams and Weston. Both men shot black-and-white imagery in similar locations in California, but their landscapes are very different. Weston photographed form in the landscape; Adams photographed light in the landscape. As you look at their images, you'll see this very clearly.

BLACK-AND-WHITE PHOTOGRAPHY IS MORE THAN THE ABSENCE OF COLOR

You can open a photograph in almost any image-processing software and remove its color. The result is a black-and-white sort of image, but this approach really isn't the best way to get a black-and-white image.

We see color very differently from black and white because we don't actually see the world in black, white, and shades of gray (**Figure 8.2**). Okay, that may seem obvious, but in color, we're looking at and discerning things in a scene based on the actual colors. In a black-and-white image, we have to look at other ways of separating pictorial elements in the photograph, such as a subject and the background. You can photograph a field of red flowers in green foliage and you'll instantly be able to discern the flowers among the foliage in color. Unfortunately, in a black-and-white photo, the

flowers often blend in with the foliage because the brightness of red and green are often the same. This is demonstrated in **Figure 8.3**, where the only difference between the two photos is that the color has been removed for the black-and-white image.

FIGURE 8.2
We respond to color and black-and-white images quite differently. These two photos are identical except for the color, though the black-and-white shot has been converted carefully, not just desaturated to remove the color.

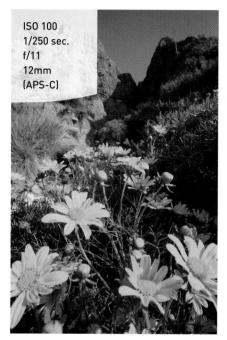

ISO 100
1/250 sec.
f/11
12mm
(APS-C)

FIGURE 8.3
The pink Prickly Phlox flowers show up very well in the color photo, but they start to blend in when the photo is desaturated to remove color.

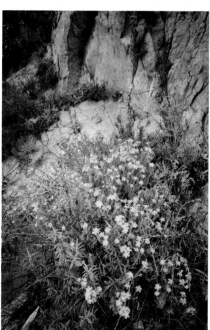

ISO 400
1/80 sec.
f/8
18mm
(APS-C)

There is no question that color is about color. Seeing the world in black, white, and shades of gray forces you, as the photographer, to look for something else. That can be hard because we're so used to looking at color. Yet as you learn to make better black-and-white landscape photographs, you may discover that your color photography gets better as well. That's because you no longer rely just on color and will start to see other things more clearly in your images.

A good way to start seeing in a black-and-white way is to set your camera to record images in Black-and-White mode. However, if you simply record everything in this mode, you may end up with only one version of your black-and-white images and you won't be able to try anything else by converting them from color.

There is an answer to this: Shoot both black-and-white and color images at the same time by setting your camera to shoot Raw + JPEG. Then, when you set your camera to shoot in Black-and-White mode, you're affecting only how it deals with JPEG images; raw files are always in color. You'll see only black-and-white images displayed on your LCD, but when you download the images to your computer, you'll have the black-and-white JPEGs and the color raw files. You can't capture an image to a Raw file and have it only be black and white.

If you open a JPEG file that has been shot in Black-and-White mode, it will show up as a black-and-white image. If you open a raw file that has been shot the same way, it will show up in color unless you're using the raw-conversion software from the manufacturer. In the latter case, the file is still in color, but the manufacturer is using some metadata with the raw file to tell the software to look at it as a black-and-white photo.

By shooting Raw + JPEG, you gain the benefit of actually seeing how a scene in front of you is translated into shades of gray when it shows up on your LCD. But you also gain the benefit of having a color file that you can work with later to get the best translation of color to black-and-white tones.

MONOCHROME AND GRAYSCALE

In this book, you won't see me using these terms to refer to black-and-white photography because I think they're misleading and give the wrong connotation for the beauty of a fine black-and-white image. First, *monochrome* doesn't refer just to black-and-white photography. Monochrome simply means that there is one color that is used for all the tonality in an image. This could mean that your photograph is blue, red, pink, or any other color as long as it's just one color. *Grayscale* is a computer term and simply refers to any image that has had its color removed in the computer. It has a connotation of color removal rather than color translation into black-and-white photography.

COMPOSING IN BLACK-AND-WHITE MODE

Good black-and-white imagery starts when you take the picture. This doesn't mean that you have to previsualize every image in shades of gray in order to find some interesting black-and-white photos when you're back at the computer. Sometimes you'll discover images that look great translated to shades of gray that you may not have been thinking about when you took the picture in the first place.

What it does mean is that you'll start to get better black-and-white pictures when you look for some of the things that make good black-and-white images as you photograph. In fact, as you start looking for things that make black-and-white images look better, you may discover your color images improve.

The first thing that you really have to keep in mind is that, as discussed earlier, black-and-white landscape photography cannot be about color. Black-and-white work is totally about shades of gray or the tonalities of an image. This requires a different mindset when you're looking at a scene.

One thing that I find very interesting about black-and-white photography is that it expands the range of times that you can get good images of a landscape. Often a color landscape simply doesn't look very good in the middle of the day. The colors look washed out or have an ugly blue cast to them. In a sense, black-and-white photography removes those problems with color so that you can focus on other aspects of the scene. Although midday light still can be harsh and unattractive even in tones of gray, there are times that you can get excellent black-and-white images throughout the entire day (**Figure 8.4**).

Black-and-white compositions are largely defined and structured by contrast. One reason that many photographers' black-and-white images fail when they first start shooting this way is because of lack of contrast.

There are three key types of contrast to look for when shooting a black-and-white image:

- **Tonal contrast:** Tonal contrast is contrast in tones or brightness of pictorial elements throughout the composition. Any time that you can have one part of the landscape brighter than another, you get a tonal contrast.

- **Textural and pattern contrast:** Textures and patterns are related because they both show up as distinct and defined "designs" of light and dark in an image. When you can show off one texture as distinctly different from another, you have a contrast.

- **Sharpness contrast:** Sharpness contrast occurs when part of the image is sharp and part of the image is out of focus. This type of contrast is not as common a way of dealing with landscapes as it is with other types of photography.

ISO 100
1/160 sec.
f/8
6mm
(compact)

FIGURE 8.4
A juniper tree in
a Capitol Reef
National Park
landscape gains a
dramatic look as
a black-and-white
image even though
it was photo-
graphed midday.

In looking for contrasts based on tonal differences, look for a change that is dramatic (**Figure 8.5**). Just having something a little bit brighter gray then something else won't give much strength to your contrast. These contrasts will become very important in structuring your composition, so they need to be obvious. On the other hand, you don't always need a pure white and black contrast because that can be too harsh for some scenes—plus, it may not even be possible.

Simply look for change in brightness in your scene and use any changes in brightness as part of your composition (**Figure 8.6**). This change can be due to the natural brightness of the subject matter or it can be due to light.

I've taught many photographers to create better color and black-and-white images, and I'm always interested in how many of them strongly focus on color and don't see brightness changes in an image. The color just overwhelms their way of seeing. Simply becoming aware of brightness changes in a scene will start you on a totally different path. You'll discover things about your landscape images—both color and black-and-white photos—that you might never have noticed before.

FIGURE 8.5
It isn't just the clouds that make this landscape in Kenai Fjords National Park near Seward, Alaska, look dramatic. It's the contrast between the sky and the ground that gives the image its bold look.

ISO 100
1/500 sec.
f/5.6
18mm
(APS-C)

FIGURE 8.6
Tonal contrasts can be more subtle, too. Here, a breaking fog and backlight in the Tennessee side of the Great Smoky Mountains National Park creates all sorts of contrasts that give the image its energy.

ISO 100
1/750 sec.
f/9.5
70mm
(APS-C)

Textural and pattern contrast is a very useful way of looking for contrast in the landscape. Landscape scenes very often have changes in texture and patterns. Those changes can create structure and definition for your composition.

This contrast has to be significant (**Figure 8.7**). There are lots of things that can have changes in texture, but if those changes are only slight, they might not help your black-and-white landscape. You need to look for a strong contrast in order for this to work. You might think of textures in terms of smooth, fine, and coarse textures. Any time you can put one of those textures against the others (for example, smooth against fine, fine against coarse, or smooth against coarse), you'll typically have a strong enough contrast to help separate things in your picture.

Sometimes texture itself can make a landscape photograph interesting (**Figure 8.8**).

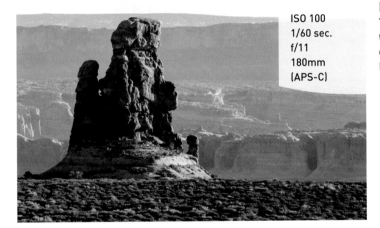

ISO 100
1/60 sec.
f/11
180mm
(APS-C)

FIGURE 8.7
There are a number of distinct textures in this image to help define this landscape of Arches National Park.

ISO 100
1/250 sec.
f/8
30mm
(compact)

FIGURE 8.8
This winter landscape near Bishop, California, is totally about texture.

Can sharpness contrast ever be used in landscape photography, let alone black-and-white shots? It isn't a usual sort of landscape work, but it does offer some creative possibilities if you're willing to explore it. One type of shot that can be fun is a close-up or intimate landscape where part is in focus and part is not (**Figure 8.9**). This technique also works for moody sorts of images with a foreground of the landscape in focus and the background out of focus. Try it, too, with out-of-focus, really close objects in the foreground that provide a contrast and sense of depth for a sharp background.

FIGURE 8.9
A miniature black-and-white landscape gets a unique feel by using sharpness contrast.

ISO 100
1/30 sec.
f/11
10mm
(APS-C)

VARIATIONS IN LIGHT

Light is such an important part of photography that it keeps coming back into the discussion! Much of what you learned in Chapter 3 about light certainly applies to black-and-white photography. There are some refinements to some of those ideas, though, that can help you better capture black-and-white images. To start, light can definitely affect tonalities in a black-and-white image; plus, it has a huge effect on texture.

SEPARATION LIGHT

A *separation light* is any light that brightens part of your scene and keeps other parts dark so that it separates and defines the visual elements of the image. This type of light is very useful for black-and-white landscape photography because it can help you define your composition through the use of tonal contrast.

A separation light can really open up your landscape and highlight different elements in it (**Figure 8.10**). It's great for illuminating ridges of mountains, tops of rocks, edges of trees, and other things that allow you to create some definition in areas that might otherwise be a large blob of one tone.

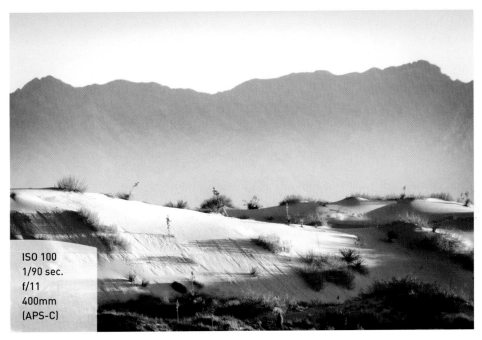

ISO 100
1/90 sec.
f/11
400mm
(APS-C)

FIGURE 8.10
The light on this White Sands National Monument scene separates and defines the visual elements of the composition.

Separation light often is a light coming from behind the subject and toward the camera, although behind the subject and to one side also work (Figure 8.10). Light coming from behind the subject and toward the camera can cause flare. Flare is never just one thing—it varies based on the lens you use (zoom lenses can be especially susceptible to it) and the angle you are to the light. A lens shade can help—I always use one on my lenses (it also helps protect them from stray fingers or other things that might touch the lens). In addition, you can hold your hand or hat out to block the sun from hitting your lens.

DRAMATIC LIGHT

In Chapter 3, you learned that dramatic light is useful for any landscape photography. It can be especially important for black-and-white images, where you have only the tonalities of the scene to define it. Dramatic light gives you dramatic changes in the tonalities from bright areas to dark areas. It especially gives strong shadows that can offer strength to the tonalities of your photo.

Shadows help define shapes into forms and make textures show up (**Figure 8.11**). Side light is an important light for many black-and-white photos because it does such a good job of both. Start looking for shadows and what they're doing in your black-and-white landscape, but also remember that although shadows can help, they also can hurt. Shadows in the wrong places across your scene can be distracting at any time, and this will be especially true with black-and-white imagery.

Now a caution: As soon as I say dramatic light is great, I know many people reading this will just start shooting dramatic light. But this isn't a cure-all that always works. It can be very effective for a black-and-white photo, but on the wrong subject, it can be terrible. Dramatic light coming from one direction may make a landscape look great, but from another direction at a different time of day, the light can look terrible because of shadows being in the wrong places, for example.

Also, dramatic light can be a challenge for exposure, especially if you have large areas of dark from shadows (this can be a large shadow or lots of shadow in texture). Your camera will see those dark areas and often overcompensate and cause important sunlit areas of the scene to be overexposed. Dramatic light can lose its effect when this happens. You may have to underexpose such scenes in order to hold the drama. However, this doesn't mean automatically shooting with a lot of underexposure, either—that can make for very murky, muddy-looking black-and-white photos.

FIGURE 8.11
The dramatic light on this landscape from California's Alabama Hills gives the image an abstract design of light and shadow.

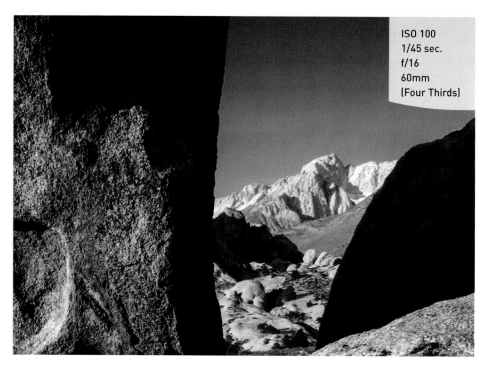

ISO 100
1/45 sec.
f/16
60mm
(Four Thirds)

BACKLIGHT

Backlight is something to make friends with if you want to succeed with black-and-white landscape photography. This does not mean that backlight is the only light to use for this type of work. It does mean that it offers so many benefits for black-and-white images that it has long been used for effective black-and-white landscape photography.

Many of the aspects of dramatic light also apply to backlight. When the sun is bright, backlight can be very dramatic (**Figure 8.12**). It creates bold shadows, sparkle on water, and strong texture. But backlight also helps when the light is more subtle as well. Subtle light can be challenging to use for black-and-white photography. By looking for backlight in those conditions, you often can gain some needed contrast.

Again, be very careful of your backgrounds with backlight. Avoid big, blank areas of sky. Avoid any large overexposed area. And watch out for glare and flare.

Sometimes no matter what you do, you can't avoid flare. And sometimes you can use that flare to good effect. Try moving around slightly to see if you can get the flare to fall in parts of the image that aren't hurt by it and where it might even add a cool look!

ISO 100
1/4 sec.
f/11
10mm
(APS-C)

FIGURE 8.12
A strong and obvious backlight adds drama to this image of towering redwoods in California's Humboldt State Park.

SILHOUETTES

Silhouettes are especially effective in black-and-white photography. A silhouette defines the composition by putting a dark foreground object against a bright background.

There are two things you really have to be careful of with a silhouette: the foreground object and exposure. You can't simply silhouette your object—pay attention to what it looks like and what angle will make that silhouette look its best.

Exposure is always an issue with silhouettes. You need to be careful not to give too much or too little exposure. Too much exposure will make the subject and background too bright, and you'll lose the silhouette effect. Too little exposure, and the background gets dark instead of light, and you'll also lose the effect. Your camera reacts to the brightness of the scene. If you have a lot of shadow, the camera will tend to give too much exposure, so you need to force it to give less (you can use minus exposure compensation with autoexposure).

If you have a large bright area behind the subject, the camera will tend to expose to make the bright area dark instead of bright. In that case, you need to force it to give more exposure (you can use plus exposure compensation with autoexposure). Also, you really need a lot of contrast between your subject and the background for a silhouette to work well (**Figure 8.13**). Just underexposing a subject in front of a background won't give you a silhouette. The image should start with high contrast between the subject and the background.

FIGURE 8.13
A silhouette is one of the strongest forms of tonal contrast that you can get. I chose both a specific Joshua tree and angle to it for its unique form and the relationship to the background.

ISO 100
1/15 sec.
f/22
23mm
(Four Thirds)

LOOKING AT COLOR FOR BLACK-AND-WHITE SHOOTING

After all this discussion about black-and-white issues, I want to come back to color. Although you have to be able to see beyond color, color is still important for black-and-white photography because color has to be translated into shades or tones of gray. Earlier in this chapter, you saw a problem that occurs when colorful pictures are simply converted to black-and-white images: Often the colors that created some contrast in the picture lose that contrast when they're changed to tones of gray.

In order to work effectively with color, you need to consider all the things discussed in this chapter about contrast and light. However, you can get good-looking black-and-white photos from images that have color contrast if you understand a bit about how color translates to a black-and-white image.

In the next section, I'll give you some ideas about the actual translation of color to black-and-white images in the computer. But first, I want to talk a little more about how we look at color when shooting black-and-white images.

Colors can be translated to any shades of gray that you want. A dark blue could be a dark gray or a light gray, depending on what you need from a photograph. But one of the things to keep in mind is that if you want different colors to separate as different shades of gray (which can be very important in a black-and-white photograph), then those colors need to be different as well.

That isn't as simple as it might seem. For example, think of a tree with yellow fall color that sits among a lot of other trees that have orange color. That yellow tree will still be distinct in the color image. However, orange has yellow in it, so the difference between the yellow tree and the orange trees won't be as strong when the image is converted to a black-and-white photo. On the other hand, if the yellow tree were against a blue sky, the tree would show up well both in color and black-and-white images. That's because the yellow can be adjusted to a shade of gray separately from the blue sky.

What all this means is that when you're out photographing a strongly colored scene and you think it might have potential for a black-and-white image, look for color contrasts that are strongly different so that the translation to shades of gray will be more easily accomplished.

TRANSLATING COLOR TO SHADES OF GRAY IN THE COMPUTER

Working from a color image that you translate to a black-and-white image in the computer is the best way of getting a black-and-white photo. The big reason for this is that you gain so much more control over how colors are translated into shades of gray than you had when you took the original photograph. Image-processing software offers the potential of using an almost infinite variety of filter effects that better separate colors into shades of gray than any filter you could ever use on your camera.

Another advantage of translating a color image to a black-and-white image is that you can make this translation differently in different parts of the image. That's something that's nearly impossible to do in the field. For example, you could translate the way that the sky and clouds are defined by one set of adjustments, and then use a different set of adjustments to help separate important pictorial elements of the ground.

In this book, I can give you only an overview of how you might do this conversion work in the computer, to get you started. *Black and White: From Snapshots to Great Shots,* by John Batdorff (Peachpit Press), goes into much more detail and is worth a look.

Photoshop, Photoshop Elements, Camera Raw, Lightroom, and Aperture all have good black-and-white conversion controls, but there are some variations in their approach. The key to using any of these black-and-white tools is to understand that you're trying to separate parts of your picture into contrasting tones of gray. Never simply accept the default translation of color to black, white, and gray without at least trying some variations. On all these programs, you can adjust some sort of color sliders to change how bright or dark the grays appear from colors in the image. Find the black-and-white controls (use the program's Help menu to locate them), and experiment a bit.

I don't have the space to go into all these programs in detail, but I'll give you an idea of how these controls work in Photoshop and Lightroom. Lightroom uses a section in Develop labeled B&W as a part of the Color and HSL panel. Click on B&W on that panel head, and the picture is instantly changed into shades of gray.

The first translation of your color image often doesn't do it justice (**Figure 8.14**). If you first look at that image, it's hard to believe that there are brightly colored cactus flowers in the foreground. With a little adjustment, the cactus flowers become bold and interesting in the photograph (**Figure 8.15**). You can see the original color and then the good black-and-white translation in **Figure 8.16**.

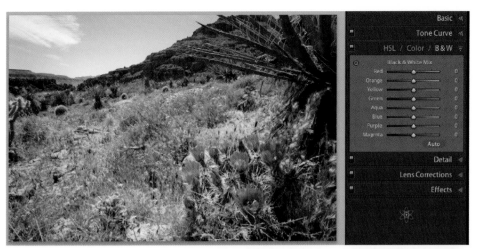

FIGURE 8.14
This Mojave Desert
landscape looks
a bit flat in the
default Light-
room translation
of the original
color image. The
foreground cactus
flowers have
disappeared.

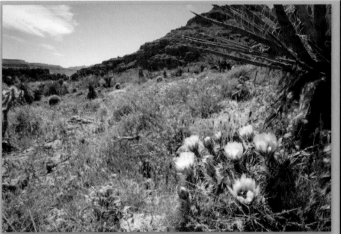

FIGURE 8.15
Now the landscape
is transformed with
livelier tonalities
and the foreground
cactus flowers
have become quite
obvious.

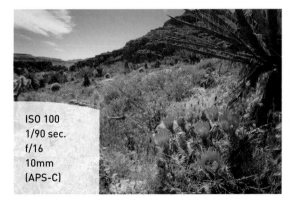

ISO 100
1/90 sec.
f/16
10mm
(APS-C)

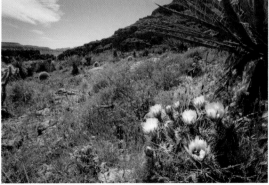

FIGURE 8.16
Here you can see the original color image and a good black-and-white translation of this desert landscape.

This adjustment in Lightroom is truly drag-and-drop easy. When you first try it, you may think that there has to be something else that you're missing, but there usually isn't. Once you've clicked on B&W, you need to click on the little target button in the upper-left corner of this adjustment panel (**Figure 8.17**). This activates your cursor so that when you move it over the picture, Lightroom automatically finds the right color for you. Then if you click and drag up and down on that spot, Lightroom makes that color a lighter or darker shade of gray. Press Esc to get out of this activated cursor.

FIGURE 8.17
Click on the target button at the upper-left corner of B&W in Lightroom. This activates your cursor to make it work on your image by clicking and dragging up and down.

Don't panic when you click on the picture and the cursor disappears—it's supposed to do that. Keep your mouse button pressed down, and just drag up and down and watch the gray tone get brighter or darker. Then click and drag on other parts of your picture to make them brighter or darker. It's that simple. The hard part is deciding what you want to be lighter and what you want to be darker. You always can adjust individual sliders as needed. All these adjustments are global adjustments, meaning they affect every instance of that color in the photo.

Photoshop has a similar control called Black & White in the Image menu under Adjustments; it's also one of the Adjustment Layer options. I recommend using the Adjustment Layer version because it offers a click-and-drag control similar to that used in Lightroom. And you can see that the default black-and-white translation is equally poor for the same image shown in Lightroom (**Figure 8.18**). *Remember:* This isn't a poor translation just because it's the default; it's a poor translation because the default conversion of color simply doesn't work well for this particular black-and-white image.

If you look carefully at the Black & White adjustment panel, you'll see a funky little icon of a hand with the pointing finger over a double-headed arrow (**Figure 8.19**). Click this arrow to get the same direct adjustment capabilities that are in Lightroom. One weird thing about this is that now you make the adjustments by clicking on something in the picture and dragging left and right to change the brightness of the tone rather than dragging up and down. And the cursor stays visible! This activated cursor is not available from the Black & White window from Image > Adjustments.

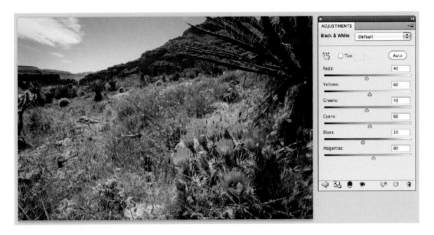

FIGURE 8.18
This Mojave Desert landscape looks flat in the default Photoshop translation of the original color image, too.

You don't have the full range of color conversion in Photoshop that you have in Lightroom. This doesn't necessarily mean that you can't get equally good translations of your image, but it may mean that you have to spend a bit more time tweaking the color sliders (**Figure 8.20**). Also, you always can adjust individual sliders as needed, just as you can in Lightroom.

In both Lightroom and Photoshop, you often need to do some additional contrast and brightness adjustments like those described in Chapter 10 to bring out the best in your black-and-white image.

FIGURE 8.19
Click on the hand icon at the upper-left corner of the B&W window in Photoshop. This activates your cursor to make it work on your image by clicking and dragging left and right.

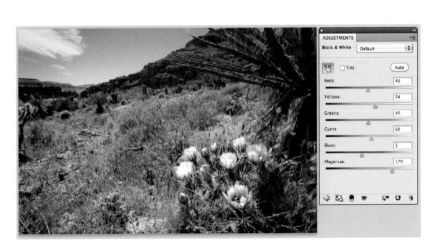

FIGURE 8.20
Now the landscape is transformed with livelier tonalities and the foreground cactus flowers have become quite obvious.

SILVER EFEX PRO

I think that the best way of translating color to black-and-white is with Nik Software Silver Efex Pro. All the black-and-white images you see in this chapter were translated from color using Silver Efex Pro except for the Mojave Desert shot used with Lightroom and Photoshop. Silver Efex Pro is what I use for creating black-and-white landscape photos.

Silver Efex Pro is a plug-in that works with Lightroom, Camera Raw, Photoshop, or Photoshop Elements. It doesn't work on its own—you have to have one of these other programs as a host program for it.

Silver Efex Pro does a number of things to make color to black-and-white conversion both easy and effective. First, there are a great set of presets along the left side that quickly give you a visual indication of different interpretations of your image (**Figure 8.21**). Next, on the right side, there is a section called Color Filter (**Figure 8.22**). This is one of the quickest and easiest ways of separating tones in your picture because of how it interprets the colors. Open that panel and then click on any of the little color filter icons. You also can click on the Hue slider to give you an infinite range of "color filters" and on the Strength filter to make the effect stronger or weaker.

FIGURE 8.21
Silver Efex Pro includes a very helpful set of presets that you can click on to start your black-and-white processing.

FIGURE 8.22
The Color Filter panel on the right is a quick and easy way of separating tones in your photograph based on the original colors.

The right side of Silver Efex Pro also includes global adjustments that allow you to make very effective changes in your brightness, contrast, and structure of your image (**Figure 8.23**). Structure in Nik Software products is something that changes the contrast of midtone tonalities and can really enrich a landscape photograph.

A very important and useful part of Silver Efex Pro (and, in fact, most Nik Software products) is the ability to use Control Points (**Figure 8.24**). Control Points allow you to target a very specific part of the image for adjusting and nothing else. They're far easier to use than Layer Masks in Photoshop, and you have much more control than using the Adjustment Brush in Lightroom.

FIGURE 8.23
Most photos need some overall adjustments, and the right panel gives you many controls to do just that.

FIGURE 8.24
Control Points are a unique feature of Nik Software products that allow you to adjust part of a picture without affecting anything else.

Chapter 8 Assignments

Search for Tonal Contrast

Set your camera to shoot in Black-and-White mode. Then go out and try to find at least 20 images that are based on tonal or brightness contrast within your scene. Look for changes in brightness that you can exploit as you take pictures. Use these tonal contrasts to help you define and structure a composition based purely on these changes in brightness.

Check Out Texture Contrasts

Texture contrast can be really interesting to use in black-and-white images. But you have to search them out, and you have to look for distinct differences in textures in order for this to work. Again, set your camera to its Black-and-White mode and go out and photograph texture differences. When you start becoming aware of them, they'll become more obvious and you'll start finding them everywhere.

Be Bold with Light

Keeping your camera set to the Black-and-White mode, go out and look for bold and dramatic light. Don't try to find interesting subject matter in the landscapes. Find that interesting subject matter in the way the light interacts with the landscape. Photograph the light, not just the landscape, and look for bold light that does something impressive with the landscape.

Experiment with Translating Color

This is one of the most important exercises that you should do in exploring black-and-white photography. Bring a color image into your image-processing software and go to the black-and-white conversion controls. Note what the image looks like with the default conversion. Then just try adjusting the color sliders to see what happens to the tones in your image. Don't be afraid to make extreme adjustments just to see what happens. This will give you some really good ideas on how colors translate to black-and-white tones.

Share your results with the book's Flickr group!

Join the group here: www.flickr.com/groups/LandscapesfromSnapshotstoGreatShots

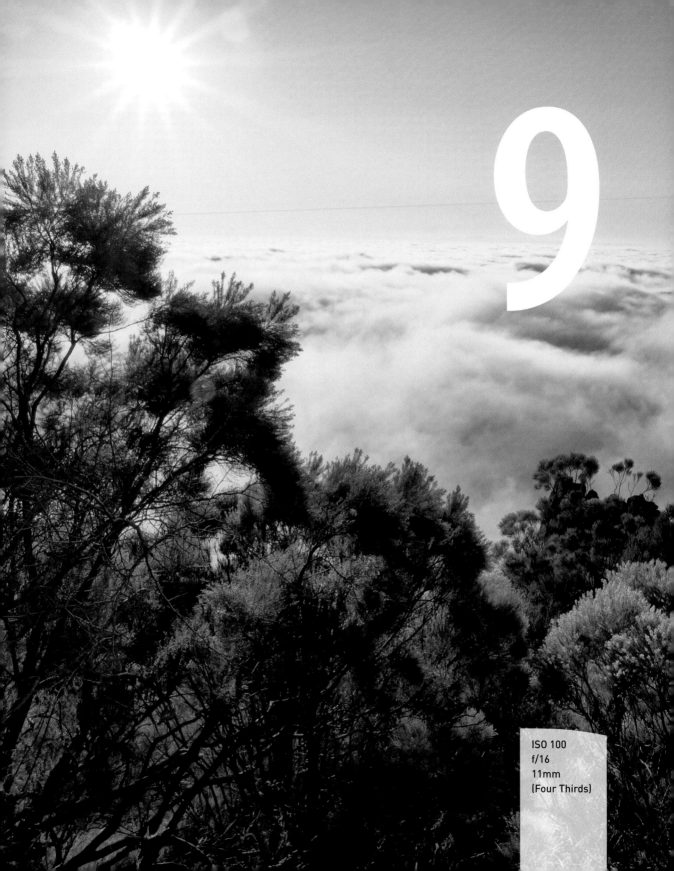

9

ISO 100
f/16
11mm
(Four Thirds)

HDR

CAPTURING MORE OF YOUR LANDSCAPE

Let's acknowledge the elephant in the room right away. Many people think that high-dynamic-range (HDR) photography is gimmicky and not appropriate for traditional landscape photography. I acknowledge that HDR can be gimmicky, but it doesn't have to be. It's possible to do HDR landscapes that are totally real and accurate. I believe HDR can be a very important tool for all landscape photographers. And whether or not you know what HDR is all about, this chapter will help you understand and use it.

Personally, I'm not that interested in the gimmicky aspects of HDR photography. What HDR does do, however, is enable you to capture a wider range of tonality from a landscape than your camera can handle. Cameras simply can't see the world the way that we do, and HDR allows us to capture images that potentially come much closer to the way that we see the world.

In many ways, HDR photography is a lot like Ansel Adams's Zone System. Adams would expose carefully for the conditions and then process the image to get the widest range of tonality appropriate to that landscape. With HDR photography, you expose carefully for the conditions and then process the image to get the widest range of tonality appropriate to that landscape as well!

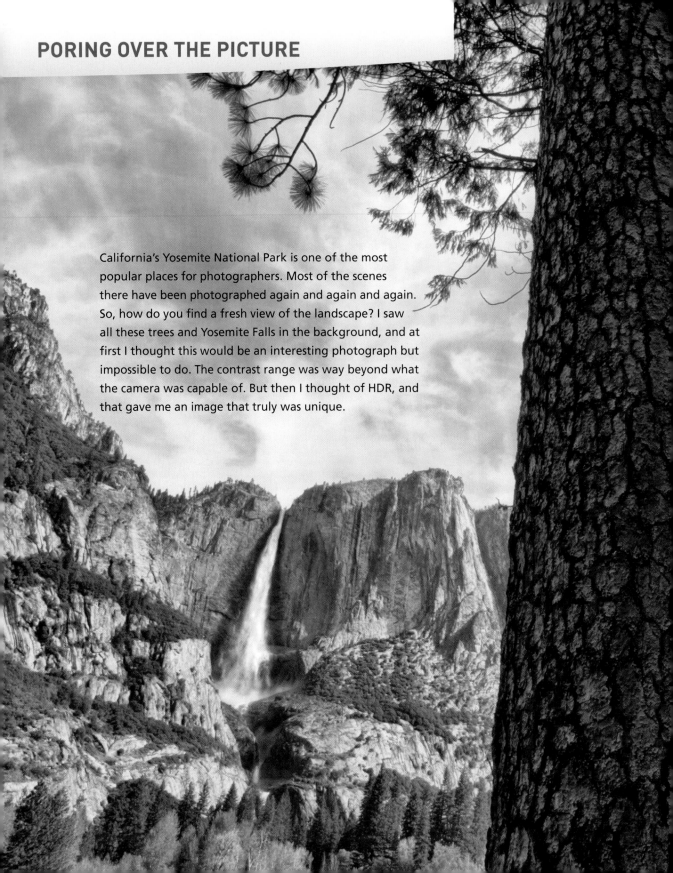

PORING OVER THE PICTURE

California's Yosemite National Park is one of the most popular places for photographers. Most of the scenes there have been photographed again and again and again. So, how do you find a fresh view of the landscape? I saw all these trees and Yosemite Falls in the background, and at first I thought this would be an interesting photograph but impossible to do. The contrast range was way beyond what the camera was capable of. But then I thought of HDR, and that gave me an image that truly was unique.

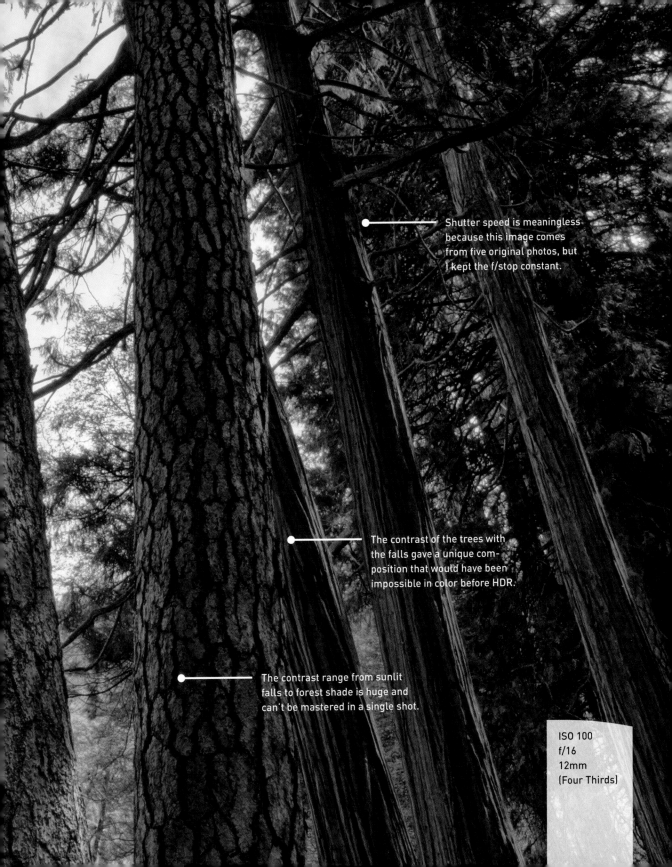

Shutter speed is meaningless
because this image comes
from five original photos, but
I kept the f/stop constant.

The contrast of the trees with
the falls gave a unique com-
position that would have been
impossible in color before HDR.

The contrast range from sunlit
falls to forest shade is huge and
can't be mastered in a single shot.

ISO 100
f/16
12mm
(Four Thirds)

The textures of the shadowed part of the rock add a strong visual element to the foreground.

The sunlight on the rock and on the ridges in the background is still important for shaping the landscape.

This is a small arch (the opening is about 12 inches wide) in the rocks at Castro Crest in the Santa Monica Mountains of California. I wanted to give a feeling of the setting, but the light made the contrast great between the shadows of the arch and the bright sky. No exposure could hold detail in both the shadowed parts of the arch and the blue of the sky. HDR let me capture an image much closer to what I originally saw.

I used a small aperture with a wide-angle focal length to maximize sharpness from foreground to background.

This bold composition wouldn't be as interesting or as effective if the background were washed out.

ISO 100
f/11
10mm
(APS-C)

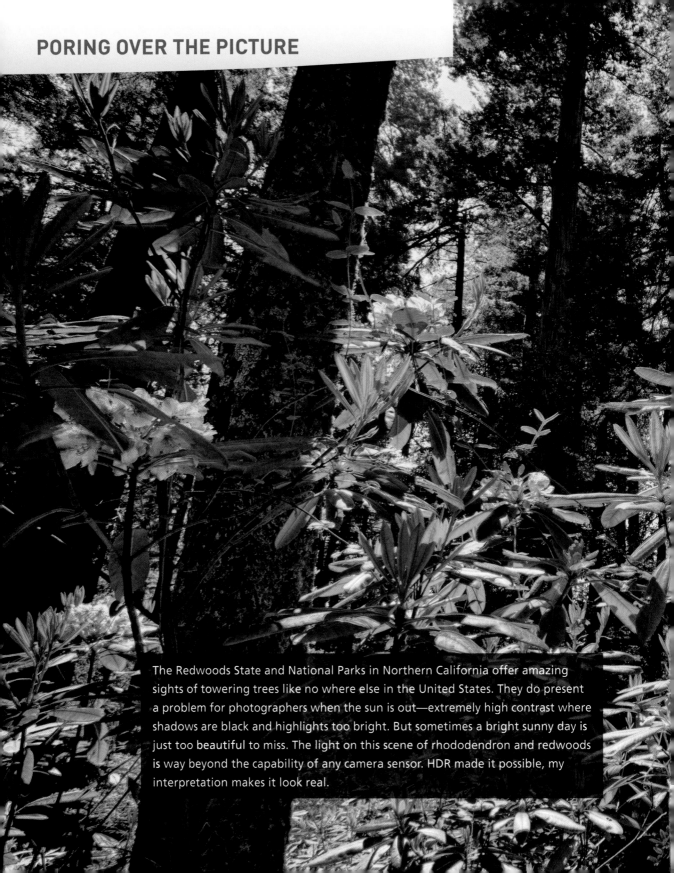

The Redwoods State and National Parks in Northern California offer amazing sights of towering trees like no where else in the United States. They do present a problem for photographers when the sun is out—extremely high contrast where shadows are black and highlights too bright. But sometimes a bright sunny day is just too beautiful to miss. The light on this scene of rhododendron and redwoods is way beyond the capability of any camera sensor. HDR made it possible, my interpretation makes it look real.

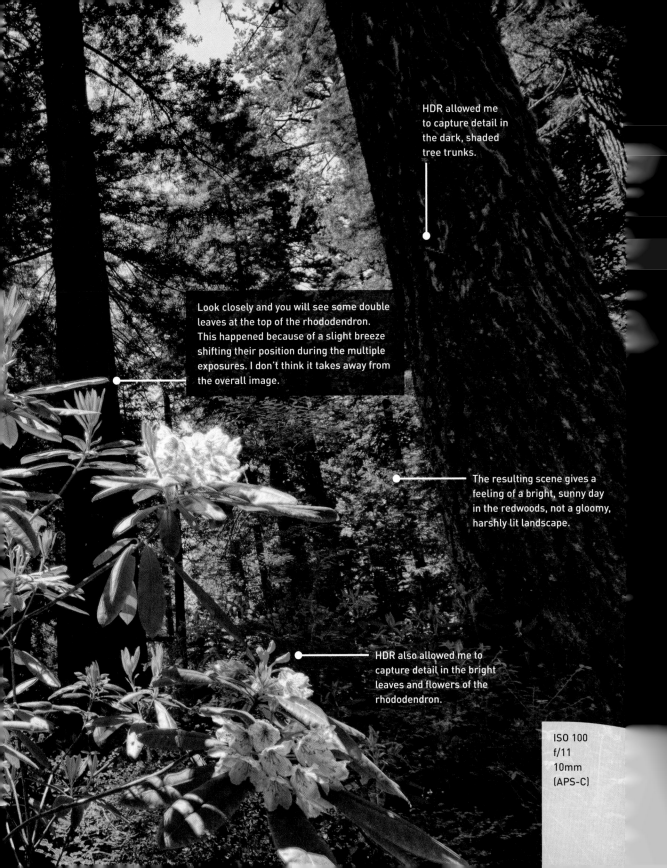

HDR allowed me to capture detail in the dark, shaded tree trunks.

Look closely and you will see some double leaves at the top of the rhododendron. This happened because of a slight breeze shifting their position during the multiple exposures. I don't think it takes away from the overall image.

The resulting scene gives a feeling of a bright, sunny day in the redwoods, not a gloomy, harshly lit landscape.

HDR also allowed me to capture detail in the bright leaves and flowers of the rhododendron.

ISO 100
f/11
10mm
(APS-C)

HDR BASICS

High-dynamic-range photography is exactly that: photography that offers a higher *dynamic range* (range of tones) than your camera and sensor can capture on their own. It allows you to photograph scenes that used to be very difficult to get because the brightness from highlights to shadows were considered extreme. You can see such scenes just fine, but your camera can't, so HDR photography has the potential to give you photographs closer to what you can see.

HDR photography starts with multiple exposures of a scene to cover the range of brightness in the landscape. Each exposure varies by one to two steps of exposure change (a full f-stop is one step). These photos are best taken from a locked-down camera position on a tripod. Then they're brought into the computer in order to combine the best tonality and color from the multiple shots into one.

SHOOTING FOR HDR

Here's a fast and easy way to shoot for HDR:

1. Put your camera on a tripod and compose your picture.

2. Set your camera to Aperture Priority mode. It's important to keep your depth of field consistent from picture to picture. Aperture Priority mode allows you to set your f-stop and then have the camera vary the shutter speed for the changes in exposure.

3. Set your camera to Auto Exposure Bracketing (AEB). Set up your bracketing so that you get an exposure change of at least one full EV step. (EV stands for *exposure value,* and it's used for bracketing.) I find that 1.5 steps works well for me most of the time. Some cameras offer three exposures at the exposure value you've chosen: one exposure based on what the camera meter thinks is proper, one exposure 1.5 steps overexposed, and one exposure 1.5 steps underexposed. Other cameras will add additional exposures for this mode. Three exposures works well to start.

4. Take the three (or more) exposures you've set with your AEB. On many cameras, you can set the self-timer to two seconds; when it's triggered, it will set off a complete set of exposures for the bracket.

5. Check your images on your LCD. Check the brightest exposure and the darkest exposure. Look to see that your brightest exposure is giving reasonable detail in the dark areas of the picture. Then check the darkest exposure to be sure that your bright areas are being exposed well.

6. If you find that all the pictures are too dark, shift your base exposure to give the image more exposure. If all the pictures are too light, shift your base exposure to give less exposure.

7. If you find that your exposure range doesn't fully capture the brightest and darkest parts of your scene, do more than one set of auto bracketing, changing your base exposure appropriately so that you do get a range of exposures that cover the brightness range of the scene.

This procedure is exactly what I did in photographing Fern Canyon in Prairie Creek Redwoods State Park in California. If the sun is out, this location is practically impossible to photograph and show off what the canyon actually looks like. In the past, photographers would always shoot it in foggy conditions, which are not unusual along the northern coast of California, in order to get light that better matched the capabilities of the camera.

However, if you always have to wait for a foggy day, you're going to miss opportunities to portray landscapes the way that they appear on other days. You can see from the three images that were shot using different exposures that none of them handle the bright areas and dark areas well at the same time (**Figure 9.1**). The contrast is simply too great. The final image offers a bright view of this scene that is much closer to what you would see if you were there (**Figure 9.2**).

FIGURE 9.1
Three different exposures were used to capture the brightness range of Fern Canyon. The f-stop stayed the same while the shutter speed varied (1/8 sec. top, 1/20 sec. middle, and 1/3 sec. bottom).

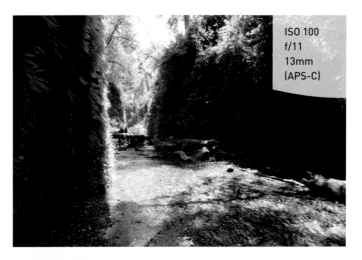

ISO 100
f/11
13mm
(APS-C)

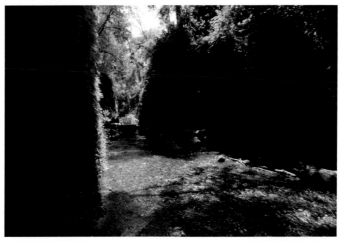

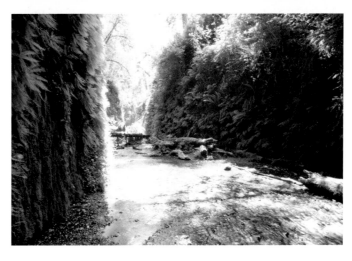

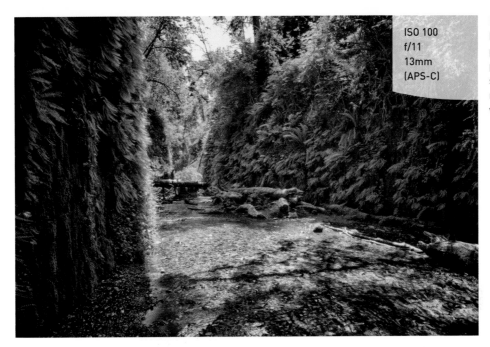

ISO 100
f/11
13mm
(APS-C)

FIGURE 9.2
I combined the photos in the computer, and now the scene has a tonal range closer to what I actually saw.

Here are some pointers to keep in mind as you practice shooting for HDR:

- **Pay attention to the range of auto bracketing your camera allows.** You need at least a full step difference in exposure for each shot; 1.5 or 2 steps is better. If your camera doesn't allow AEB of at least a full step, you'll need to change the exposure manually. For example, my Sony NEX camera brackets only up to a +/– 0.7 step, which isn't enough. When I use this camera, I don't use AEB; instead, I set each exposure manually.

- **Make sure you've done everything you can to minimize camera movement before you shoot.** All your shots have to line up with one another in order for HDR to work. Modern HDR software does try to deal with variations in the images, but any strong movement will be difficult to work with. One way to minimize movement is to shoot with the camera's drive mode set to Continuous; this allows you to hold down the shutter and get a series of exposures without doing anything that might move the position of the camera. If you have to set your exposures manually (as I have to do with my NEX camera), be sure to really lock down your camera on the tripod; set an f-stop for needed depth of field and then vary only the shutter speeds.

- **If you can't minimize movement (for example, under windy conditions), you may not be able to take the picture with HDR or you may just have to wait until the wind calms down.** Running water may or may not be a problem—that's something that I find hard to predict so I shoot it anyway (**Figure 9.3**).

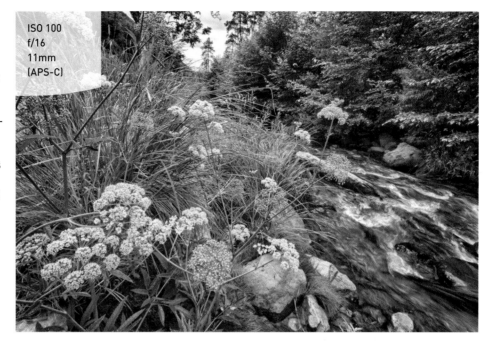

FIGURE 9.3
There is so much in this image that could move and spoil this HDR shot along Oak Creek in Sedona, Arizona. The stream's movement isn't a problem, but any wind would cause issues with the flowers in the foreground and other plants.

ISO 100
f/16
11mm
(APS-C)

COMBINING THE SHOTS FOR HDR

Once you have your three or more exposures, you need to be able to put them together in the computer. There are a number of programs available that allow you to combine the images to create a true HDR file. The actual conversion of your images to HDR is fairly straightforward: You simply tell the program which images to use from your hard drive and it combines them.

What these programs do is look at the brightness range of all the images, and then take essentially the best parts of each picture to combine them into an image file that has a huge range of tonality or dynamic range. That range is greater than what your monitor is capable of displaying. The program then creates what is called a *tone map* to map the limited number of tones available for display to the huge amount of tones in the file.

Every program does this slightly differently. In most programs, you never see the true HDR image, only a tone-map version. You can control how the image looks by adjusting things like contrast, brightness, color saturation, small detail enhancement, and so forth.

How the program interprets the HDR image as it tone maps it and the controls that you have over adjusting it give you the ability to greatly affect the look of your HDR image. You can go from a very funky, so-called "artistic" look to a very realistic landscape image, depending on how you use these controls.

Although HDR programs have become easier to use, using them to create natural-looking images takes some practice. Photoshop has had an HDR capability for a while, but I wasn't too impressed with it until the CS5 version. Most of my HDR work is done with Nik Software HDR Efex Pro (**Figure 9.4**), a plug-in that works with Lightroom and Photoshop. Many photographers have had success with Photomatix HDR software, which works both as a plug-in and as a standalone program.

FIGURE 9.4
Nik Software HDR Efex Pro offers a great deal of flexibility in how you adjust your HDR image.

IN-CAMERA HDR

Many cameras today have HDR capabilities built into the cameras themselves. Surprisingly, point-and-shoot cameras were the first to have these capabilities. I think manufacturers thought it was more of a gimmick until photographers really started to look for this feature. Now HDR capabilities are available in most types of cameras.

In-camera HDR usually works by having the camera shoot three images of different exposures and then process them inside the camera. You get a final image that combines the best of the three exposures. This is a great way to try out HDR. The downside is that you don't have as much flexibility as you do when you process HDR images in the computer.

HDR FOR NATURAL EFFECTS

Natural-looking landscapes are possible with HDR (**Figure 9.5**). It starts when you're taking your pictures. There isn't a lot that you can do with the camera to get a more natural shot, other than being sure you have a full range of tones from the bright areas to the dark areas in your exposures.

Light, as always, plays a big part in how successful your images will be. Everything about light in Chapter 3 still applies when you're using HDR. I've sometimes seen photographers try to use HDR as a panacea for bad light. Bad light for a landscape is often bad light regardless of the way you're photographing it.

What you can do with light is expand how much is seen in the shadows and highlights at the same time. In the past, high-contrast light often meant that you could expose for only part of it and you had to let the rest go. That might result in an image that had good-looking light on part of the landscape, but the rest of it was almost black. Such a picture isn't necessarily a bad image—sometimes that sort of light is very dramatic and quite effective. With HDR, though, you get another option that can give you bright and open scenes that never would've been possible in the past.

FIGURE 9.5
You would hardly know this scene in California's Santa Monica Mountains is an HDR image unless you thought about how difficult it would be to hold detail in the sky and sun and still see all the rocks, shadows and all.

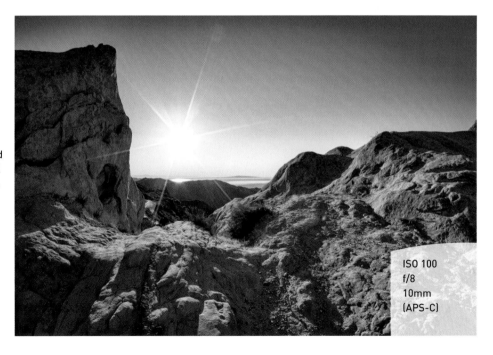

ISO 100
f/8
10mm
(APS-C)

I do want to point out something in this photograph of spring along the Apalachicola River (**Figure 9.6**). The image has a very open feeling to it from the HDR. For me, this was much closer to my experience of spring there than the heaviness that I got from any exposure that would hold detail in the bright areas. Now, if you look closely, you may notice that there is a slight bit of added brightness in the sky along the top edges of the trees. This is an artifact of the HDR process. It's possible to process your image so that you don't get that artifact, but I happen to like the way that the sky appears in this image, so I left it.

Some people say that HDR isn't real and is manipulating the landscape image. I say that a scene with a strong contrast that I just described—part of it in nice light, but the rest of it very dark—usually doesn't make for a very realistic image. If the bright areas look good, the rest of the image will be very dark. We don't generally see scenes like that. The camera does, but that doesn't make it real just because that's what the camera captures.

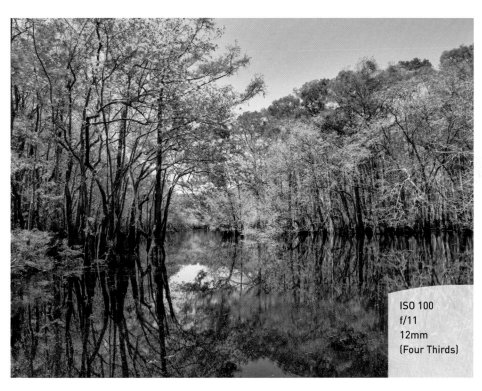

ISO 100
f/11
12mm
(Four Thirds)

FIGURE 9.6
With HDR, this landscape along the Apalachicola River in northern Florida has the feeling of a bright and airy spring.

I think that the HDR image of such a scene can be closer to reality. HDR gives us a new tool to show off the world in better ways (**Figures 9.7** and **9.8**). I think it's funny that some publications won't use HDR images because they aren't "real," yet they *would* print a distorted reality based on the limitations of the camera and call that "real."

When processing your image, you can do some things to get a final result that's more natural looking. One reason I like HDR Efex Pro is that it gives you a set of presets with previews on the left side of the screen that you can use to decide which method of tone mapping looks best for the scene you're working with.

Once you have an image processed in your HDR program, do the following in order to give your image a more natural look:

- **Check your blacks.** One thing that will make an HDR image look very unnatural is if the darkest parts of your photo are gray and not black.

- **Watch the saturation.** It isn't unusual to have an HDR image gain too much saturation when it's processed. That can make the scene look very unrealistic.

- **Look carefully at the midtones.** The midtones of any image are always important, but sometimes in HDR images they become too contrasty and separated. That isn't a normal look, and you may need to adjust the image to avoid it.

- **Do more than one HDR conversion.** Sometimes getting everything in the picture looking its best with one conversion is really difficult. Try doing one conversion that makes the ground look good and then another conversion that's optimum for the sky. Then put these two images together in Photoshop.

- **Don't consider your final conversion final!** There's only so much that you can do to an image in the HDR program itself. Bring your image back to Lightroom or Photoshop and do some tweaking there to be sure that the image is looking its best.

ISO 100
f/11
80mm
(APS-C)

FIGURE 9.7
The stormy sky over these cliffs near Sedona, Arizona, has a great deal of subtle tonalities that are lost in a single exposure. In addition, the color and texture of the rock shows up better in this HDR shot.

FIGURE 9.8
In order to hold detail in the brightest parts of the sky in one shot, I had to expose everything else to a dark tone. This makes the image heavy and perhaps moody, but it loses the more realistic feeling of the HDR shot. We don't normally see the rocks as so dark and muddy looking.

WILD EFFECTS AND HDR

If you really like to play with your photography, you might enjoy doing more special-effects type of HDR work. This can give you some very interesting looks that aren't based on what either you or the camera actually saw (**Figure 9.9**). Not everyone likes this look, but you may love it. Personally, I'm not fond of using it much, but I know some photographers, including Dan Burkholder, who have done some absolutely stunning work with the wilder edges of HDR. (Check out the Color of Loss on Burkholder's website, www.danburkholder.com.) There are no real rules when you start moving into this type of photography because you're leaving the bounds of reality.

FIGURE 9.9
The conditions this morning along the coast of Northern California were hazy sun, not at all what this HDR image shows.

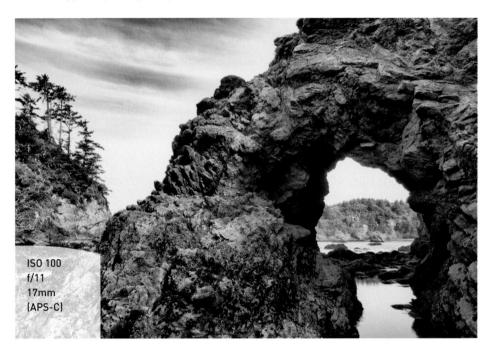

ISO 100
f/11
17mm
(APS-C)

Chapter 9 Assignments

Just Try It!

If you've never tried HDR photography, the best assignment I can offer for you is to just go out and try it. Find a location that has an extreme range of brightness from shadow to highlight areas. Take a look at it and notice what you can see with your eyes. You should be able to see detail in the dark and bright areas at the same time. Now take a picture with exposure based on the bright area so the bright area isn't too bright. Notice how dark the rest of the picture becomes. Take an exposure based on the dark areas and notice how washed out the bright areas become. Take a couple pictures in between, and then bring this sequence of images to your computer and try processing them in HDR. Most HDR programs offer a free trial version for a couple weeks to a month, so you can try them out for no cost.

Experiment with Clouds

Clouds are a great part of HDR photography. HDR often strongly brings out clouds. One of the big problems photographers have with clouds is that to expose bright clouds properly, the rest of the scene is just too dark. With HDR, we can get clouds exposed properly and reveal detail in the ground as well. Go out on a day that has clouds. This can be any sort of clouds, including clouds that cover the sky, as long as there's some definition in the clouds—a bland gray sky won't work. Then shoot a series of exposures and bring them back to the computer to see what you can do with the clouds.

Check Out Movement

Movement can definitely cause problems with HDR photography. When the HDR software tries to line up images that have picture elements that have changed, it doesn't quite know what to do with them. You never know what you'll get. Sometimes it's just ugly, and sometimes it's interesting. But it's worth doing some experimenting so you at least get a feel for what movement does in HDR. Take some pictures of a scene where something moves in it as you do your sequence of exposure changes on that scene.

Share your results with the book's Flickr group!

Join the group here: www.flickr.com/groups/LandscapesfromSnapshotstoGreatShots

10

ISO 100
1/100 sec.
f/16
18mm
(APS-C)

Traditional Darkroom Work on the Computer

SEEING HOW ANSEL ADAMS'S IDEAS STILL RESONATE IN THE DIGITAL AGE

The tradition of landscape photography goes way back. This is where photography got started. Black-and-white landscape photography has had a strong influence on all photography and continues to influence landscape work today.

The tradition of landscape photography also goes back to the darkroom. As Ansel Adams said in his book *The Print,* "Much effort and control usually go into the making of the negative, not for the negative's own sake, but in order to have the best possible 'raw material' for the final [image]." That is darkroom work.

PORING OVER THE PICTURE

The Pacific Coast from California to Washington offers many great locations for landscape photography. This image was taken in Northern California not far from Crescent City. I started shooting from before the sun went below the horizon until well after sunset. The cloud didn't stay the whole time.

The beach and rocks at the lower right were too dark in the original shot, so I opened them up with a traditional darkroom technique of local brightness control.

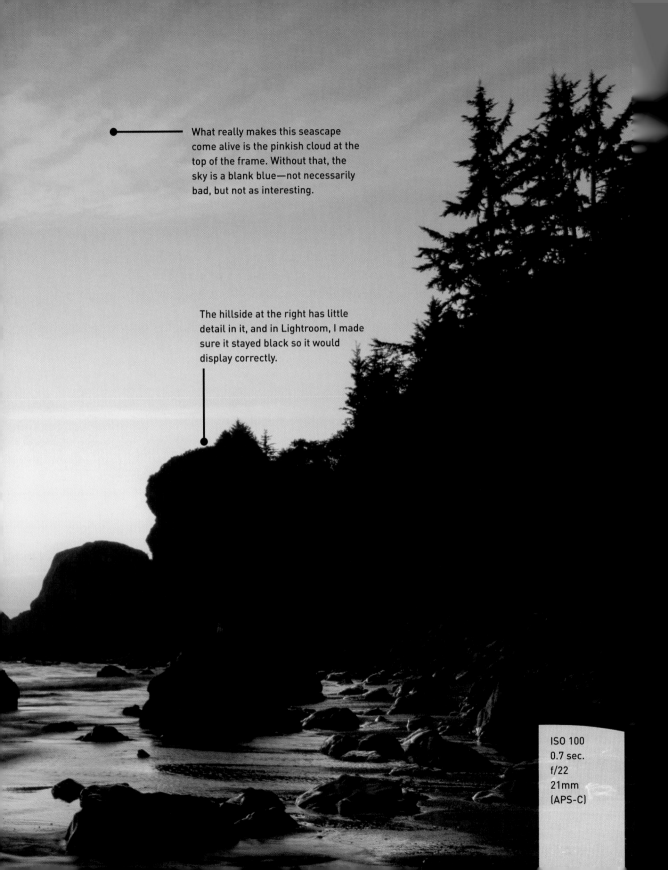

What really makes this seascape come alive is the pinkish cloud at the top of the frame. Without that, the sky is a blank blue—not necessarily bad, but not as interesting.

The hillside at the right has little detail in it, and in Lightroom, I made sure it stayed black so it would display correctly.

ISO 100
0.7 sec.
f/22
21mm
(APS-C)

PORING OVER THE PICTURE

A challenge all photographers face with digital cameras is that they tend to overemphasize the gray, low-contrast conditions of a cloudy day. Photos taken then almost look like they were shot with a gray dulling filter. In this image, the forest scene along the Elwha River had to be adjusted deliberately to enable this Olympic National Park landscape to display properly.

The textures of these early spring trees and their contrasts were revealed by setting blacks and whites in Lightroom.

Midtone adjustments ensured that the image had the proper overall brightness.

A traditional Ansel Adams technique of edge darkening gave the image more depth and strengthened the composition.

Structure in Viveza 2 helped enhance the visual strength of the trees.

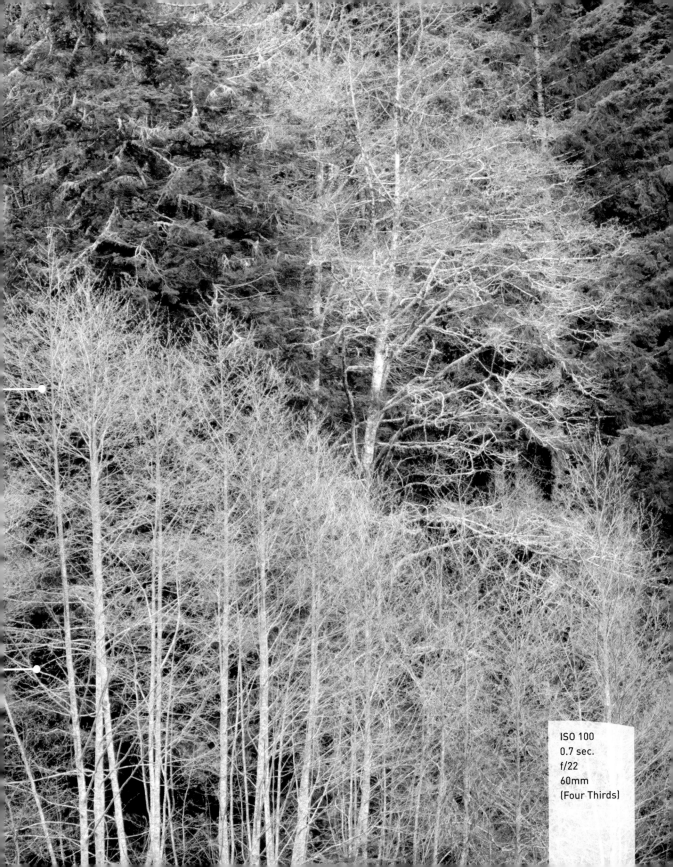

ISO 100
0.7 sec.
f/22
60mm
(Four Thirds)

PORING OVER THE PICTURE

This shot of a spring landscape was captured in the Alabama Hills area of the Eastern Sierra near Lone Pine, California. The original image (inset) is rather gray and does not come close to conveying what the scene really looked like. In addition, there is green flare in the lower right corner due to the sun being close to the edge of the frame— definitely not part of the landscape. With some work on the file, the scene comes alive. I used Adobe Photoshop Lightroom and Nik Software Viveza 2 to bring out the best from the original image file.

The big rocks of the Alabama Hills are always dramatic, and they looked quite interesting next to the trees. I toned down the big rocks on both the right and left of the trees to give a bolder framing.

ISO 100
1/125 sec.
f/11
75mm
(APS-C)

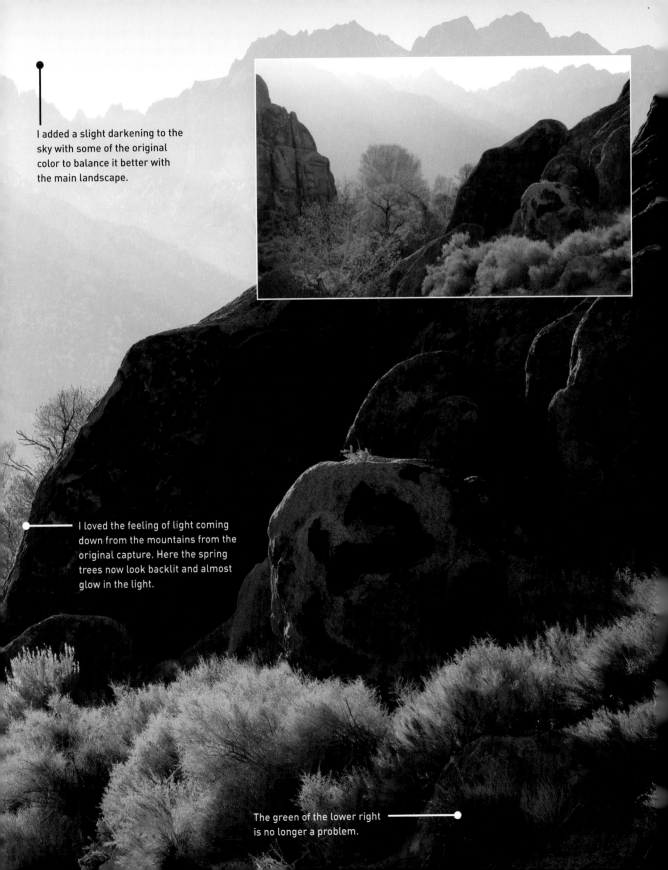

I added a slight darkening to the sky with some of the original color to balance it better with the main landscape.

I loved the feeling of light coming down from the mountains from the original capture. Here the spring trees now look backlit and almost glow in the light.

The green of the lower right is no longer a problem.

The *LIFE* magazine photographer Andreas Feininger once said that the uncontrolled photo is a lie because of the way it arbitrarily and superficially records reality. In the darkroom, the photographer continues the control over the image that started when the photo was shot. That control can make the photograph lie worse, but it also can make the photograph more truthfully and accurately show off the landscape and better express how the photographer felt about the landscape in the first place.

This is why the computer and its controls for processing your landscape photograph are so important to effective landscape photography. This book is not a guide to using the computer for better image processing. But this chapter will give you some important things to keep in mind when you're working on a landscape photograph in the computer.

REFINE YOUR PHOTOS WITH TRADITIONAL DARKROOM TECHNIQUES

I believe that one of the best references for working on landscape photos in the computer is Ansel Adams's book *The Print,* originally published in the 1950s and still in print today. You'll also need some instruction on how to use whatever software you're using, but the Adams book has outstanding information on how you look at an image and adjust it to get the most from it.

One of the challenges that I think many photographers face is trying to master software rather than mastering their photographs. There is no question that a lot of the instruction and books that are available on image-processing software is about the software, not about the photography. I think the key to better landscape images is remembering to keep the image the star.

As you read this book, you've probably noticed that I think it's a big deal that photographers and our cameras don't see the world in the same way. Sometimes the limitations of the camera can cause us problems and make it difficult to get the photographs that we believe are possible. Working on your image in the computer often will reveal the true photograph that you envisioned when you first took the picture.

You can really see this in Figures 10.1 and 10.2. This scene of a small stream in Yosemite National Park had its contrast overemphasized by the camera (**Figure 10.1**). This wasn't at all how the image really appeared, but the camera had trouble dealing with the range of brightness from the white water to the dark rock. Working mostly in Lightroom, I was able to balance out the tonalities in the picture to show off the scene much better (**Figure 10.2**).

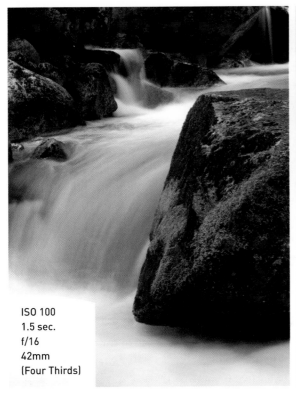

ISO 100
1.5 sec.
f/16
42mm
(Four Thirds)

FIGURE 10.1
The camera had trouble dealing with the contrast range of the tonalities of this stream and rocks. I had to expose to hold detail in the brightest areas, which made the rocks very dark.

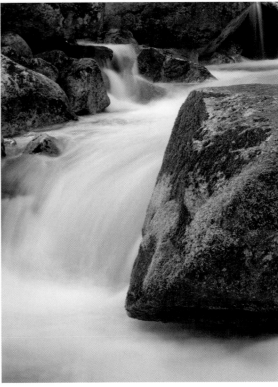

FIGURE 10.2
Midtone adjustment and local adjustments were very important to bringing out the original qualities of this scene.

GLOBAL VS. LOCAL ADJUSTMENTS

There are also two ways of looking at adjustments on a picture: global and local. *Global adjustments* are adjustments that affect the whole image. In other words, if you change a color, that color throughout the entire photograph is affected. These were the overall adjustments that a photographer made to a print first when working in the darkroom.

Local adjustments are adjustments that are confined to a specific part of the image. They don't affect the entire image. In the darkroom, these adjustments were done by dodging (lightening) and burning (darkening) local or specific parts of the photograph. In other words, with a local adjustment you can brighten a rock in the foreground and not brighten the entire picture.

BASIC PHOTO NEEDS: A WORKFLOW

You can do many things with a photograph, including cropping it, sharpening it, straightening horizons, and so forth. You can learn those sorts of things in many books about specific image-processing programs. In this section, I'll emphasize a workflow covering the four basic photo needs that are important for all image processing. These steps go back to the traditional darkroom and are absolutely important today:

1. **Blacks and whites.** You need to set blacks and check whites in your photograph.
2. **Midtones.** Midtones include the tonalities between pure black and pure white in your photograph, and how they're separated has a strong effect on the overall appearance of the image.
3. **Color.** Color is never a simple thing, and cameras don't always capture it accurately. Color needs to be corrected when it's wrong and enhanced when it isn't displaying properly.
4. **Local adjustments.** Specific adjustments that affect part of the picture's brightness and color are the most common local controls.

BLACKS AND WHITES

When I learned printing in the darkroom, I had to place the print face down in the developer as it developed. The print had to be kept that way until two minutes had passed to allow the image to be developed properly for its blacks and whites. If the image was processed face up, there was a temptation to pull it out of the developer

too early if it was getting too dark—but that wouldn't ensure the proper blacks and whites.

By the way, the terms *blacks* and *whites* are used, even though there really is only one black tone and one white tone. The reason for this is that the terms refer to all the areas of black or white within the picture—hence, the use of the plural.

Most images need at least something that is pure black and something that is pure white in the image. This was true in Adams's day (he talks about it in *The Print*) and it's true today. Now, I don't want to give the impression that this is an absolute rule for every photograph. A foggy day, for example, has no blacks and whites in it, and it will never look right if you try to put them there. However, most images need pure black and pure white in order to use the full range of the tonality of the media, whether that's a print, a computer monitor, or the printed page (**Figure 10.3**).

Blacks can look good with a range of adjustments as long as there is something black that should be black. This makes adjusting blacks more subjective than adjusting whites. How strongly you adjust the blacks will affect the contrast and mood of a landscape.

PHOTO EDITING VS. PHOTO PROCESSING

Traditionally, for photographers, *photo editing* simply meant going through all the photographs you shot to pick the good ones and organize everything. When Photoshop and similar programs were developed years ago, the folks using those programs were able to go into the image and cut out pixels, add something from another picture, move sections of the picture around, and so forth. They were literally editing the pixels so they used the term *photo editing*. This was a bit confusing for long-time photographers, but most of these early users of Photoshop weren't photographers—they were users of photography in the computer.

When you start adjusting an image using traditional darkroom techniques, you aren't doing photo editing in the computer sense. You're making image adjustments, or *photo processing*. This may seem like a slight distinction, but this change in attitude affects how you look at and work with your picture. It's interesting that Lightroom, a program that was developed specifically for photographers (which Photoshop never was), doesn't use the term *photo editing* in anything that you do with the picture inside of Lightroom. It only uses the term *photo editing* when you move the picture from Lightroom to another program, such as Photoshop. That choice of words is deliberate. If you look at working on your image as photo processing, not photo editing, you'll look at both your photograph and how you work with your photograph differently.

FIGURE 10.3
The first image in this pair has not had its blacks and whites adjusted. It almost looks like it was shot with a gray dulling filter. The only difference with the second image is that its blacks and whites have been adjusted.

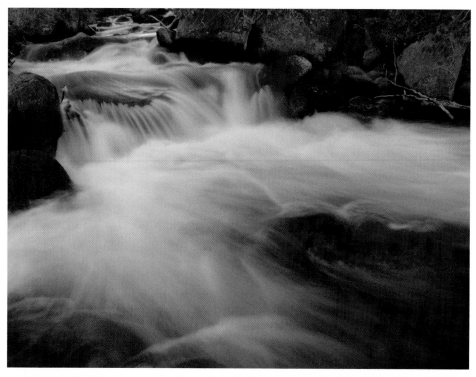

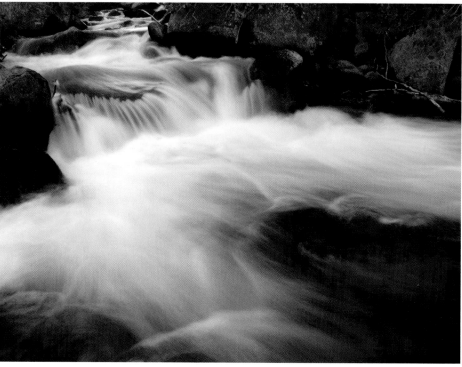

Whites are extremely sensitive to over-adjustment. If blacks lose detail, they just look black. If whites lose detail, they look washed out and empty. A bright sun and bright highlights on water can be pure white without a problem. But most other parts of the picture generally should not be.

LIGHTROOM AND CAMERA RAW

In Lighroom, blacks and whites are adjusted with the Blacks and Whites slider in the Basic section of the Develop module. (Before Lightroom 4, whites were adjusted with the Exposure slider using the same technique, but the Exposure slider is not the same in Lightroom 4 as it is in earlier versions.) Camera Raw uses the same processing sliders and techniques as Lightroom.

One thing I really like about Adobe products is that you can press and hold Alt (PC) or Option (Mac) as you make the adjustment in order to see a threshold screen that shows you exactly where the blacks and whites are in the image. That makes this adjustment truly visual and helps you make it quickly and easily.

For blacks, press and hold the Alt or Option key as you click and drag the Blacks slider. Your image will turn white because usually there won't be any blacks in the picture. Move the slider to the left until you start to see colors and/or actual black in the photograph. (In versions of Lightroom prior to Lightroom 4, move the slider to the right.) Anywhere you see a pure black in this threshold screen, you'll have a pure black in the photograph.

On most pictures, you'll want to have at least something black showing up (**Figure 10.4**). Sometimes you'll get a photograph that has a highly colored subject matter. Then you might not get or even want a pure black. In this situation, you'll see colors appearing. Those colors indicate that you're maxing out color channels, which is okay for that type of picture.

For whites, press and hold the Alt or Option key as you click and drag the Whites slider. Your image will turn black if there are no whites. Usually, I'll move the slider until either colored or white spots just start to appear (**Figure 10.5**). If you go much beyond that, you can start to lose important detail in your bright areas.

FIGURE 10.4
Blacks are adjusted with the Blacks slider and a threshold screen. This is the image shown in Figure 10.3.

FIGURE 10.5
Whites are adjusted with the Whites slider and a threshold screen.

PHOTOSHOP AND PHOTOSHOP ELEMENTS

Adjusting blacks and whites in Photoshop and Photoshop Elements is very similar to adjusting them in Lightroom. Once again, you'll press and hold the Alt or Option key. This time, however, you'll be using Levels. Levels can be used directly on the image or as an adjustment layer—the technique is the same for either one.

For blacks, press and hold the Alt or Option key as you click and drag the black slider at the left side of the histogram in Levels (**Figure 10.6**). Use the black slider immediately under the histogram, not the one that's on the next slider below that. You'll get the same blacks threshold screen that I described in the preceding section; adjust blacks by moving the slider to the right as you watch the threshold screen.

Whites are adjusted by moving the white slider at the right side of the histogram to the left as you hold down the Alt or Option key. Again, watch the threshold screen to make sure you don't over-adjust the whites.

FIGURE 10.6
Blacks and whites are adjusted in Photoshop and Photoshop Elements with Levels and a threshold screen.

MIDTONES

I like to put the midtones of a photograph into one group. Techniques for adjusting them are the same as they are for blacks and whites, although you could split them apart into dark, middle, and light tones and talk about them separately in a book that was more about the software than this book is.

How bright your midtones are affects how bright your picture looks. It also affects how clean and clear colors look or how muddy and dingy they appear. A big challenge that every photographer faces is that digital cameras are more challenged by the dark tones of an mage than they are by the brighter areas. If your midtones are not bright enough, these dark areas will look muddy and less defined.

LIGHTROOM AND CAMERA RAW

Midtones can be adjusted simply and easily with the Exposure and Contrast sliders in the Basic Develop panel in Lightroom 4. (In earlier versions of Lightroom, use Brightness and Contrast.) The same is true for the most recent version of Camera Raw.

However, I believe that a better adjustment of midtones comes from the Tone Curve. This allows you to adjust specific aspects of the midtones—from shadows to darks to lights to highlights—somewhat separately (**Figure 10.7**), which can be very helpful when you have an image that needs only part of the midtones adjusted, not all the midtones. For example, when you have a landscape that has a lot of dark tones that aren't being well revealed, you may find that, as you use Exposure, the bright areas of the picture get too bright when the dark areas begin to look good. By using the Darks slider of the Tone Curve, you can bring up the brightness of the dark areas without making the bright areas too bright.

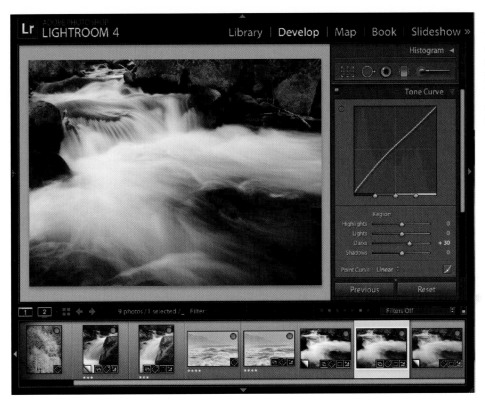

FIGURE 10.7
Midtones are best adjusted with the Tone Curve in Lightroom. The Darks slider can be especially important.

PHOTOSHOP AND PHOTOSHOP ELEMENTS

The simple and easy way of dealing with midtones in Photoshop and Photoshop Elements is to use Levels again, this time using the middle slider under the histogram (**Figure 10.8**). Simply click and drag that slider left and right to make the picture brighter or darker. The slider favors the midtones and adjusts the darkest and lightest tones less.

FIGURE 10.8
A simple way of adjusting midtones in Photoshop and Photoshop Elements is to use the middle slider below the histogram in Levels.

You also can use Curves in Photoshop or Color Curves in Photoshop Elements. You can gain a lot of control over midtones in Curves, but it takes a bit of time to learn this control. There are some presets that you can use without having to understand much about Curves, however. Color Curves is easier to work with because it uses sliders instead of clicking and dragging on the curve itself. The sliders are pretty intuitive; plus, some presets are available.

COLOR

Color adjustment was not a common part of the traditional darkroom. Color in the darkroom was difficult to work with for the average photographer. That's no longer true. Before Adams died, he stated in an interview that he saw a lot of potential in working on photos in the computer, especially with color.

Color is typically adjusted in two different ways for landscapes:

1. **Color correction:** The color is wrong because of the way white balance is seeing the light on the landscape.

2. **Color enhancement:** The camera doesn't capture colors equally or necessarily the way we see them, so often we need to enhance colors from the way the camera recorded them.

If you're setting your camera to a specific white balance, you'll rarely have to color-correct your image. If you use Auto White Balance, you'll have to do color correction quite often, if you really want the best colors from your landscapes. That's why I can't recommend the use of Auto White Balance for landscape photography.

Color enhancement is a different story. Colors vary depending on how a particular sensor deals with the colors in a scene and based on exposure. One of the challenges that we all face with a landscape is that the light can cause problems with consistent exposure across the scene. That also can mean problems with some of the colors so that you need to do some adjustments.

LIGHTROOM AND CAMERA RAW

Color correction is pretty straightforward in Lightroom and Camera Raw. There is a white balance eyedropper available in both programs. You simply click on that eyedropper in the Basic panel (**Figure 10.9**) and then move your cursor out onto the photograph. Click on anything that should be a neutral tone. That can be something that should be white, black, or a shade of gray. The program will then remove the color cast and try to make that neutral tone neutral. Keep clicking in different places

until you get something that looks good. In addition, you can use the Temperature slider in the Basic panel to make the image cooler or warmer, and the Tint slider below that to correct any green or magenta color casts.

The HSL panel in Develop in Lightroom is a wonderful feature for correcting or enhancing specific colors that aren't recorded properly by the sensor; Camera Raw has something similar. This panel has three sets of color adjustments:

- **Hue:** Hue affects the color of a color. This can be very important if you find that a specific color is a little off.

- **Saturation:** Saturation affects the intensity of a color. Sometimes both over-and underexposure will reduce the intensity of the color, and it needs to be corrected.

- **Luminance:** Luminance changes the brightness of a color. This can be a very effective way of darkening the sky without darkening anything else.

There are eight different colors that can be varied in each of these categories (**Figure 10.10**). Lightroom does an extremely good job of keeping these colors separate so as you adjust one color, you're adjusting only that color in the whole picture.

There is also a very important part of this panel, a targeted adjustment button at the upper left. Click this little target and your cursor becomes activated. Now you simply move your cursor out into the picture and click and drag up and down on any color that you want to adjust. Lightroom finds the colors for you automatically.

FIGURE 10.9
Color balance can be corrected quickly by using the white balance eyedropper in Lightroom.

FIGURE 10.10
The HSL panel is the place to go in Lightroom for correcting and enhancing specific colors.

PHOTOSHOP AND PHOTOSHOP ELEMENTS

There are a number of ways to correct color in these programs that can get pretty involved. However, there is a control that acts a lot like the white balance eyedropper of Lightroom: the middle gray eyedropper in the Levels adjustment window or panel (**Figure 10.11**). Select it, and then move your cursor out over the image. Click anything that should be a neutral tone—white, black, or a shade of gray. Clicking will remove the color cast and try to make that neutral tone neutral. Again, keep clicking until you get something that looks good. This tool is especially effective when used with an adjustment layer because you can find an adjustment that's too strong, and then turn it down by changing the opacity of the layer. (Photoshop Elements also separates this eyedropper into another control in the Enhance menu, Remove Color Cast.)

Correcting or enhancing specific colors is done with the Hue Saturation adjustment controls (**Figure 10.12**). When you first open Hue Saturation, you get overall adjustment sliders for both. (You also get Luminosity, which is pretty much worthless.) Generally, it isn't a good idea to use those overall adjustments to any significant

FIGURE 10.11
Color balance can be corrected quickly with the middle eyedropper in Levels in Photoshop.

FIGURE 10.12
Colors in Photoshop can be controlled by Hue Saturation. Use the control's ability to adjust individual colors, which is set to Reds in this screenshot.

amount. Click Master and you'll get a drop-down menu that allows you to select specific colors that you can adjust. When you've selected the color, you also can move your cursor out onto your picture and click that color. Photoshop or Photoshop Elements will then refine how it looks at that specific color. Now you can limit your adjustments of Hue and Saturation to that color. That's the best way of dealing with these adjustments in your landscape.

LOCAL CONTROLS

Once you start using local controls on your landscape images, you'll rediscover the capabilities that Ansel Adams and other darkroom workers like him had in creating their marvelous images. Much of what they did to create their stunning black-and-white landscape photography was to use local controls in very effective ways. Once again, the Adams book *The Print* gives many ideas on how to do just that.

There is no question that this is a craft and not something that you're going to learn by reading a few paragraphs in a book. You have to practice, experiment, and see what happens to your images as you do.

You'll be looking for small areas in your picture that need to be adjusted separately from the rest of the picture. It may be that the entire picture needs to be brightened, but that makes one area look too bright, so you need to bring that area back to its original brightness. Or you may find that when you adjust an image globally, there are areas that are bright enough to take your attention away from key parts of the composition. Or perhaps there are areas that are too dark and create black blobs without good detail in your image.

The photo of a Joshua tree at sunset in the Red Rock Canyon Conservation Area outside Las Vegas is a good example of how local adjustments can bring out and enhance the original image. The original shot has had global adjustments made to it (**Figure 10.13**). The photo was shot using a flash to start to balance the tree against the sky, but the flash wasn't strong enough to make the effect work as well as it could. When the image was processed overall, this made the background too bright and gave less of the drama of this plant than I wanted.

In the image with local adjustments (**Figure 10.14**), I've done a number of things to bring out important details in the original image. The strengthening of the light on the Joshua tree is pretty obvious. If you look closely, you'll see that some parts of the tree had to be brightened more than others. In addition, I darkened the nearly black background of the mountain so that the detail there wasn't a muddy distraction. Finally, I did a little work to the sky to better highlight its texture and color.

FIGURE 10.13
Global adjustment has been made to this image, but it's difficult to make it any brighter to show off the tree without washing out the sky.

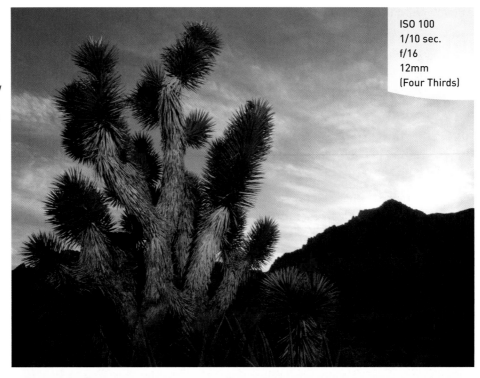

ISO 100
1/10 sec.
f/16
12mm
(Four Thirds)

FIGURE 10.14
Local adjustments have been made to this image in order to enhance the tree and the mood of the photograph.

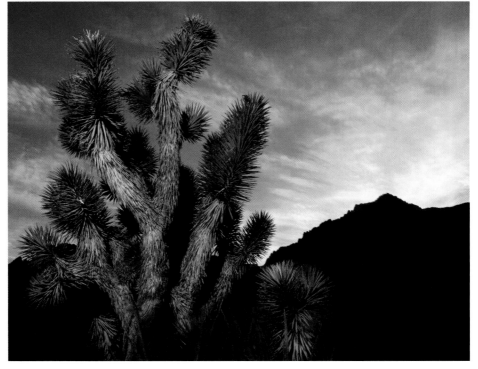

LIGHTROOM AND CAMERA RAW

Lightroom and Camera Raw have three important tools for local adjustment: Post-Crop Vignetting, the Graduated Filter, and the Adjustment Brush. To a degree, HSL acts as a local control because it allows you to affect specific colors, although that effect will occur wherever that color is found across the image.

Post-Crop Vignetting is an edge darkening effect found in the Effects section of Develop in Lightroom and in the Effects tab of Camera Raw. It mimics a standard darkroom technique of darkening the edges of the image. Adams talks a bit about edge darkening in *The Print*, noting that it helps keep the viewer's eyes on the photo.

Both the Graduated Filter and the Adjustment Brush offer a variety of adjustments. There are 11 different sliders that you can adjust, but it can drive you crazy if you start trying to use all of them at once. Remember that Ansel Adams had only two local controls—brightness and contrast—when he was doing his amazing prints. I recommend you get started using these local adjustments simply by using positive or minus Exposure (or positive or minus Exposure or Brightness for versions of Lightroom prior to Lightroom 4).

You can learn the basics of how to use these local adjustments pretty quickly, but knowing how they work is not the same as being able to use them effectively. I don't know any way to learn to use them effectively other than experimenting—you need that hands-on experience. One nice thing about Lightroom is that you can play with these tools as much as you want and nothing is ever applied to the actual image until the image is exported from Lightroom or Camera Raw.

I recommend that you play with these tools. Try them out on different pictures. Try all sorts of things just to see what they do. One thing that can be very helpful is to set your original adjustment way too strong. This lets you see it as you use it on your picture. Then go back and readjust the setting to a more appropriate level after the basic local control has been applied.

So, to start learning to use these controls, begin with the Graduated Filter in the toolbar of both Lightroom and Camera Raw (**Figure 10.15**). Set Exposure to a large minus amount, such as –2.00, so you can easily see what you're doing. (You can change this at any time to a more appropriate amount.) Click and drag on your photograph to create the "graduated filter." The maximum adjustment starts where you click first and then gradually changes to zero adjustment where you finish your drag. You can change how quickly that gradation occurs by clicking and dragging the outside lines. You can rotate this entire graduated filter as you click and drag, or you can click on the middle line to rotate it at any time. Move the entire adjustment by clicking and dragging on the dot in the middle.

FIGURE 10.15
Play with the Graduated Filter to see how it can help you. Set it to a high minus Exposure to quickly make changes you can see. Readjust Exposure to a more appropriate amount when you've completed the basic adjustment.

For the adjustment brush, try something similar (**Figure 10.16**). The difference here is that you literally paint on the adjustment by clicking and dragging on the image. Change your brush size as appropriate to the subject matter. For most pictures, leave Feather at 100 because that keeps the edges of the adjustment very soft and blended.

FIGURE 10.16
Play with the Adjustment Brush in the same way. Paint on the effect wherever it's needed or, to start, anywhere so you can see what it does.

PHOTOSHOP AND PHOTOSHOP ELEMENTS

Local controls are quite possible in Photoshop and Photoshop Elements. To do them well, you need to understand how to use adjustment layers and layer masks. I'll briefly give a couple ideas on doing this. They'll help you if you understand how to use these parts of the programs, but you won't learn much if you don't know layers and layer masks. For more on layers and layer masks, check out *Layers: The Complete Guide to Photoshop's Most Powerful Feature,* 2nd Edition, by Matt Kloskowski (Peachpit Press). (The challenge of learning adjustment layers and layer masks is one reason why Lightroom is so appealing—you don't have that struggle.)

My preference for darkening areas in the picture is to use a Brightness/Contrast adjustment layer with its layer mask. I'll add this adjustment layer and then use a strong minus Brightness to start. I fill the layer mask with black to block the adjustment, and then paint white wherever I want the adjustment to occur. Black in the layer mask blocks the adjustment, and white allows it.

To brighten areas, I'll often use a Levels adjustment layer without any adjustment but with its blending mode set to Screen. This brightens everything, so I add black to the adjustment layer to block that brightening. Then I paint white where I want to allow the brightening.

VIVEZA

Nik Software offers an outstanding plug-in called Viveza that makes local controls a lot easier to do in Photoshop and Photoshop Elements; it works for Lightroom as well. In Chapter 6, I mentioned the importance of the Structure slider, but a key use of Viveza is its local control through the use of control points. I admit that I quite like Viveza and its ability to selectively adjust parts of the picture much more easily than anything you can do in Photoshop or Photoshop Elements with adjustment layers and layer masks. Lightroom is a little different because of the way it uses its local controls, so, for me, Viveza complements Lightroom but doesn't replace it.

Control points are used by choosing Add Control Point and clicking on something in the image where you need a change to occur (**Figure 10.17**). Viveza very smartly looks at whatever is around that point and looks for similarities in color, tone, texture, and a number of other things. Then when you make an adjustment based on that control point, everything that is nearby and similar also will be adjusted automatically.

It's harder to describe how to do this in words than it is to actually do it. Nik Software has free webinars on its website (www.niksoftware.com) to help you understand and use the software; plus, you can get a free trial version and try it out.

FIGURE 10.17
Viveza uses control points to allow you to locally adjust specific parts of a photo, such as the clouds in this image.

CASE STUDIES

How you use local controls will vary tremendously from photograph to photograph. You may find that in one image you hardly use any local controls, but for another image, you use them all over the picture. The point is not how much you use local controls, but how you use them to help define, reveal, and enhance your composition. Compositions are strongly affected by what is bright in a photograph, so as you adjust local areas in brightness, for example, you'll affect the composition.

In the landscape from White Sands National Monument (**Figure 10.18**), I did a number of things in Viveza because of uneven brightness in the photograph. First, I did my initial processing of blacks, whites, midtones, and color in Lightroom. Then I increased structure overall when I sent the image over to Viveza. That gave more strength to the patterns in the sand.

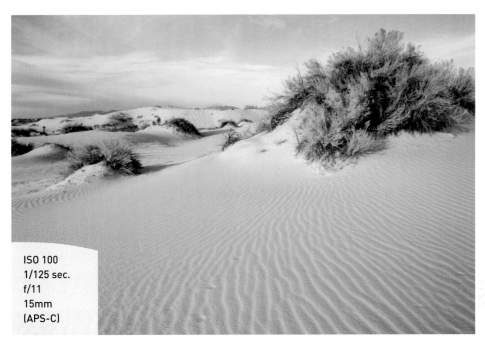

FIGURE 10.18
Local controls
helped me define
and refine the
composition of
this landscape
from White Sands
National Monument
in New Mexico,
especially in the sky.

ISO 100
1/125 sec.
f/11
15mm
(APS-C)

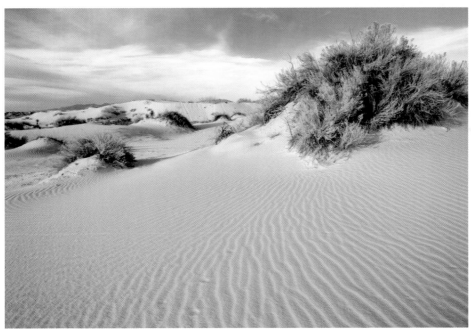

Next, I used control points to affect specific parts of the image. I added a control point in the clouds to add structure and brightness to bring them out more. I added several control points across the sky to darken the blue. I used several so that I could use a smaller area of control for each point and, therefore, more carefully limit the adjustments to the sky.

I felt there was a little bit too much brightness where the sun was directly hitting the sand on the foreground dunes, so I used control points to darken the sand. I also added a control point to the bushes and increased structure there in order to enhance the definition of the plants. Finally, I added some control points across the sand in the bottom of the picture to make a couple adjustments to further bring out the patterns in the sand.

I did all my adjustments for the intimate rainforest landscape in Lightroom. One thing you'll notice right away is how the emphasis of the composition changes (**Figure 10.19**). The original image shows off the entire scene just fine, but it doesn't give the emphasis on the tree that I felt the scene deserved. That's how we would be looking at this scene with our eyes, not seeing the whole scene without any emphasis.

I used Post-Crop Vignetting to darken the outside parts of the picture. Then I used the Adjustment Brush to brighten the tree trunk and darken areas throughout the picture that were too bright. This gave a better balance to the tonality of the image and help reveal the forestscape that I originally saw.

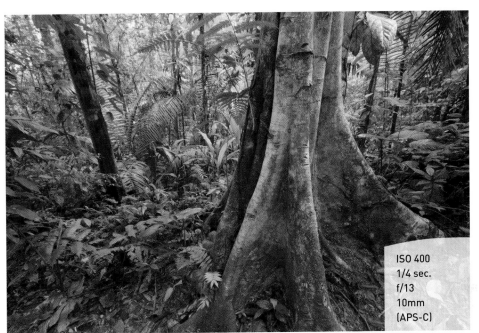

FIGURE 10.19
Local controls
affected the
emphasis within
the composition
of this rainforest
landscape in
Costa Rica.

ISO 400
1/4 sec.
f/13
10mm
(APS-C)

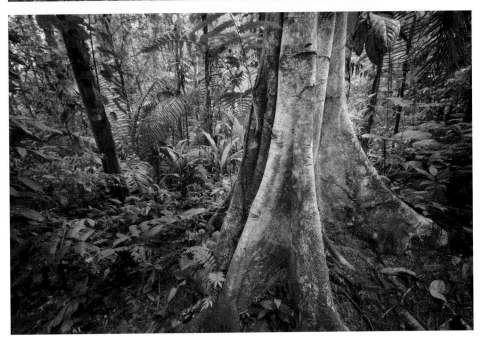

Chapter 10 Assignments

See the Graduated Filter

To learn to use local controls in Lightroom or Camera Raw, you need to be able to see them and get an idea of how they work. This will help you get a feeling for what they can do. Find a picture with a large area of bright, but not washed out, sky. Click the Graduated Filter in the toolbar above Basic in the Develop module. Set Exposure to a high minus amount. Click and drag in the sky. Remove the adjustment by pressing Delete. Click and drag again, this time changing the direction of your drag and the distance. You'll quickly see how this control works.

See the Adjustment Brush

To learn to use local controls in Lightroom, you also need to be able to see the difference in how the Graduated Filter and Adjustment Brush work. Now click the Adjustment Brush in the toolbar. Keep Exposure set to a high minus amount. Click and drag in the sky, using your cursor as if it were a spray can painting the adjustment across the sky. Remove the adjustment by pressing Delete. Click and drag again, this time changing the direction and distance you paint. You'll quickly see how this control works.

Experiment with Virtual Copies

Lightroom includes something called Virtual Copy that is a great asset in helping you learn to use all the adjustments described in this chapter. Right-click your picture to get a context-sensitive menu that will include Virtual Copy. (All Lightroom and Photoshop users should have a right-click mouse because it gives you access to context sensitive menus; if you don't have one, you can Control-click to get the same contextual menu.) Select Virtual Copy to create another reference to your image without actually copying it. Now experiment with adjustments from how much you change blacks to the use of HSL to how you use a local adjustment. You can quickly compare the results of your experiments with the original image by going back and forth between the Virtual Copy and the image in the Filmstrip. Add additional Virtual Copies to do more experimenting.

Share your results with the book's Flickr group!

Join the group here: www.flickr.com/groups/LandscapesfromSnapshotstoGreatShots

INDEX

35mm photography, 12